IMAGES
of America

TROUP COUNTY

IMAGES
of America

TROUP COUNTY

Glenda Ralston Major,
Forrest Clark Johnson III, and
Kaye Lanning Minchew

ARCADIA
PUBLISHING

Published by Arcadia Publishing
Charleston, South Carolina

Library of Congress Catalog Card Number: 2007921844

For all general information contact Arcadia Publishing at:
Telephone 843-853-2070
Fax 843-853-0044
E-mail sales@arcadiapublishing.com
For customer service and orders:
Toll-Free 1-888-313-2665

Visit us on the Internet at www.arcadiapublishing.com

CONTENTS

ACKNOWLEDGMENTS

We wish to thank the membership and Board of Trustees of the Troup County Historical Society for sponsoring this pictorial history project. We were able to produce this work because of the excellent collections of photographs that the Troup County Archives gathers, preserves, and maintains. These collections are available because of the many individuals and groups who generously donate their photographs to the archives. Some need to be singled out. Chris Cleaveland has an extensive collection of postcards and other materials he is always willing to share. Two fairly new collections were extensively used. James Ehernberger gave us the Stanley Hutchinson collection of photographic prints and negatives, and Ruth Perdue and Frankie Newman gave us the Katherine Hyde Greene collection. We also need to thank the Georgia Department of Archives and History for sharing photographs from their Vanishing Georgia collection.

Special thanks are due to Jim Biagi for sharing his expertise in identifying automobiles. We appreciate fellow members of the Troup County Archives staff who have worked on this project, especially George Allen for his careful attention to scanning and Barry Jackson, Diana Thomas, and Randall Allen for their assistance with photographs and caption information.

We gratefully thank those people whom we have called upon from time to time with questions for sharing their time and knowledge with us. Also we thank our individual families for understanding about the time involved in writing and preparing this book.

All images without courtesy lines are from the Troup County Archives.

—Glenda Major
Clark Johnson
Kaye Minchew

INTRODUCTION

Since its creation in 1826 by the state legislature, Troup County has had a rich and colorful history. Documenting that history through photographs is an enjoyable and often challenging task. For the earliest years, when photography was in its infancy, finding pictures from this area is limited by the scarce number available. As one moves forward in time, the increasing number of photographs presents the problem of selecting from such a vast quantity. The authors have collaborated several times on similar projects. Previous pictorial histories have been arranged topically, but we decided to present these photographs and their history in a chronological format.

Photographs do not exist for the era when the Creek Indians and their predecessors lived in West Georgia. Some of their village sites are known, but most are now under the waters of Lake West Point. The chief reminder of their past in our area is found in some of the names we still use, such as Chattahoochee and Wehadkee. The earliest pioneers had scant photographic history, though many remained here long enough for the science of photography to catch up to them.

Established in 1826 from former Creek Indian lands, Troup County soon became a wealthy agriculture-based economy. Rich soil and fertile waterways made the gently rolling Piedmont foothills an ideal place for raising all manner of grains. Cotton, hogs, and cattle played important roles, too. Troup County was the fourth wealthiest county in Georgia in 1860, based on taxes paid to the state. An unusual devotion to academics, manifested early in our history, made LaGrange an educational center, which also contributed to the economy. Three women's colleges, one of which converted to a male university, and other schools of high caliber for black and white students made LaGrange synonymous with academics. Many 19th-century state political leaders had roots in Troup County.

Economically, Troup County was not as severely affected by the Civil War as other areas. Many who engaged in agriculture had other interests: law, politics, education, medicine, industry, building, and railroads. Local investors led early industrialization efforts, which beginning in the late 1860s centered on textiles. By 1907, three railroads crossed paths at LaGrange. The towns in Troup County set up public schools, fire and police departments, and light, water, and sewer systems. The major textile companies, which provided many amenities for their employees and families, soon began assisting the general public with schools, churches, parks, and in other ways.

In World War I, Troup County became a nationally recognized leader in all aspects of the war effort. Soon they dealt with the Roaring Twenties and the Depression of the 1930s. World War II found them on their feet again, and the booming days that followed led to a new wave of industrialization. Though textiles were still important, civic leaders realized that the future depended on industrial diversity.

Callaway Foundation, Inc., and Fuller E. Callaway Foundation, Inc., were created from earlier charitable groups. These and other local foundations, together with immense private support, provide many things that add to the quality of life here. Today Troup County, centered in its county seat, LaGrange, boasts all the cultural, religious, educational, charitable, and recreational opportunities found in much-larger communities. LaGrange College and West Georgia Technical

College head the list of many fine schools. A symphony, a ballet company, several art museums, fine sports facilities, an active historical society, and myriad other opportunities for enrichment abound. Special events are held throughout the year, from parades at Christmas, Fourth of July, and Martin Luther King Day to special festivals. Sport and recreation are provided with venues that attract statewide and regional tournaments. Troup County even played a part in the 1996 Olympics.

This book is designed as an insight into the history of Troup County. Every attempt has been made to insure the accuracy of our captions. It is hoped that the book will help preserve these photographs and the history that accompanies them. The book should be of interest to people new to Troup County, to longtime residents, including those whose families date back to the early years, and to those who formerly lived here. The authors hope that readers will be encouraged to use earlier publications for even more information about our heritage.

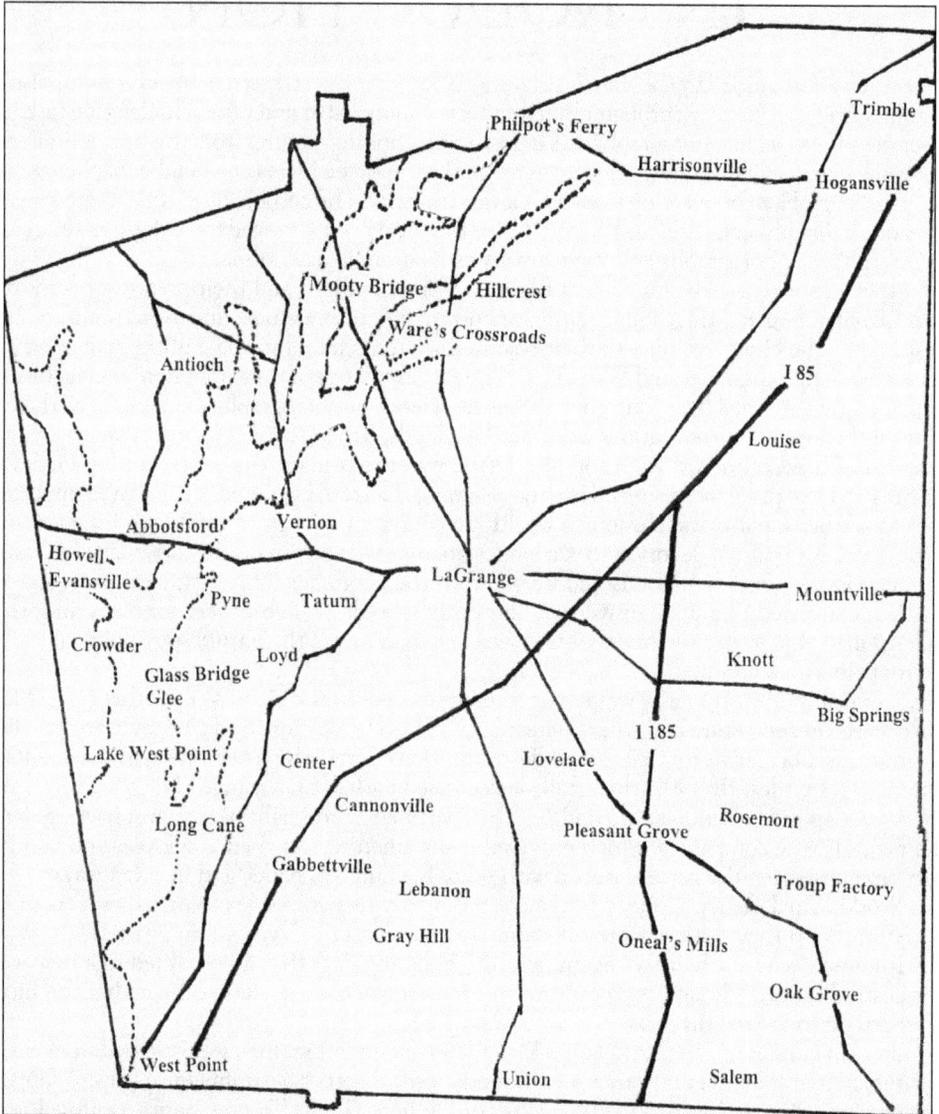

This map of Troup County shows its major highways and communities. (Map prepared by Randall Allen.)

One

ANTEBELLUM THROUGH CIVIL WAR
1826–1865

One of the earliest known Troup County photographs features Mary Emily Peavy. Born in 1832 near Mountville, she was a member of one of the first families to settle in Troup County. These early families arrived by wagons and carriages, and most came from eastern Georgia. Many brought with them fine furniture and household furnishings. They also brought books and Bibles along with plantings for flower gardens and seed for crops. Their servants and slaves came with them. They built homes, churches, schools, and stores. Some had money to spend on luxuries, such as having their images recorded by traveling photographers. Mary Emily married Dr. Elisha Dortch Pitman in 1848, and they had eight children. Dr. Pitman practiced medicine in the county for 45 years. Mrs. Pitman died in 1899.

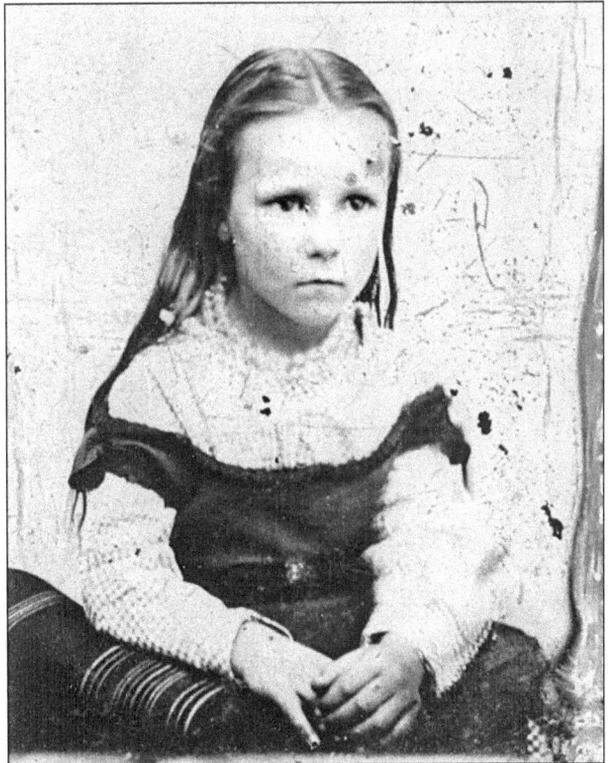

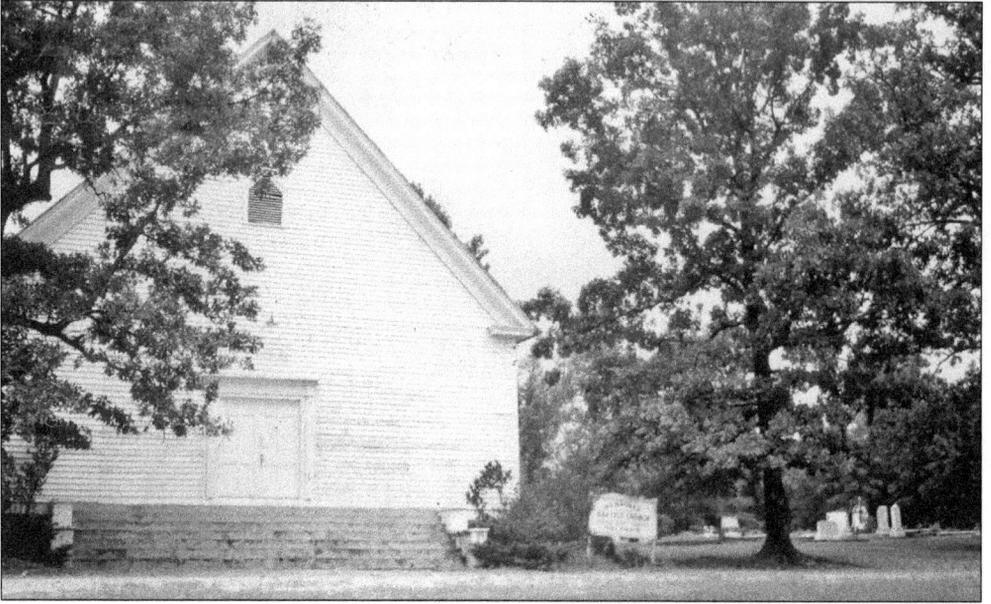

Early religious groups originally met and formed churches in homes. When enough families lived in an area, they built meetinghouses. Baptists west of the Chattahoochee River chartered Wehadkee Baptist Church in 1841, though they had possibly been meeting for several years. The church building may have originally had two doors, one for males and one for females. The earliest lettered tombstone dates from 1869, marking the grave of Jesse B. Haralson, a founding deacon. (Photograph by Katherine Hyde Greene.)

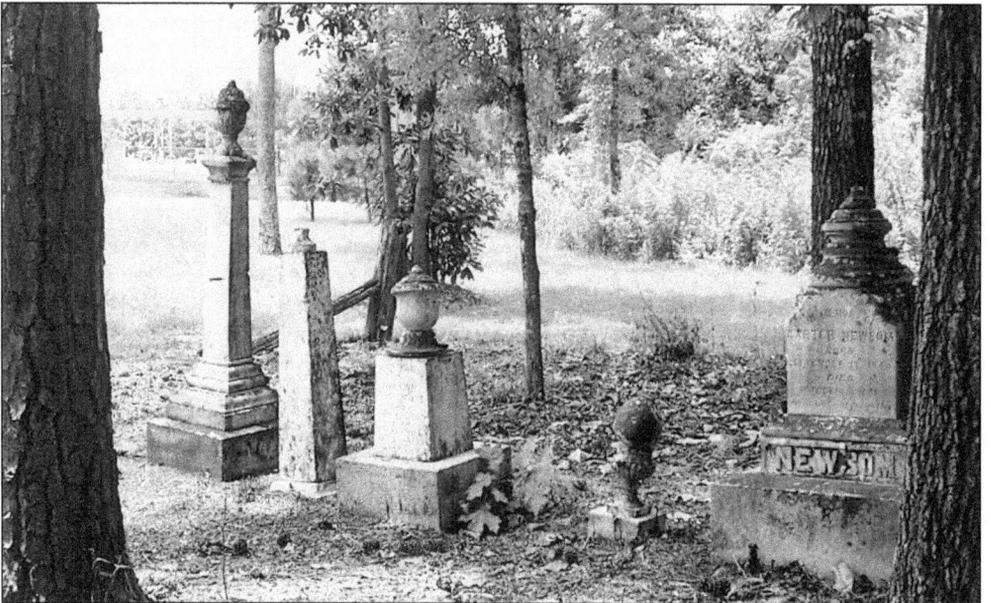

Joel Dortch Newsom brought his family from Hancock County about 1830. They built Nutwood, a fine two-story antebellum home designed by architect and builder Collin Rogers, on their plantation located midway between LaGrange and Big Springs. Another indication of their status, the nearby family cemetery, features large marble tombstones imported from across the state by wagon as early as 1833, when Newsom's first wife, Martha Waller, died.

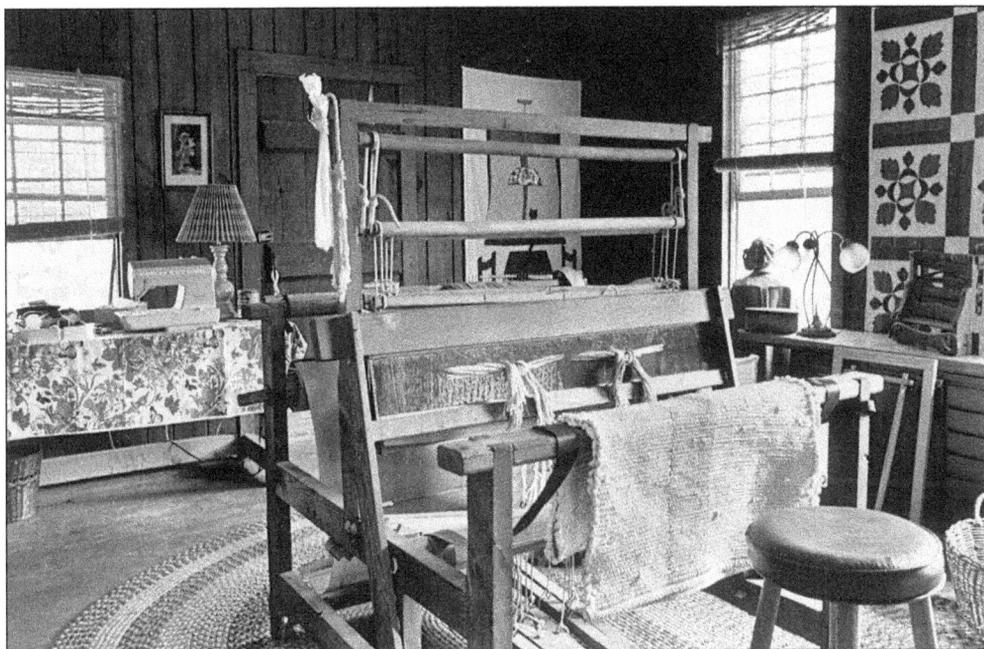

Located in the northeast corner of Troup County just east of Hogansville, the Phillips-Sims house was built by William D. Phillips in 1833. The house sat in the middle of a 465-acre plantation. One hundred fifty years after its construction, the interior remains furnished with reminders of pioneer activities, such as weaving on a home loom and quilting. A row of trees on the property marks the Meriwether County line.

Capt. Shirley Sledge built Sledge Garden as a wedding present for his bride, Elizabeth Jane Curtright, in 1844 in the Big Springs community. The formal gardens gave the home its name. Originally a story and a half with a kitchen and dining room attached by a breezeway, the house features stone chimneys quarried on the plantation. Captain Sledge served in the Creek Indian War of 1836 and the Civil War. (Photograph by Clark Johnson.)

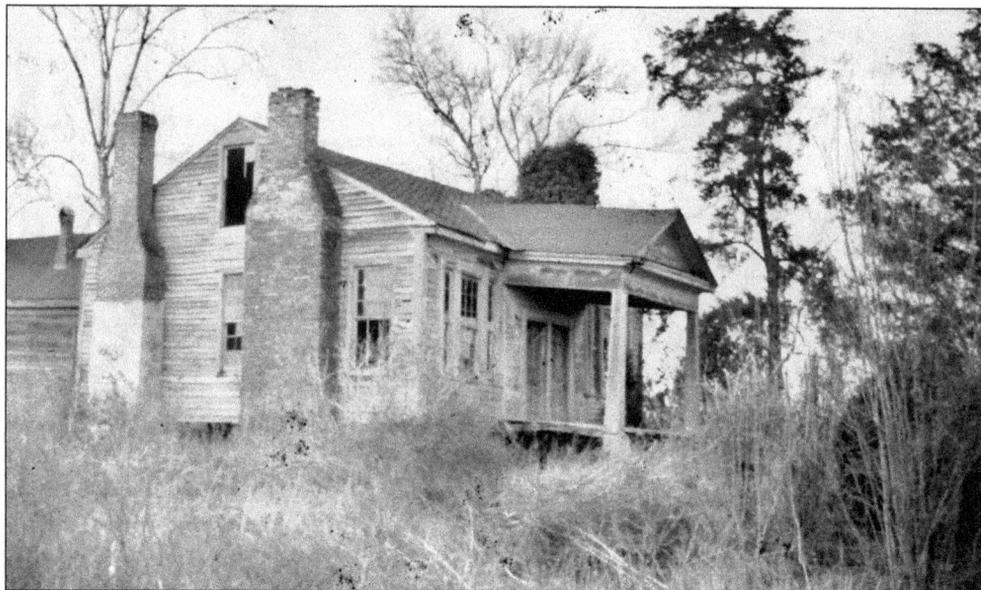

Located east of Big Springs Methodist Church, the Granny Jones house is Greek Revival, a popular style in the antebellum period in the South. Richard Jones built the house. His daughter-in-law, Adrian Davis, wife of Henry C. Jones, lived there until her death in 1924. She was known as Granny Jones. Her great-grandson Marvin and great-great-grandson Morris were Troup County commissioners. Katherine Hyde Greene made this 1960s photograph.

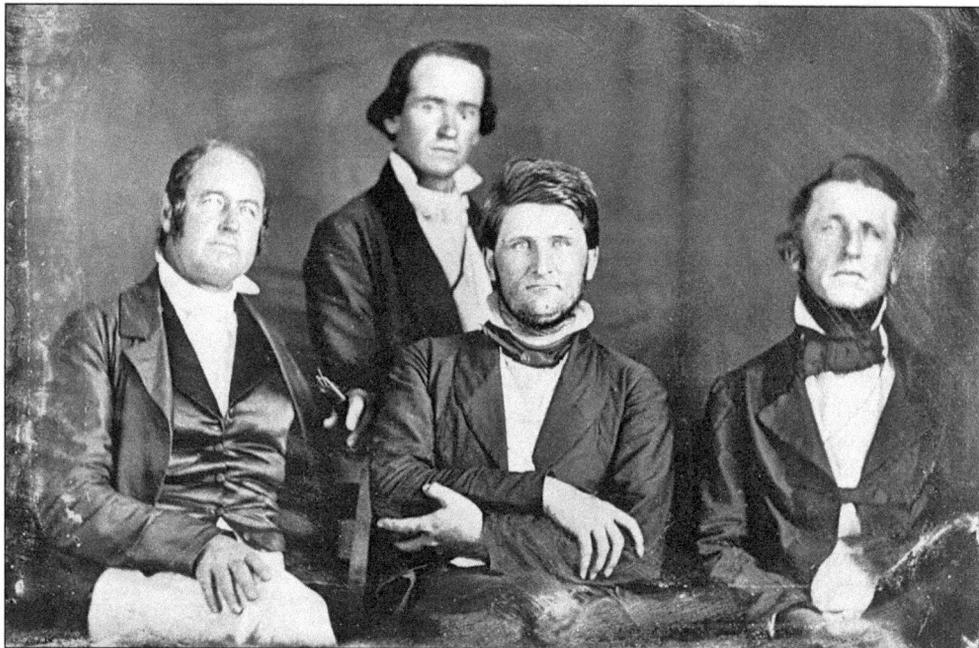

The 1856 cornerstone of First Baptist Church housed this photograph until 1995, when the building was razed to make way for a new sanctuary. With images of the men barely visible, the photograph had to be professionally restored. Phillip Hunter Greene, a prominent planter, inventor, and church leader, is shown on the left. Rev. Eldred Burder Teague, church minister, is shown in the bottom center. The other two remain unidentified.

12

William J. Sasnett served as president of LaGrange Female College from 1858 to 1859, shortly after the Methodist Church purchased the school. He then went to East Alabama Male College to serve as its first president. East Alabama became better known as Auburn University. A native of Hancock County, Georgia, Sasnett taught at Emory College before coming to LaGrange and was an ordained Methodist minister. (Used with permission of Special Collections Department, Auburn University.)

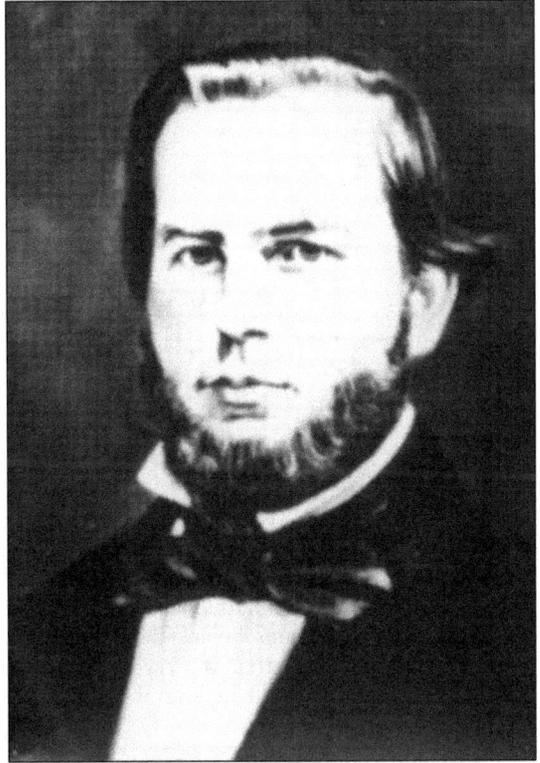

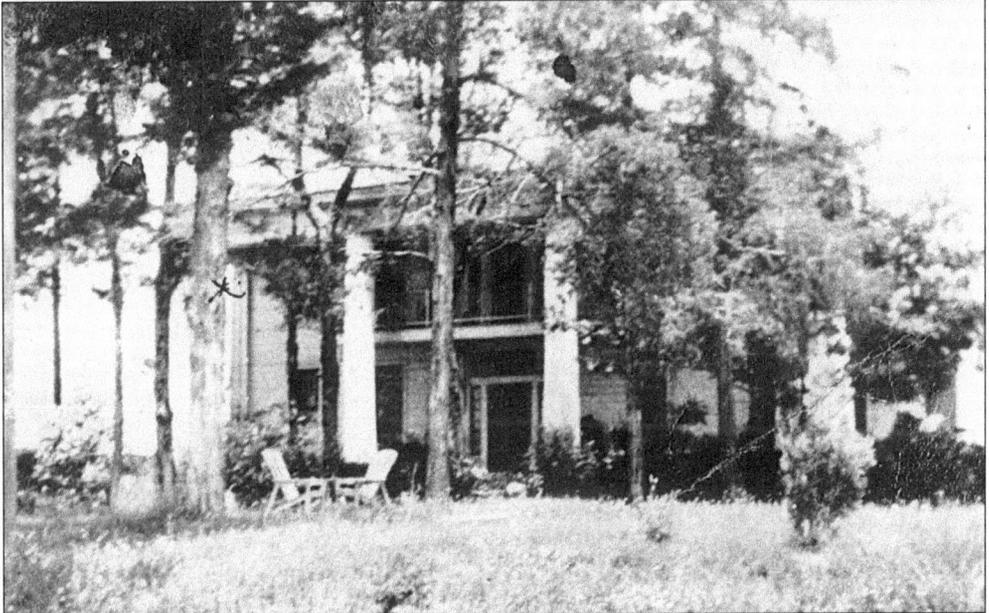

Dr. Elisha Pitman built this house in the Pleasant Grove community about 1853 after graduating from the Medical College of Georgia. The *LaGrange Reporter* described the house as an "old time Southern country mansion" after it burned in 1886. Dr. Pitman served as mayor of LaGrange from 1889 to 1891 and was one of four owners of the Macon and Birmingham Railroad. Each winter, he took 30 or more guests with him to Florida.

13

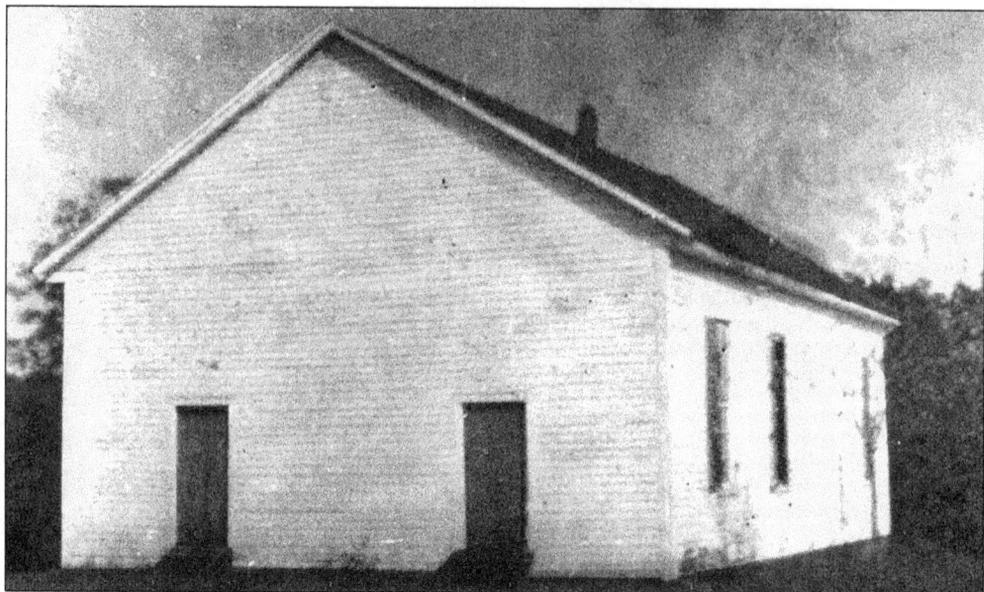

Big Springs Methodist Church looked much like this in 1861, when the funeral of Young J. Hall was held. The meetinghouse replaced an earlier structure built on the same lot that was donated by Hall's father-in-law, Nathaniel Howell. This building still serves the congregation. Its original double doors for males and females now open into a foyer.

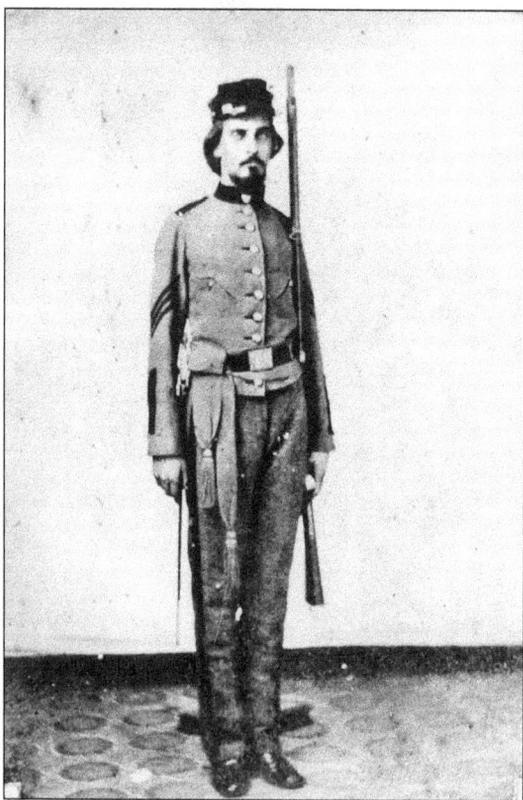

This may be Charles S. Morgan, who served in the LaGrange Light Guards, Company B, 4th Georgia, C.S.A. He died in battle at Williamsport, Maryland, on July 6, 1862. His brother, J. Brown Morgan, served throughout the war and was promoted to major. Nancy Hill Morgan, wife of J. Brown Morgan, led the Nancy Harts, the women's militia unit that defended the city of LaGrange in April 1865.

Pvt. William T. Mobley served in Company F, 21st Georgia. He joined in July 1861 and saw action in the first Battle of Bull Run. Later, in October, he wrote his family that he wanted news from "old Troup." He added, "It does me as much good to read a letter from you as it does to eat." He was discharged in August 1862 due to pneumonia. His fate remains unknown.

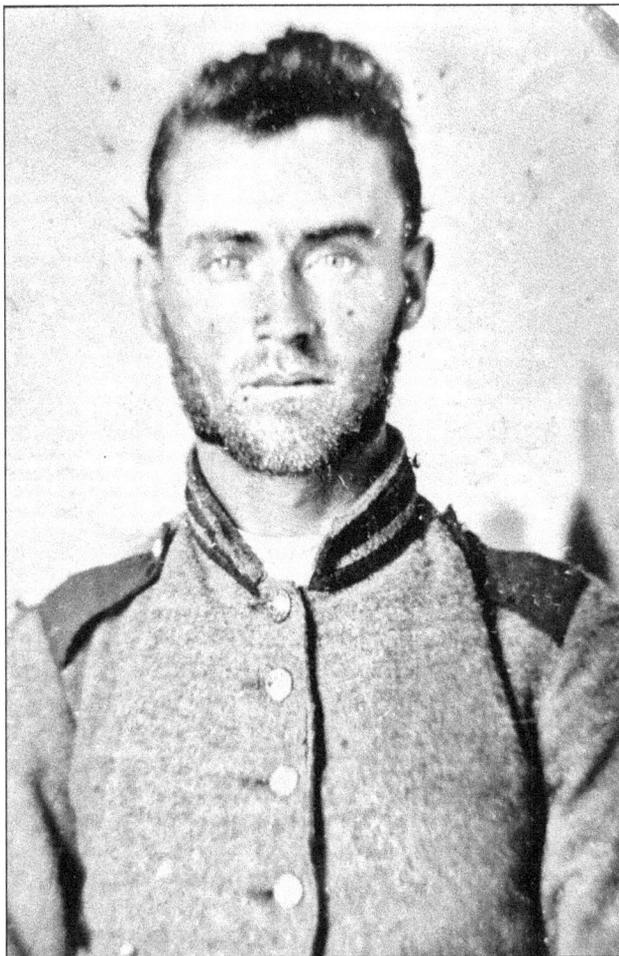

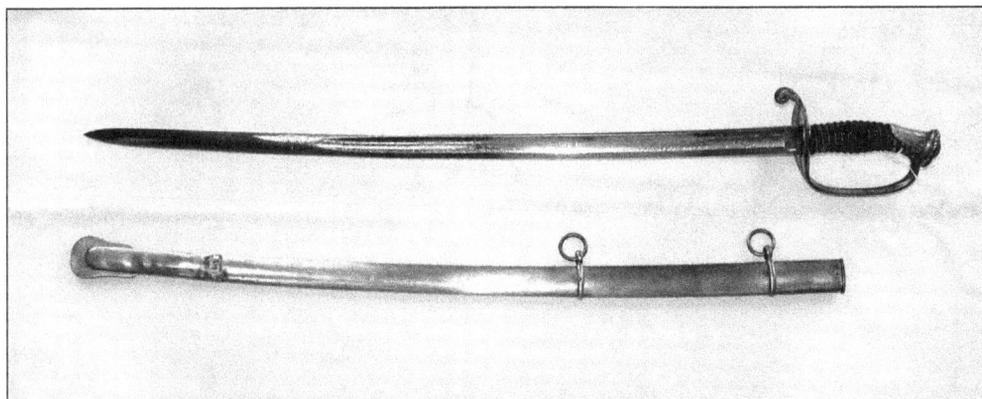

This Civil War sword and scabbard belonged to Capt. George Fauntleroy Todd of the West Point Guards, Company D, 4th Georgia. In July 1862, Todd carried this sword into the Battle of Malvern Hill, where he was injured. After he died in Richmond, his comrades returned the sword to the family. Todd's nephew, a professor in Arizona, gave it to the Troup County Historical Society, thus returning the sword home again.

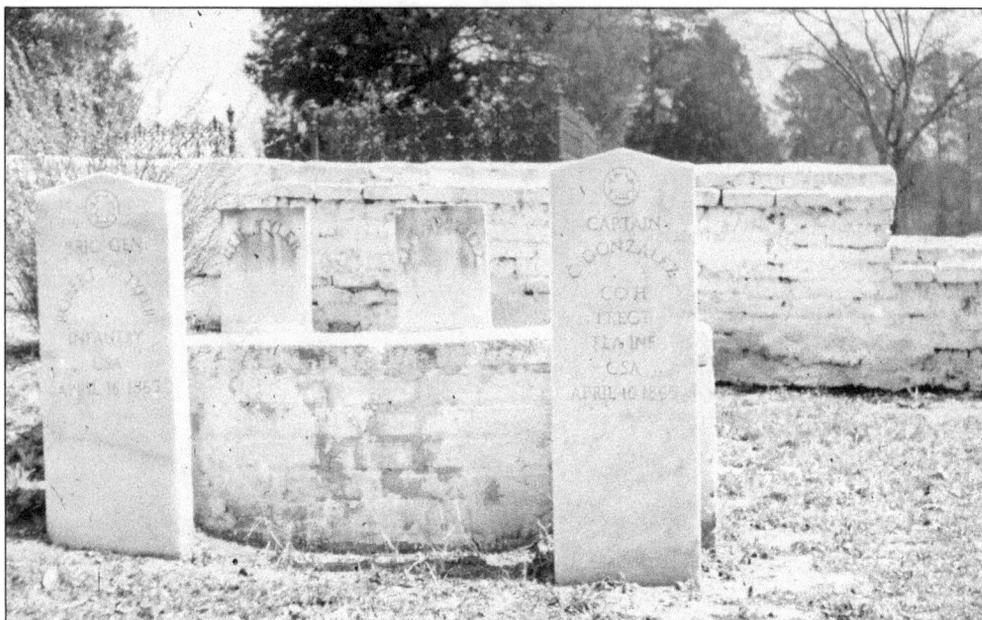

Over 401 Troup County soldiers died during the Civil War, most far from home. Others died in LaGrange and West Point after the Confederacy established hospitals here. Most of the Confederate dead in West Point fell while defending Fort Tyler on Easter Sunday, 1865. The double grave above holds the remains of Gen. Robert Tyler and Capt. Celestino Gonzales, commanders of Fort Tyler. Following their deaths and a serious depletion of ammunition, Col. James H. Fannin surrendered the fort to Union troops. The West Point cemetery is located off U.S. 29 next to Pinewood, the city cemetery. Soldiers buried at the Stonewall Cemetery in LaGrange came from all 13 Southern states and were primarily injured in battles from Chickamauga to Atlanta. Stonewall is just south of downtown, along the tracks of the same railroad that initially brought the injured into town. (Above, photograph by Katherine Hyde Greene; below, photograph by Stanley Hutchinson.)

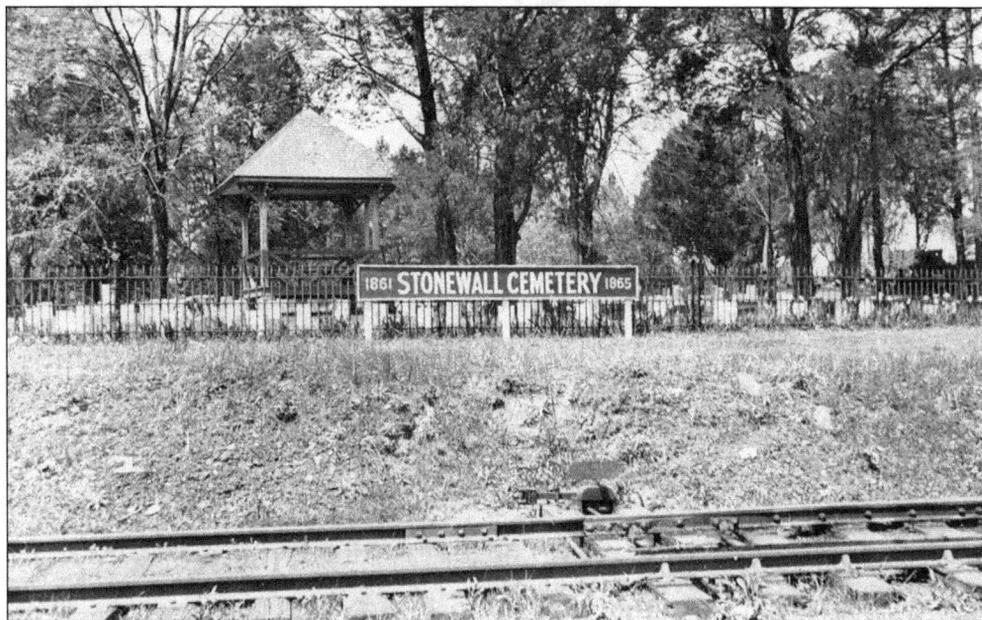

Two

THE NEW SOUTH
1866–1900

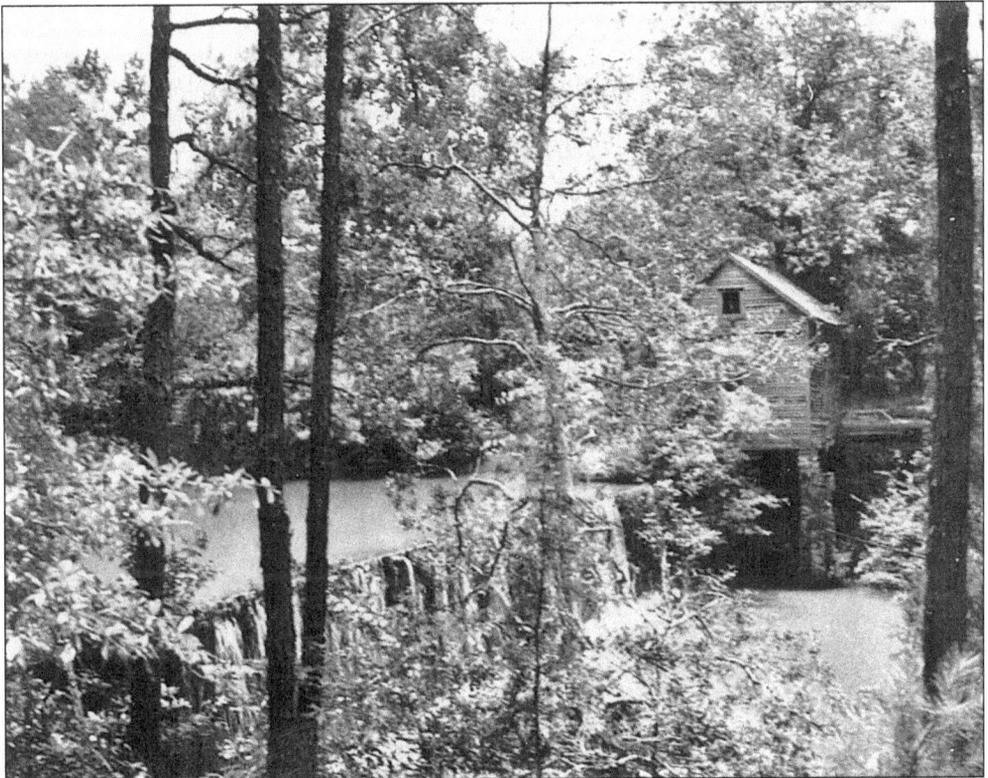

Located in southeast Troup County on Crawford Creek, this grist/flour mill typifies mills found around the county from about 1840 until the early 1900s. Hulbert W. Dallis built this mill near his antebellum home, unusual because the house was built of brick. Grist and sawmills were early forms of industry in Troup County. The last reminder of this once thriving enterprise is the name of the road, Dallis Mill Road.

Littleton W. and Mary Sturdivant pose in front of their home in the Salem community, c. 1875–1880. The picturesque fence surrounding the house served a practical purpose in keeping livestock out of flower gardens. The chair may have given Sturdivant physical support while the photograph was being made. Located in Southwest Troup County, Salem was once primarily an agricultural community and is now mostly a residential area. (Georgia Archives, Vanishing Georgia Collection, TRP-43.)

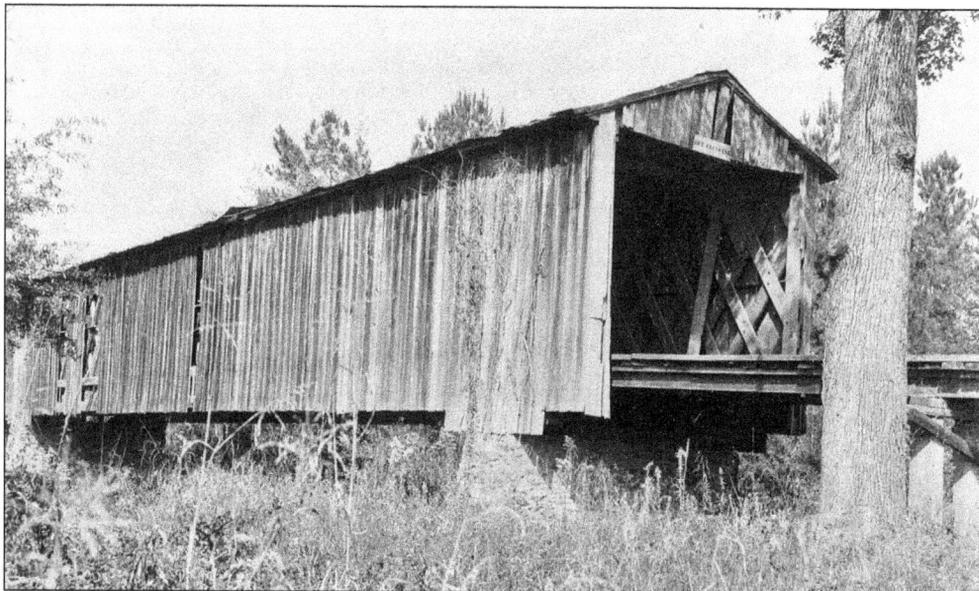

At one time, Troup County had a dozen covered bridges, including this one at Neely Road near Abbottsford on Whitewater Creek. Horace King and sons built most of these bridges between 1838 and 1890. Born a slave in 1807, King became a master bridge builder whose talents helped open western Georgia, Alabama, and Mississippi to trade and settlement. This bridge, the last one in Troup County, fell victim to a vandal's torch in 1972.

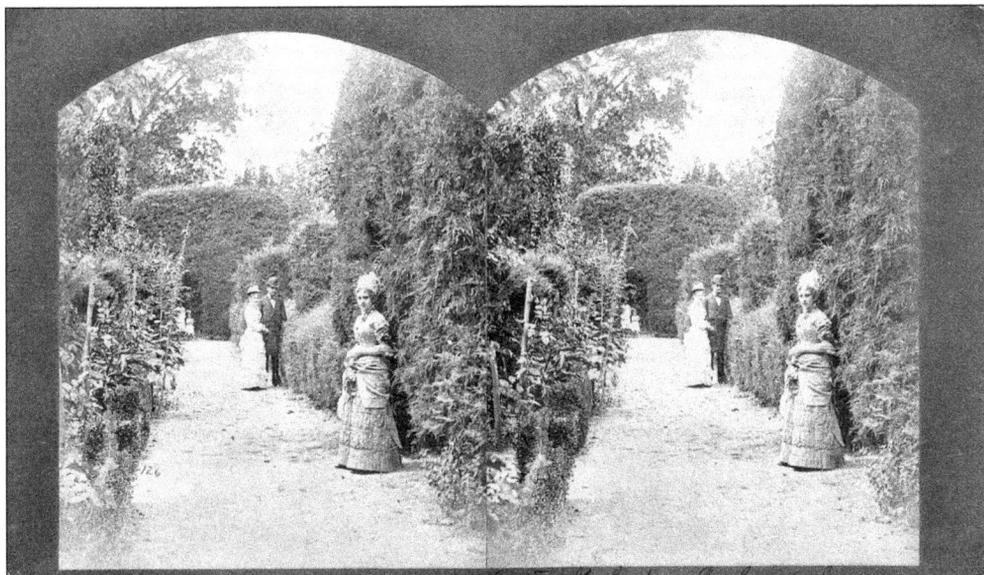

Sarah Coleman Ferrell began developing her gardens in 1841, adding to an 1832 garden her mother started. She called it "the Terraces" because cotton terraces created levels reminiscent of classical Italian gardens. The popular local name became Ferrell Gardens, though today Hills and Dales is used. In 1879, M. G. Greene made this and a series of stereoscopic photographs designed to be seen through a viewer, giving an illusion of depth.

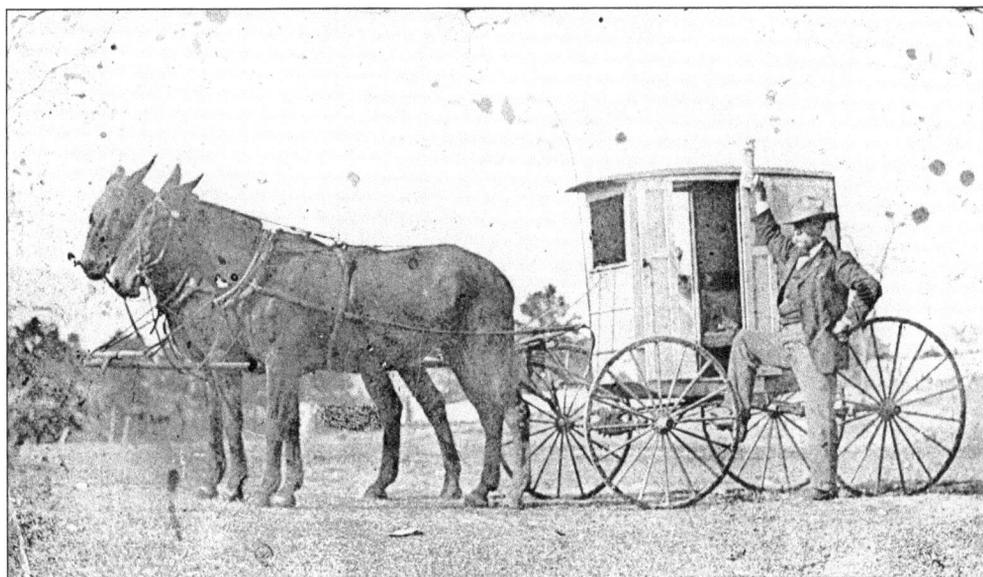

Lem Walker rode in a horse and wagon to deliver mail. In 1901, he received the contract to deliver mail on Rural Route One out of LaGrange. His route went by three schools—Big Springs, Pleasant Grove, and Oak Grove—in 1908. He was later called a pioneer rural mail carrier. His covered wagon helped ensure that "neither rain nor sleet nor snow" kept the mail from being delivered.

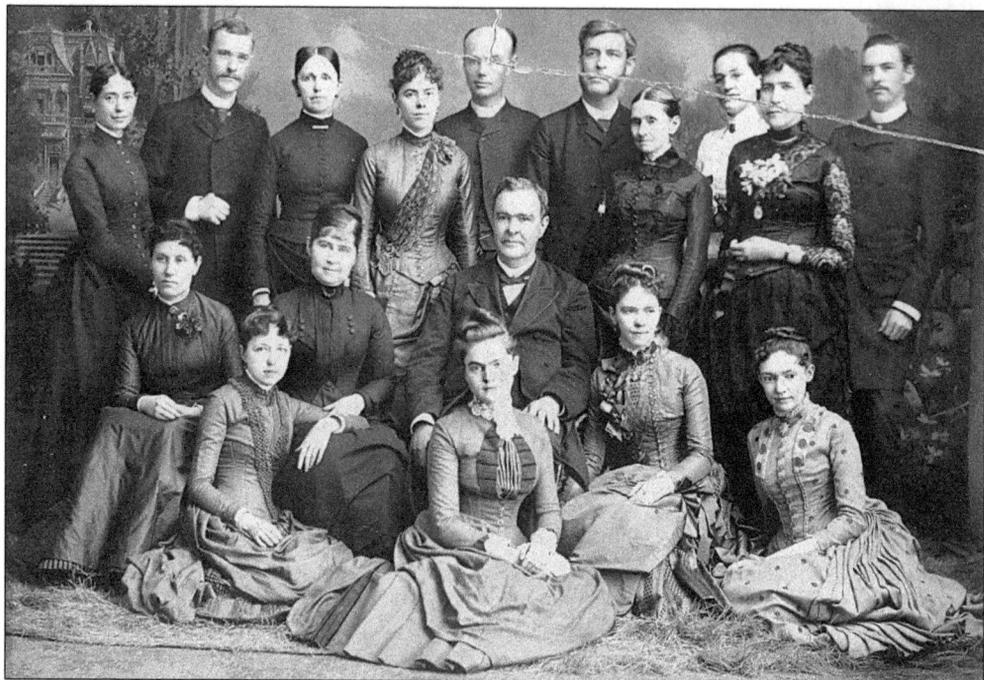

The faculty of Southern Female College gathered in 1887 wearing their finest Victorian dress. Established in 1843 by Rev. John E. Dawson, the school was affiliated with the Baptist Church. At the time of this photograph, Southern occupied the entire block of Church Street between Smith and Battle Streets. (Photograph by J. L. Schaub.)

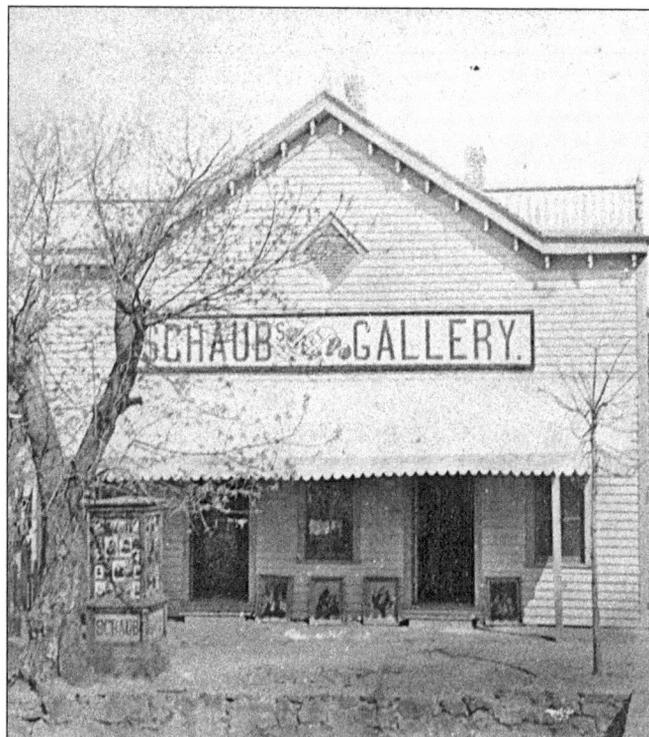

Julius L. Schaub, a Confederate veteran from North Carolina, came to LaGrange in 1880 and entered the photography business. He built this studio on Church Street in 1884. Later the building housed a variety of businesses, including a café and a stationery store. It stood until 1993, when it was razed to make way for a parking lot. For 31 years until his death in 1911, Schaub recorded Troup County's visual heritage. (Photograph by J. L. Schaub.)

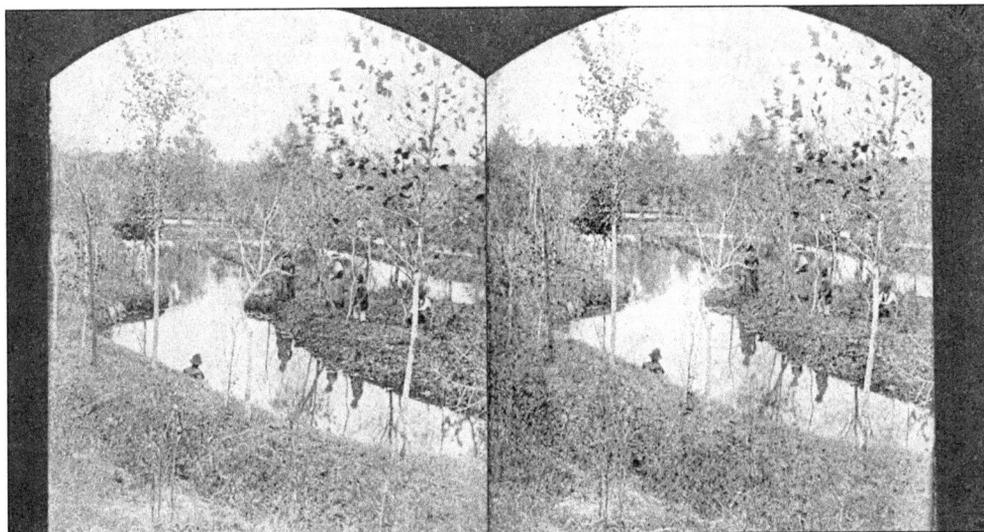

Declared to be the "prettiest fish ponds in the state" by the *LaGrange Reporter* in 1881, Ferrell Ponds occupied a low spot north of the Ferrell home. One of many in town during the era, ponds were used to raise fish for consumption. Baptisms and swimming often took place at other ponds. This is another photograph from the stereoscopic series made of Ferrell Gardens by M. G. Greene in 1879.

Established in 1865, First Baptist Church on Fannin Street grew out of the desire of some black members of First Baptist Church on the Square to have their own church. By 1882, this building on Fannin Street was nearing completion on lands donated by Judge Blount Ferrell. They later built an adjoining school. This building, which was eventually bricked over, served the congregation until 1980, when they erected a new sanctuary.

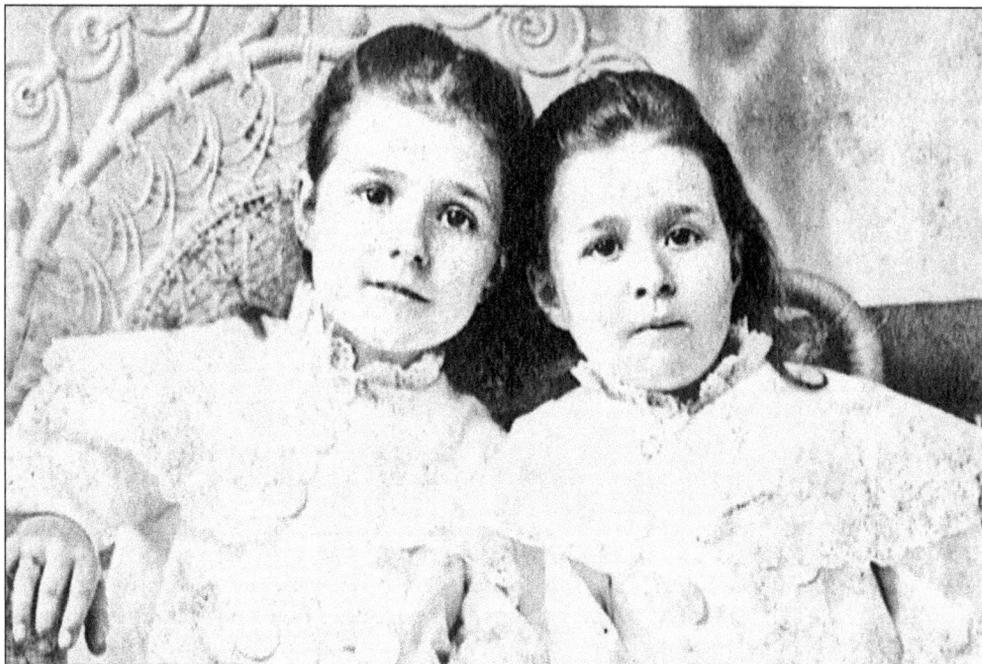

M. D. Fowler made this photograph of Ruth (left) and Nellie Broome in 1899. The girls grew up on the corner of Main and Broome Streets, the latter of which was named for their grandfather Rufus Broome. The home was located on the lot now occupied by the Troup County Historical Society. Ruth married three times—Joe Dunson Jr., B. W. Cubbage, and Jud Milam—and was widowed twice. Nellie married J. W. Ligon.

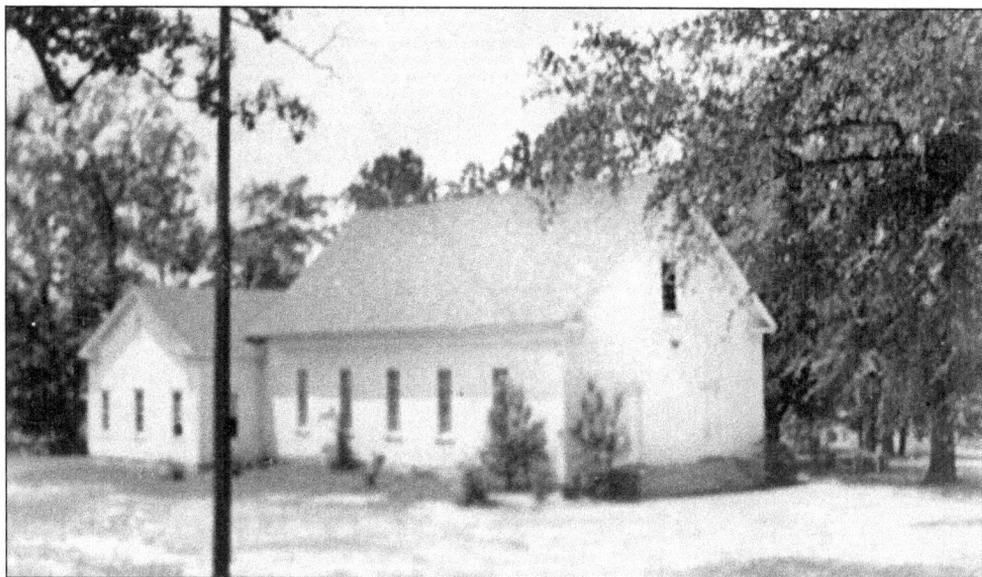

Pleasant Grove Methodist Church, located off Hamilton and Salem Roads, dates to 1831. A fire destroyed their original building, resulting in construction of the main sanctuary in 1893 for $881.98. The sanctuary stands to the right of the 1944 addition, built with lumber from the old Pleasant Grove School. Since this photograph was made in 1956, two other buildings have been added along with a foyer, steeple, and the bricking of the structures.

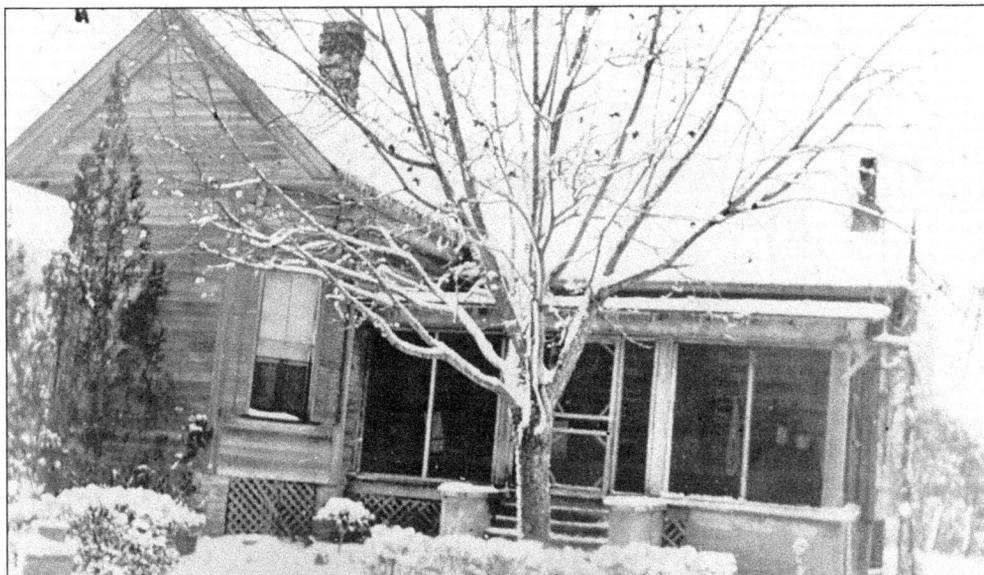

Among the founding families of Mountville, the Finchers operated a general store and farmed. Their original home displayed a plaque from a New York insurance company, which the family credited with sparing the house from a Yankee torch in 1865. In the 1890s, during what was known as the "Golden Age of Mountville," the Finchers built this Victorian home, shown in a 1939 snowstorm. (Georgia Archives, Vanishing Georgia Collection, TRP-294.)

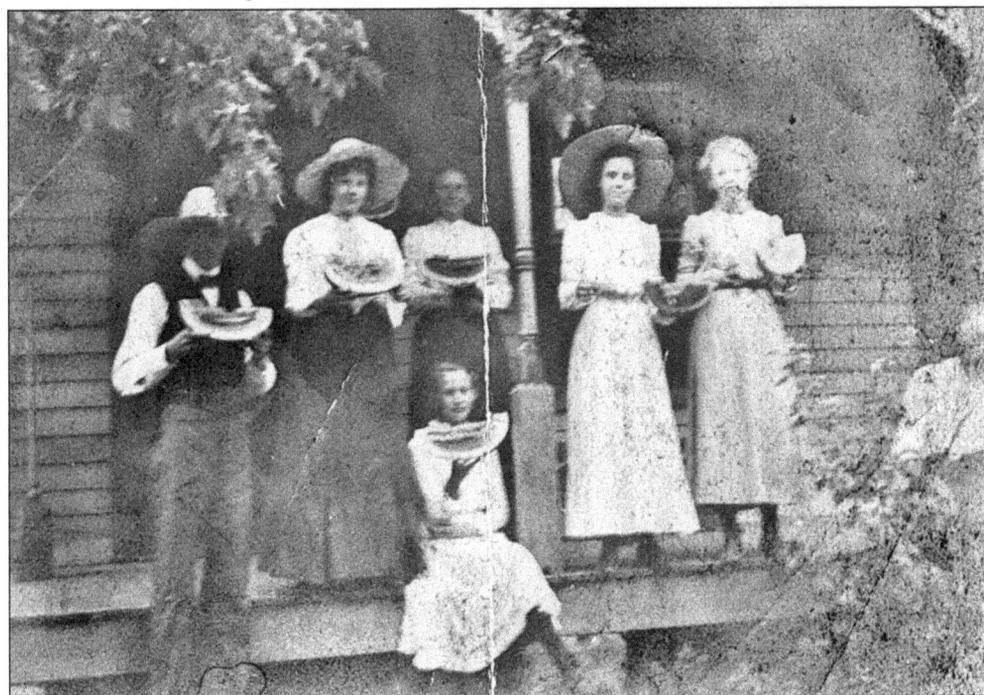

A photographer captured this unidentified family enjoying a traditional summertime treat of watermelon, possibly on a Sunday afternoon. They probably chilled the melon in a nearby creek or a well. Other favorite summer pastimes included swimming in rivers, creeks, and ponds, picnicking, and churning ice cream.

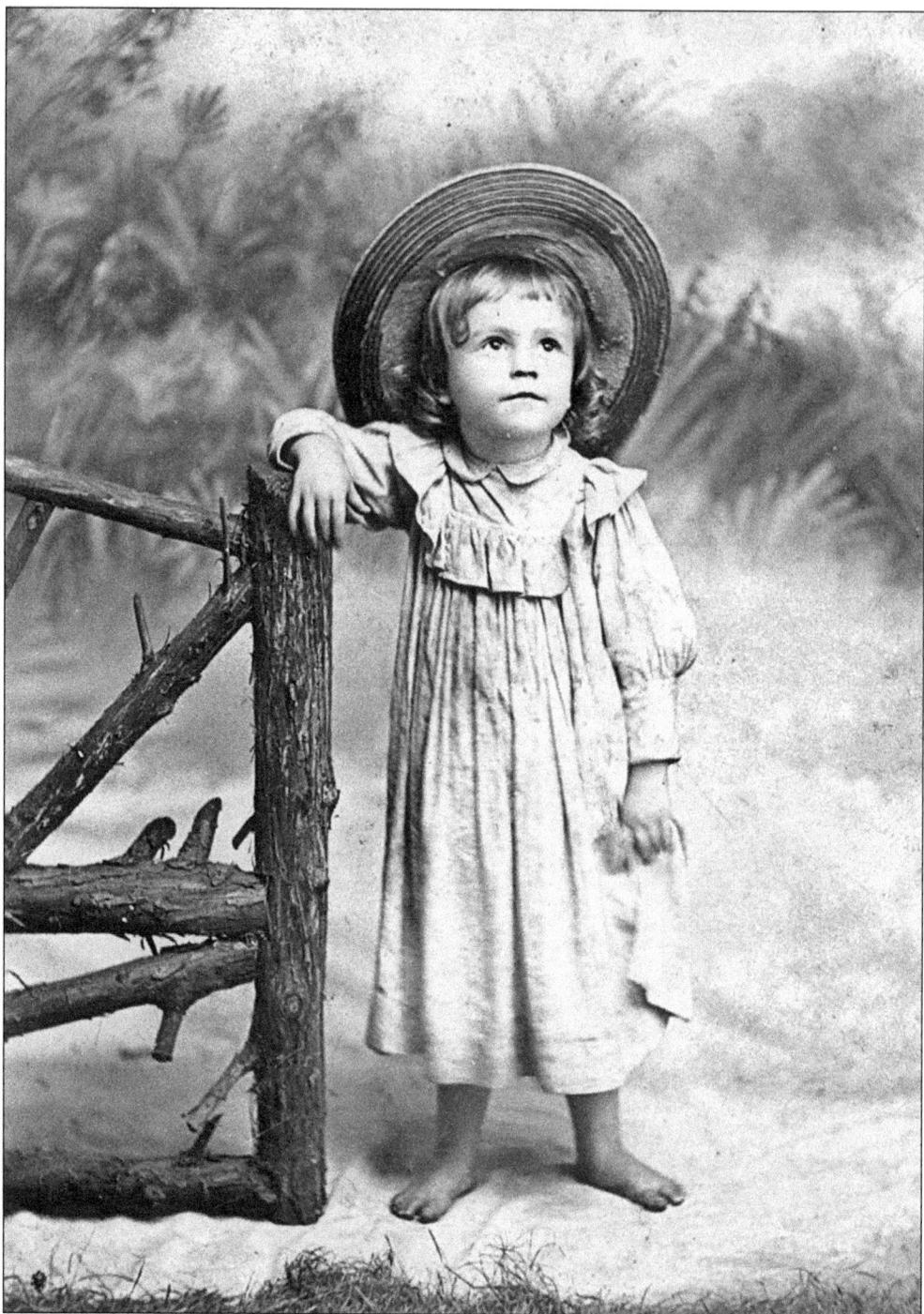

Wearing her brother's hat, young Ruth Slack walked from her home on Church Street to Julius Schaub's gallery, where he made this photograph in 1895. Her hat and bare feet, along with studio props, create the illusion of Ruth standing on a country lane. Her father, physician and pharmacist Dr. Henry R. Slack, opened the first modern hospital in LaGrange in 1902 next to the family home at Haralson and Church Streets.

24

The town of Troup Factory once boasted over 500 residents and stores, schools, churches, and a post office. Natural organizations such as Masons, Farmers Alliance, and Grange had chapters there. Built in 1848, Troup Factory was the county's first cotton factory and the major industry. Julius Schaub made the photograph at right as part of a series in 1887. The town also had a cotton gin, foundry, tannery, and flouring mills. The factory prospered into the late 1880s, shipping cloth to China and often having orders that exceeded production. Bad investments, principally in a never completed railroad, and steep transportation costs led to the sale of the factory in 1899. Ironically the map below, which preserves the layout of the factory and town, was prepared as part of the sale that led to moving the factory to LaGrange and the eventual disappearance of the town.

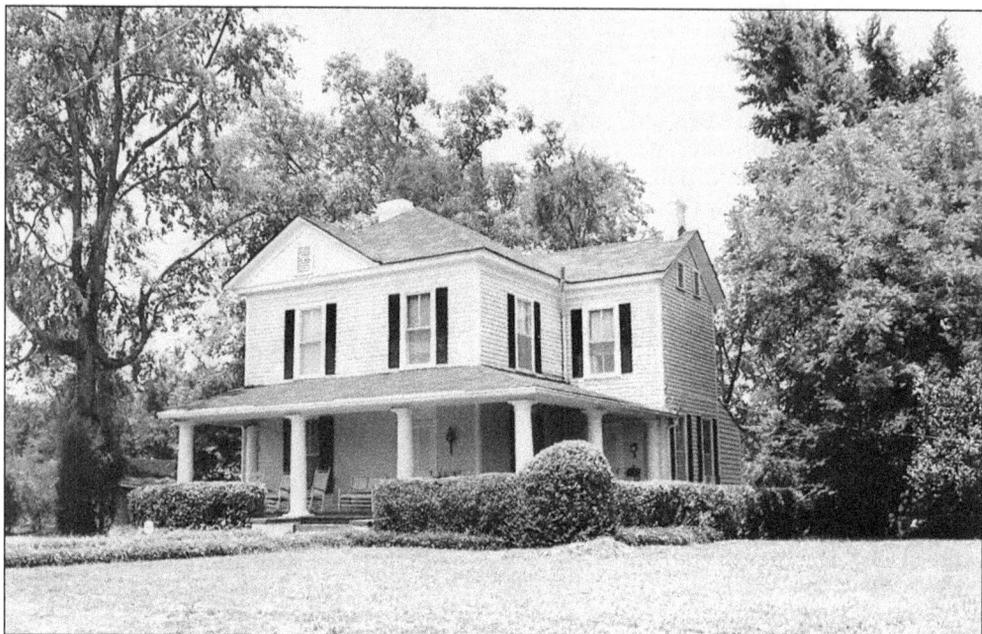

Charles Young Hall built this home in Big Springs for his bride, Ella Josephine Herndon. They built the home in the 1890s, when architectural styles began to move away from excesses of the Victorian era to more classical lines. The Halls and Herndons had long been prosperous farmers in the area. Although this 2006 photograph dates from more than a century after construction of the home, it reveals the continued excellent condition of the house.

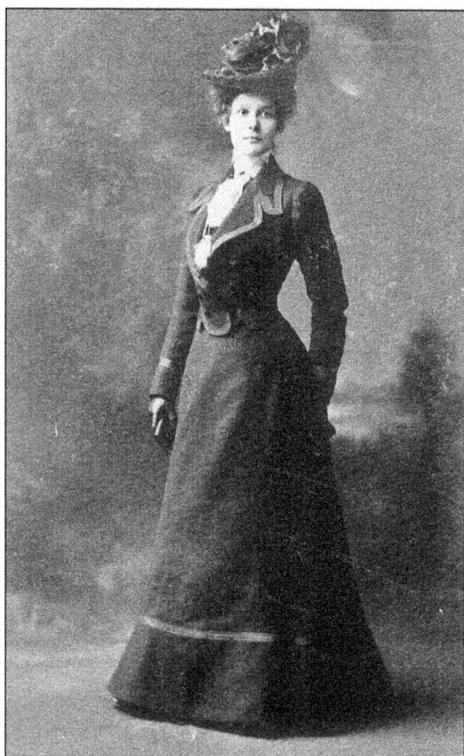

Jennie Sledge Phillips could have been a model for a Gibson Girl in this late-19th-century photograph. Gibson Girls, considered the ideal of young womanhood, were made popular nationwide by the illustrations of Charles Dana Gibson. Jennie wears a rabbit's foot as a pendant. She attended LaGrange College and married first Joseph H. Phillips, business partner of Fuller Callaway, and later Thomas W. Hill. (Photograph by Moore and Stephenson, Atlanta.)

These West Point young people appear to be posed mid-scene of a play, or perhaps they were producing a tableau or a still-life dramatic scene. J. Edward Kruger of West Point made the photograph in 1895. The hats and ladies' dresses may have been the fashion of the day or they may have been exaggerated for their production. (Georgia Archives, Vanishing Georgia Collection, TRP-121.)

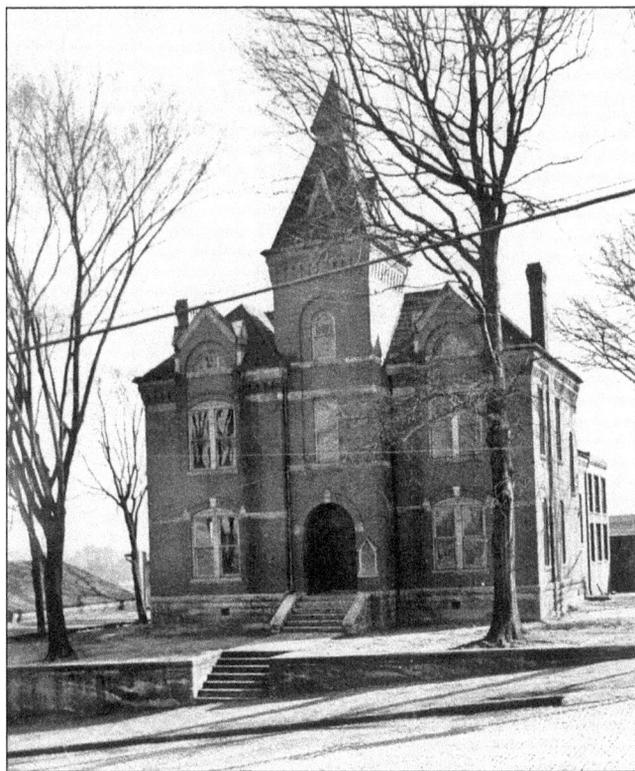

Built in 1892 as the jail for Troup County, this building has been home to the Chattahoochee Valley Art Museum since 1978. Stanley Hutchinson made this photograph on March 31, 1940, showing the original red brick exterior. Interestingly this building has outlived its 1939 replacement, located behind the courthouse on Ridley Avenue. Now enclosed with courtyards, the jail lot was once very open.

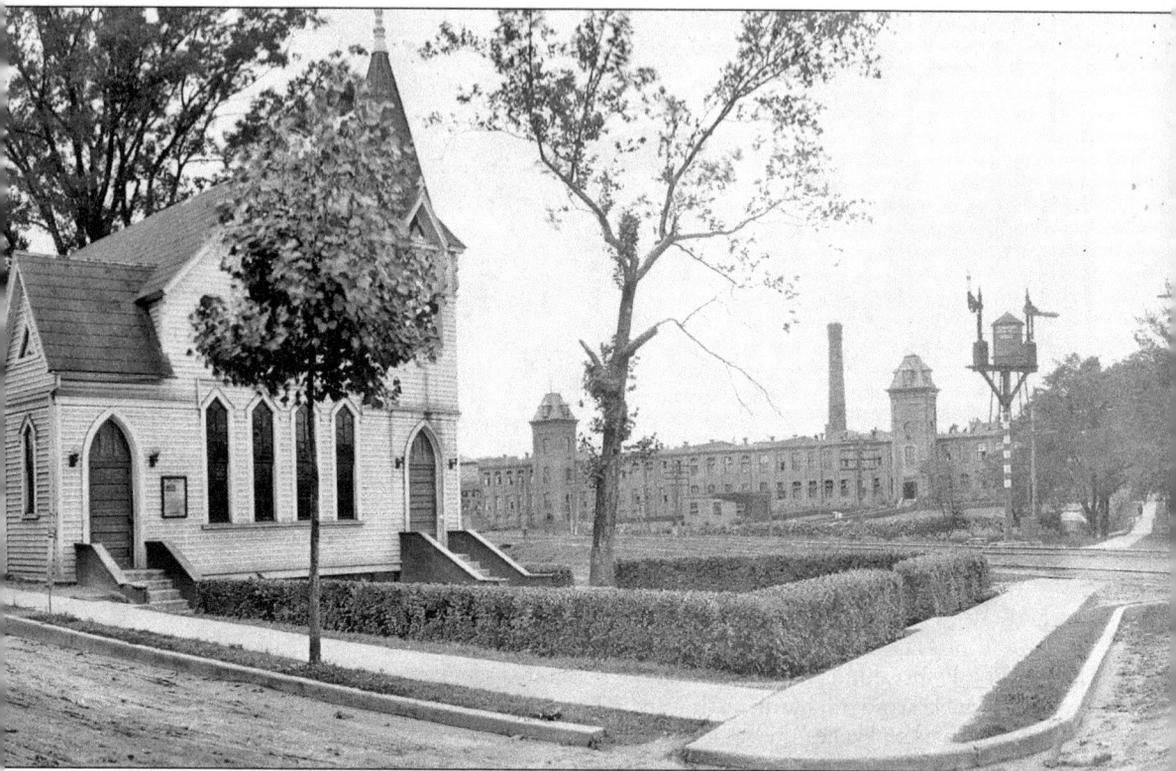

The economic landscape of LaGrange and Troup County began to change in the 1880s with the coming of textile mills. Opened in 1889 just east of downtown, LaGrange Mills later became known as Calumet Mill. First Methodist Church of LaGrange built St. John's Church in 1898 as a mission for textile workers. The neighborhood included a mill village and community center. St. Peter's Catholic Church stands on this site today.

Three

TURN OF THE CENTURY
1901–1915

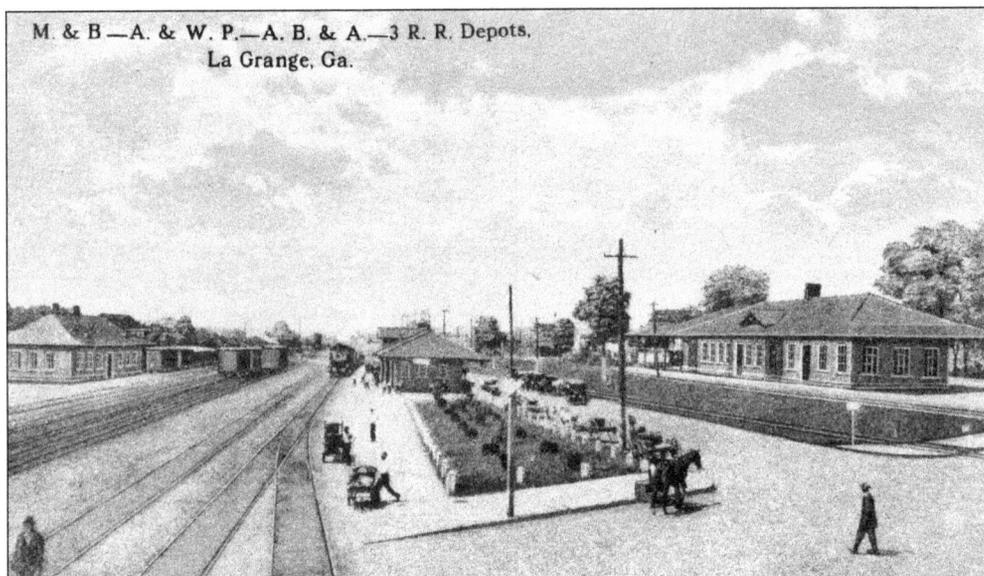

M. & B —A. & W. P.—A. B. & A.—3 R. R. Depots.
La Grange, Ga.

This rare early-20th-century postcard shows what few towns ever had: passenger and freight depots for three different railroad lines. Bigger cities had union stations, while smaller cities usually had one line. The oldest depot, the Macon and Birmingham (M&B), stands on the left. The M&B started in the 1890s but never operated beyond Macon and LaGrange. The oldest railroad, the Atlanta and West Point (A&WP), reached the county in the 1850s and had the newest depot, built in 1911. Shown in the center, the A&WP was the last of the depots built and the last standing when torn down in 1992, despite a valiant fight for its preservation. The Atlanta, Birmingham, and Atlantic Railroad was established in 1905 to create competition for lower freight rates for textile mills. It became known as the Atlantic, Birmingham, and Coast Railroad (AB&C). The depot opened in 1906.

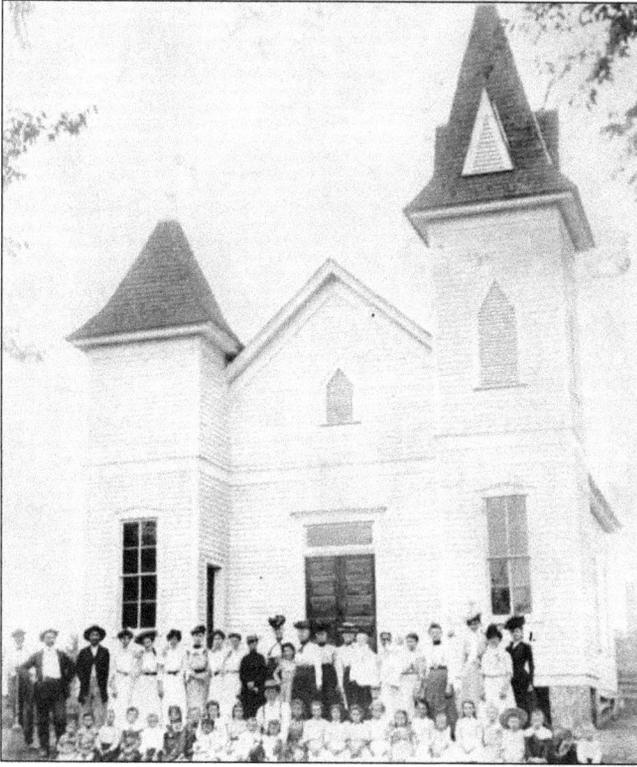

In the late 19th century, Samuel P. Smith built this church to help promote his new "subdivision" on Whitesville Street. The congregation of South LaGrange Methodist Church gathered in 1901 for the photograph, perhaps followed by dinner on the grounds. The name was later changed to Whitesville Street Methodist Church. More recently, this building, which has been bricked over, houses Bethlehem Christian Church. (Georgia Archives, Vanishing Georgia Collection, TRP-59.)

The four young men all wear LaGrange High School caps in this early-20th-century group portrait. This LaGrange High School, a private boys' school, existed from 1898 until the new public school took over its building on Harwell Avenue in 1903. The photograph by M. D. Fowler is inscribed on the back as being compliments of the boys, perhaps as a way of commemorating some special event.

This photograph leads to speculation as to why the couple braved the cold to pose in front of the house. Perhaps they were feeding birds or the dog. The swept yard features a trellis, a glider, and a low brick wall with a novel diagonal brick pattern. The two-story Victorian porch may have been an addition onto an older house. The home is the Hudson family home on Hill Street.

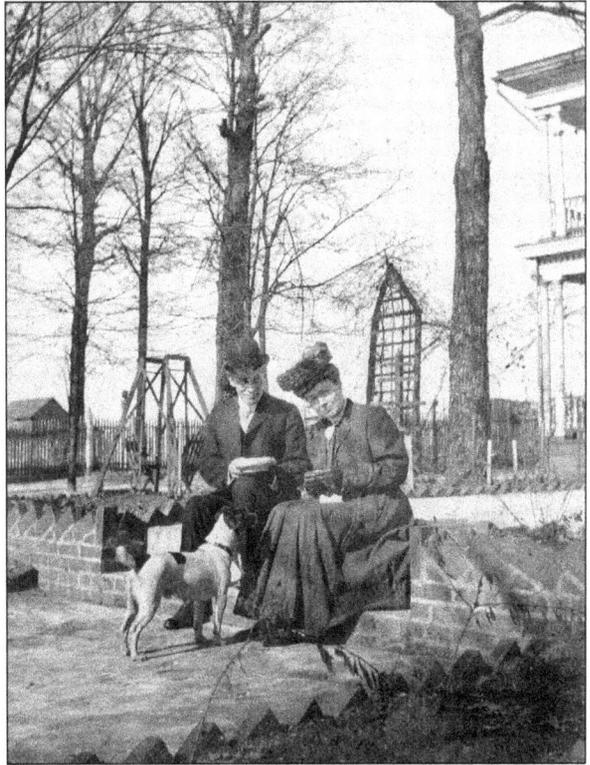

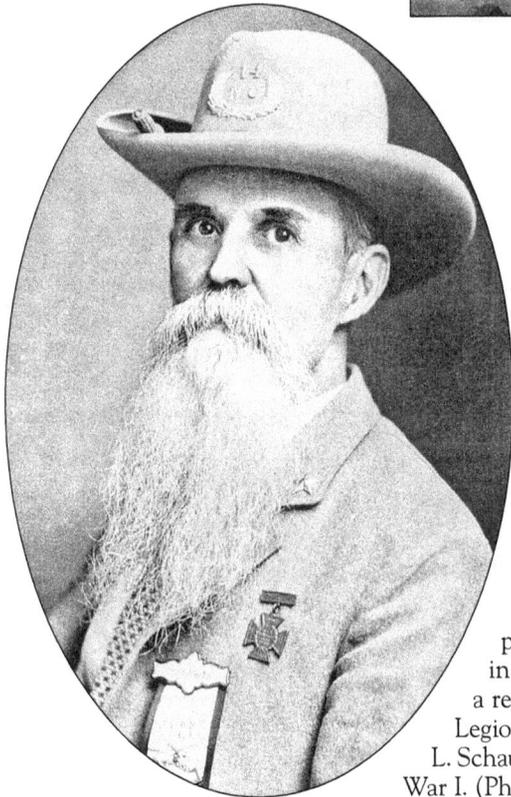

Julius Schaub served as commander of the LaGrange Post of the United Confederate Veterans and, as a professional photographer, recorded images of many of Troup County's people and places. Here he posed for his portrait in his veteran's uniform. He may have attended a reunion of Confederate soldiers. The American Legion post in LaGrange is named for his son, Baxter L. Schaub, the first Troup Countian to die during World War I. (Photograph by Schaub Studios.)

This family may have been going to church in their six-person surrey pulled by a team of horses. Though the family has not been identified, they might have been in Abbottsford in northwestern Troup County. A railroad bridge, boxcar, rails, and telegraph poles are visible in the background. The AB&C rail line reached Abbottsford by 1907.

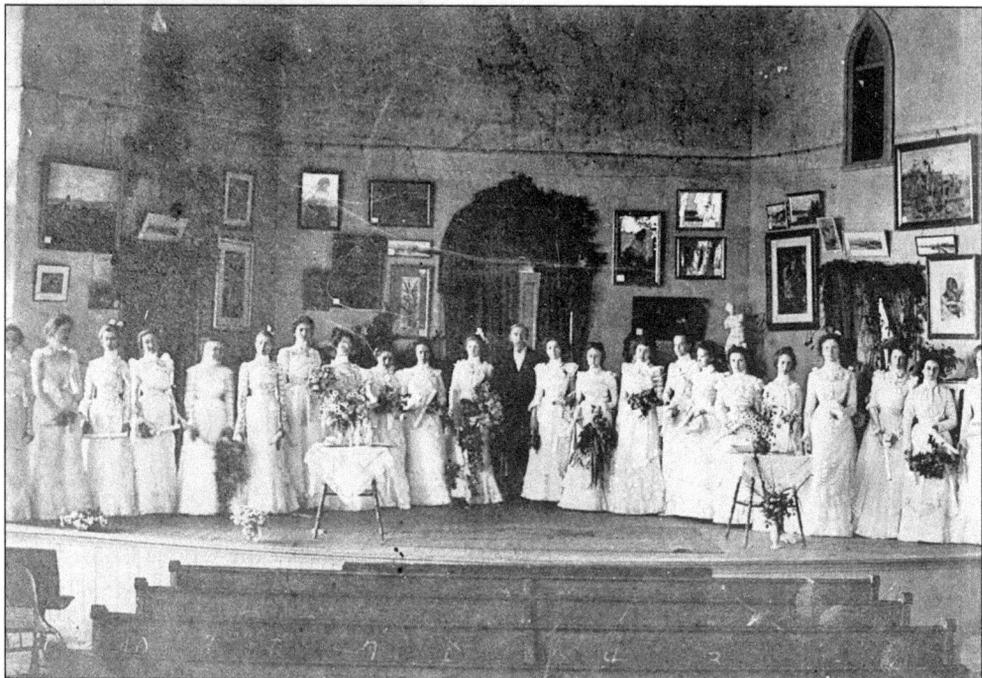

Mary Moses lamented on the back of this photograph that this was "My graduation class at Southern Female College, 1900. I'm cut off." The girls gathered on the stage of the Sarah Coleman Ferrell Lyceum. The college president, Dr. G. A. Nunnally, stands in the center. The artwork along the stage walls may have been a senior exhibit spotlighting work by the students.

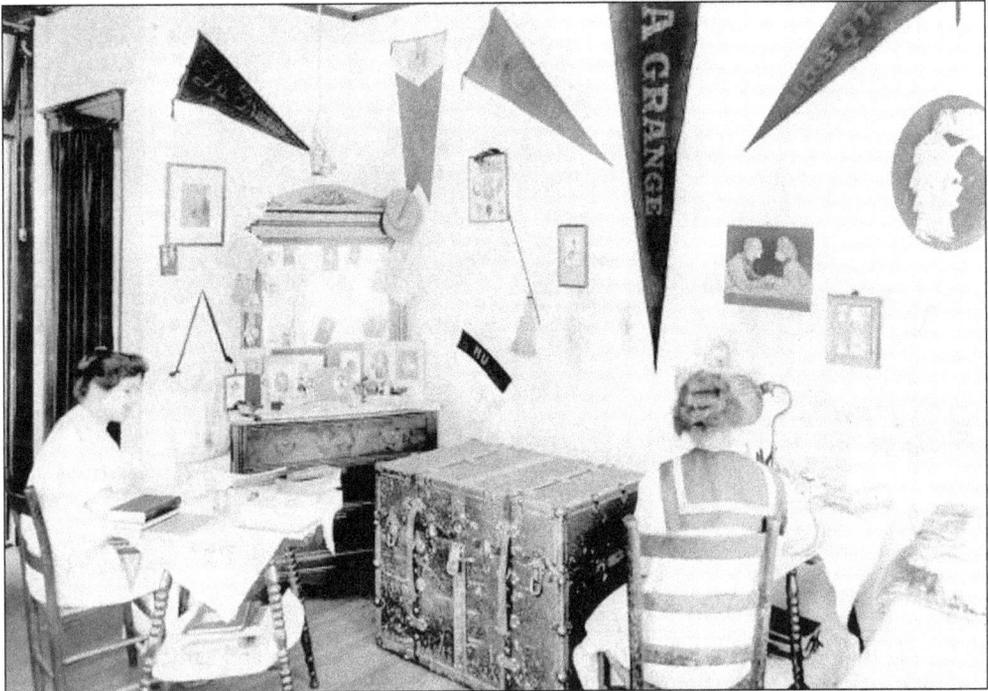

These two girls are studying in the early 1900s in their dorm room at LaGrange Female College, probably in Smith Hall. The pennants on the walls clearly reflect their school loyalty. Students often used trunks to ship clothing to school by rail and then serve as a piece of furniture. Photographs of family members lined the dresser, reminding them of home. LaGrange College first held classes in 1831. (Georgia Archives, Vanishing Georgia Collection, TRP-75.)

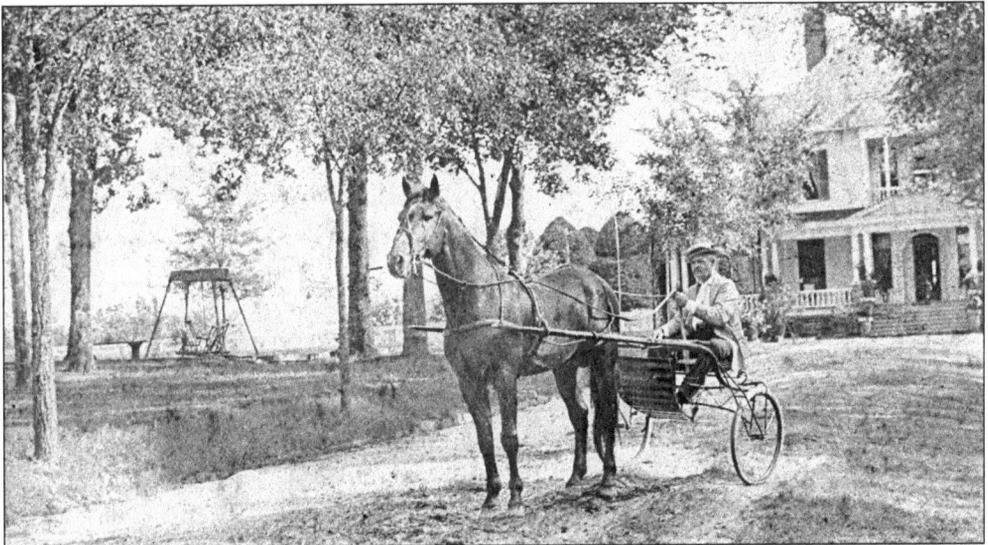

A very dapper-looking Frank Word sits in his sulky with his horse ready to trot down the driveway from his family's home, which still stands on East Main Street in Hogansville. The house occupies the site of the old Hogan home. William Hogan, founder of Hogansville, was the grandfather of Eugenia Pullin Word, Frank's wife. Frank Word spearheaded much of the economic development of the town at the beginning of the 20th century.

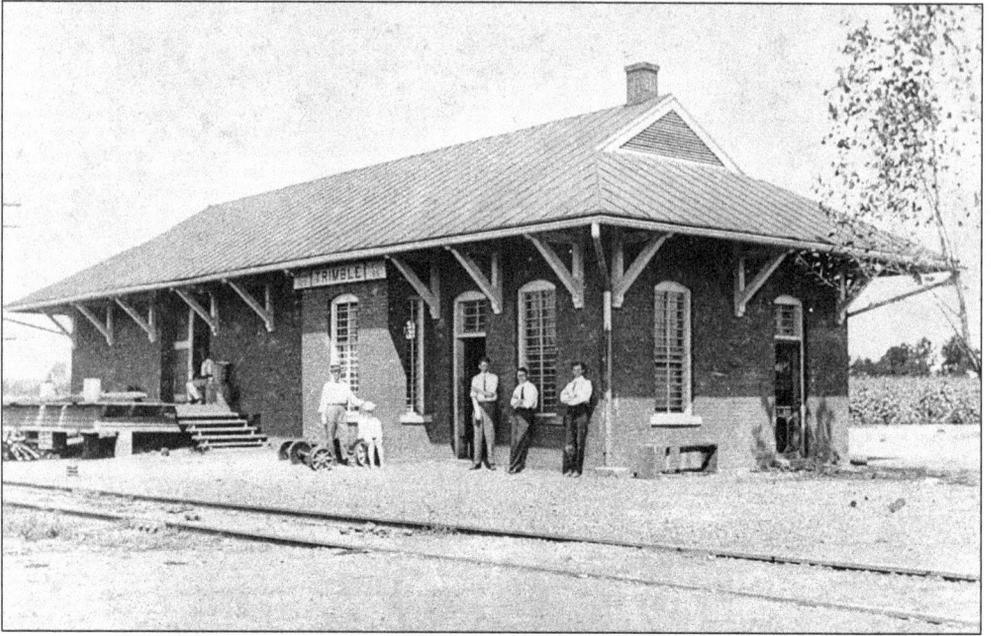

Railroads and depots helped drive the U.S. economy in the late 19th and early 20th centuries. Rail lines served as the major connection for people, goods, and services between towns and cities. Trimble Depot, shown above, served as the major transportation point for the nearby quarry and for bricks manufactured at Trimble Brickyard, which operated from the late 1800s to the 1930s. Located just north of Hogansville, the depot served the A&WP rail line. The Trimble family owned 1,600 acres of land around the depot. Communities such as Knott, Pine, Louise, and Gabbettville had brick or wood depots that served the three Troup County rail lines. The large steam engine and railcars shown below in LaGrange around 1906 could often be seen in these communities and towns.

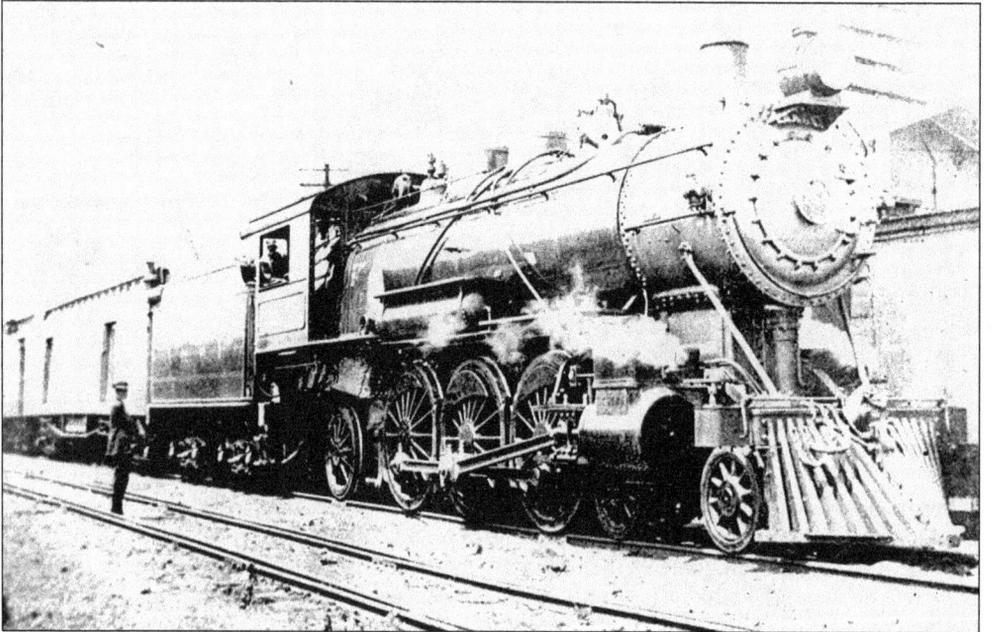

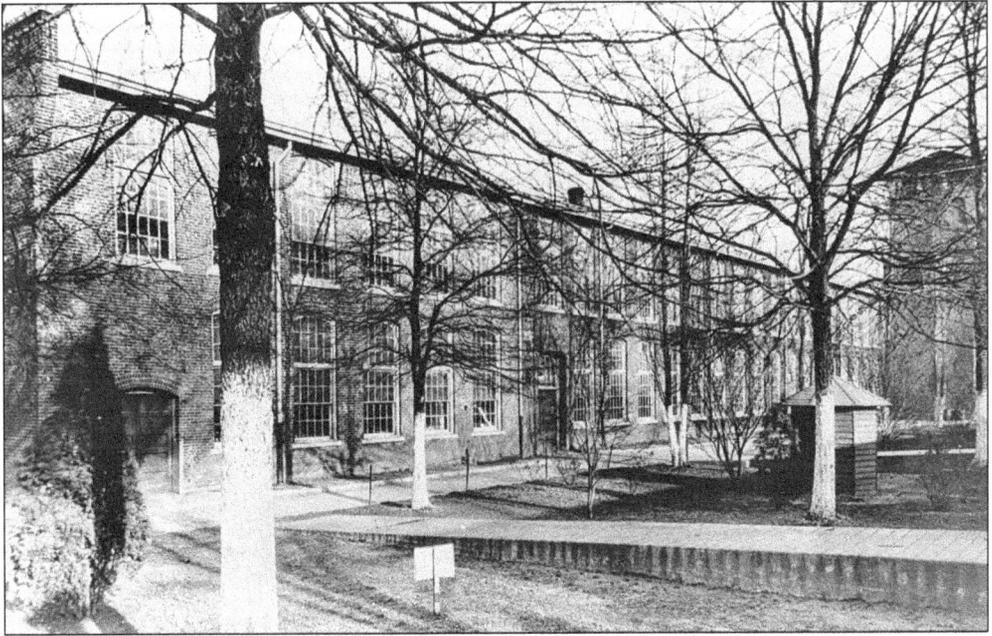

Unity Mill opened in December 1901 as the third textile mill in LaGrange. Later renamed Kex Plant because of its major product, Kex cloth, Unity was the first mill spearheaded by industrialist Fuller E. Callaway and thus the parent plant of Callaway Mills. This 1930s photograph by Walter R. Reeves shows the care taken with landscaping: grass had just been replanted and trees whitewashed in an effort to control insects.

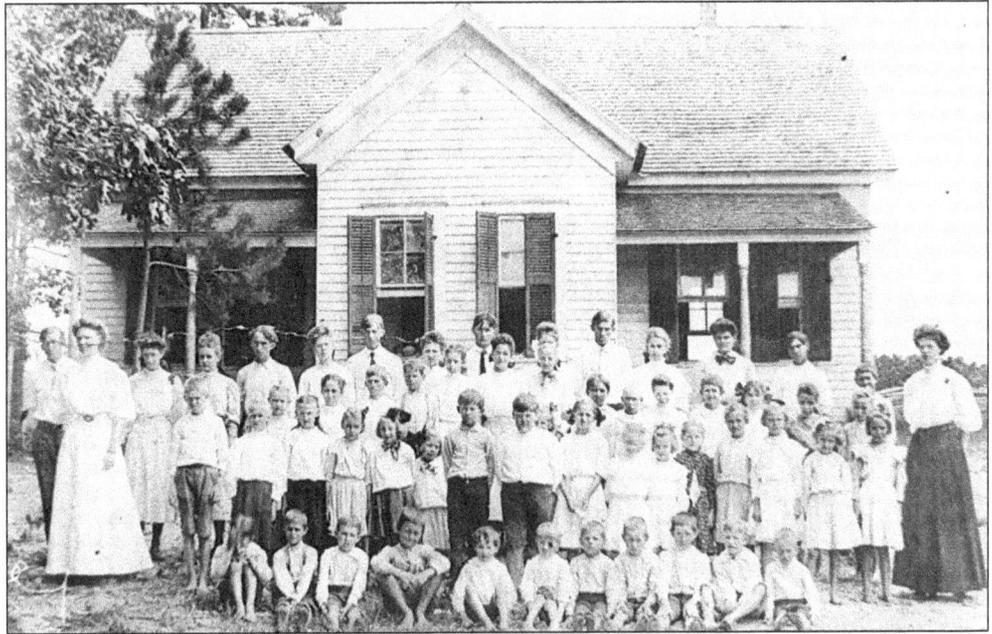

Picture day has always been an important event in each school year. Students and teachers gathered in front of Big Springs School near the beginning of the 20th century. The Troup County Public School System first organized in 1871 and included schools in Big Springs and many other communities. By 1924, one- and two-room schools began disappearing through consolidation.

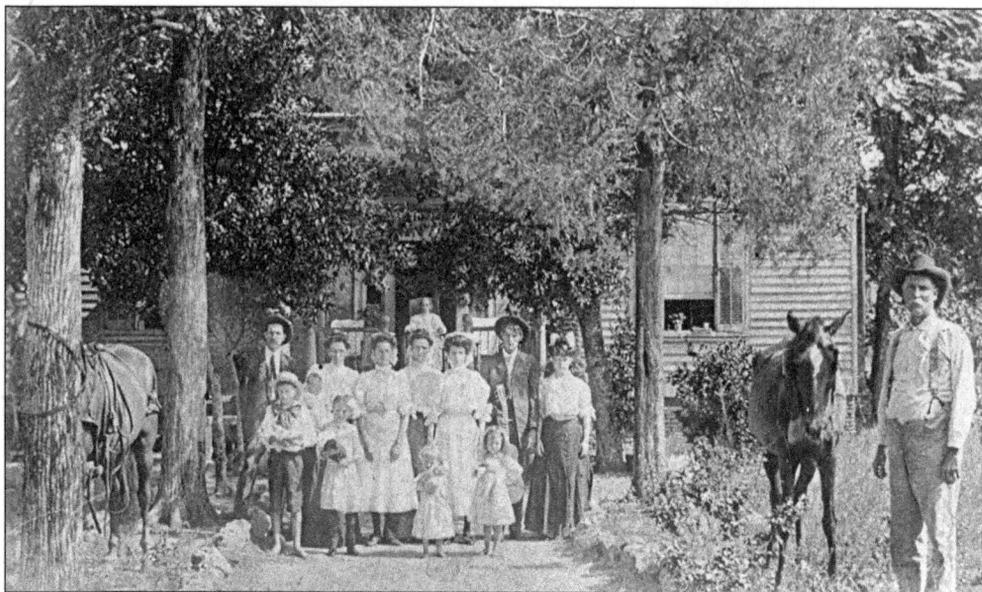

When a photographer visited country homes, the entire family often gathered on the front porch in their Sunday best. The family of John Otis Smith poses at their home at the Kidd-Robertson-Holle House on Greenville Road just west of Mountville with their horses. Amanda Mallory Smith, the wife of John, sits in her wheelchair on the porch. The house is being listed on the National Register of Historic Places.

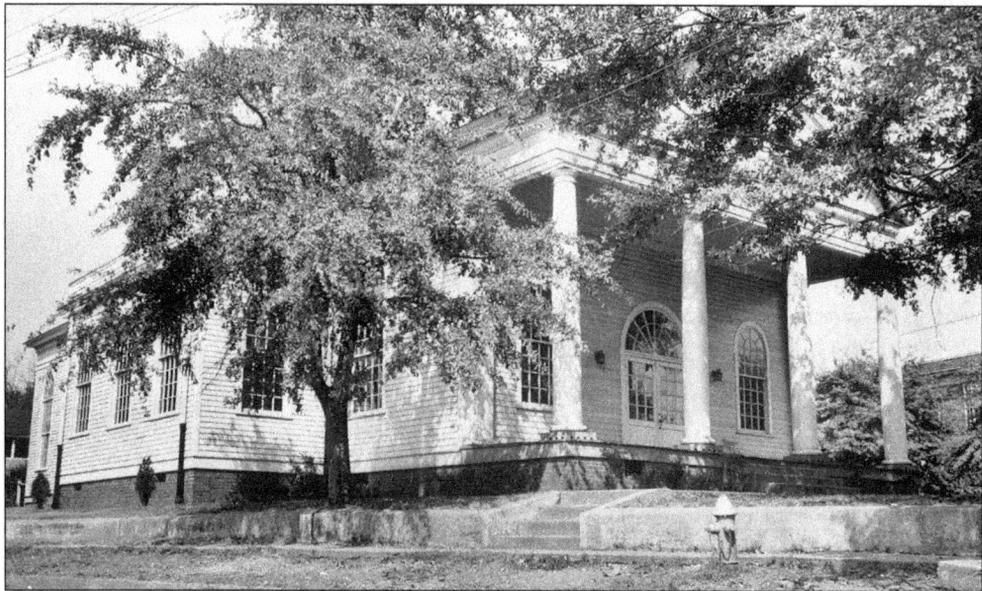

Workers who moved from farms in West Georgia and East Alabama lived in mill villages. Villages included mills, houses, schools, churches, shops, and recreation facilities. Located in southwest LaGrange, Trinity Methodist Church served employees of Callaway Mills, especially Hillside and Elm City. The church relocated to North Davis Road in 2003 as Trinity on the Hill. This building now houses DASH, an organization devoted to revitalizing neighborhoods and providing affordable housing. (Photograph by Lane Brothers, Atlanta. Used with permission of Special Collections Department, Georgia State University Library.)

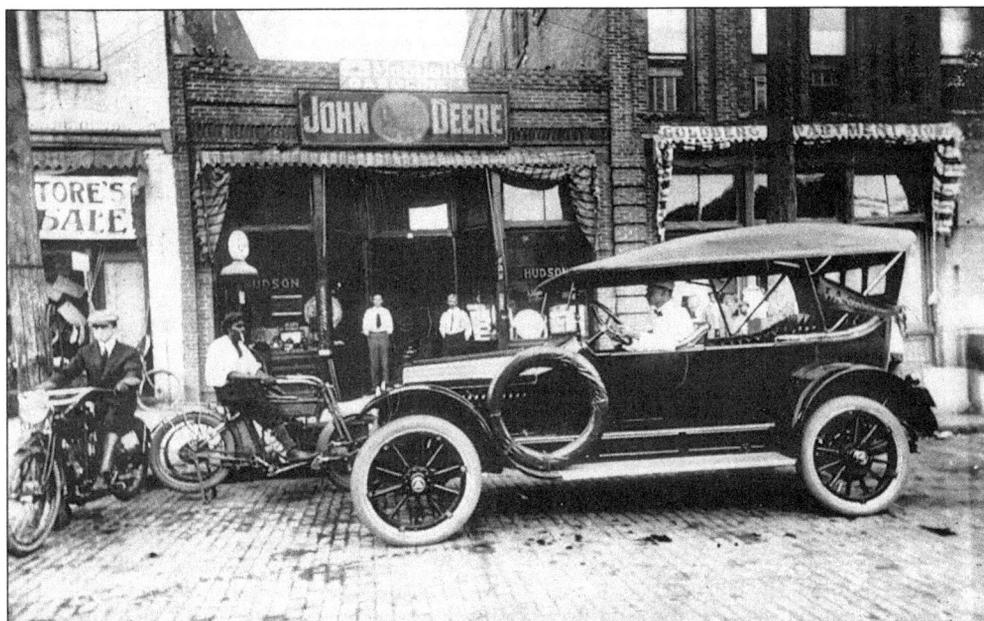

J. D. Hudson sits in a Hudson automobile in front of Hudson Hardware on Main Street in LaGrange. He sold Detroit-manufactured automobiles that coincidentally bore his name. The hardware store also served as a John Deere agent and had one of the first gas pumps in town. Hudson had many interests, including serving as a national director of the Taft Memorial Highway board, which brought U.S. 27 to the county.

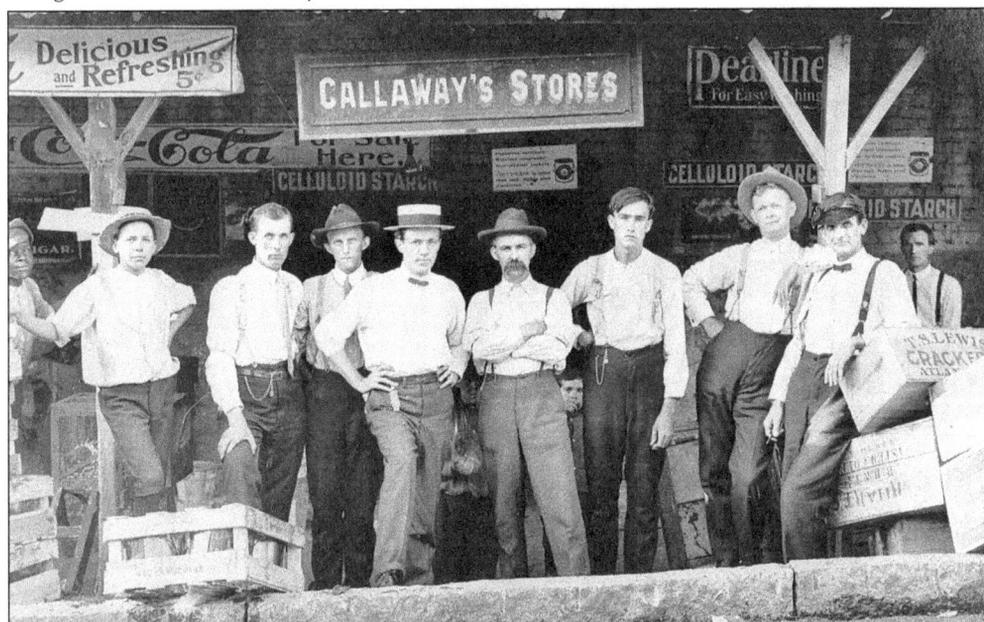

Fuller E. Callaway began his business empire in 1888 with this store on West Court Square. His stores succeeded thanks to extensive marketing, enabling him to invest in industry, banks, other retail stores, and a wholesale business. The men gathered at the Vernon Street side of the store include store manager Ely Callaway (in straw hat and bow tie), workers, and clerks. Signs advertised horseless carriages and the latest in wireless communication: telegraphy.

Like many families, the Dunsons often held family gatherings, including this picnic in 1910. The men included organizers of Dunson Mills, a textile plant that opened that year. Once the largest mill in the area, Dunson became part of WestPoint Stevens and closed in 2004. The little girl on the far right in the first row is Pearle Dunson (Sims), who celebrated her 99th birthday in 2006. The house stands on North Barnard Avenue, which once served as its driveway. (Photograph by Julius L. Schaub.)

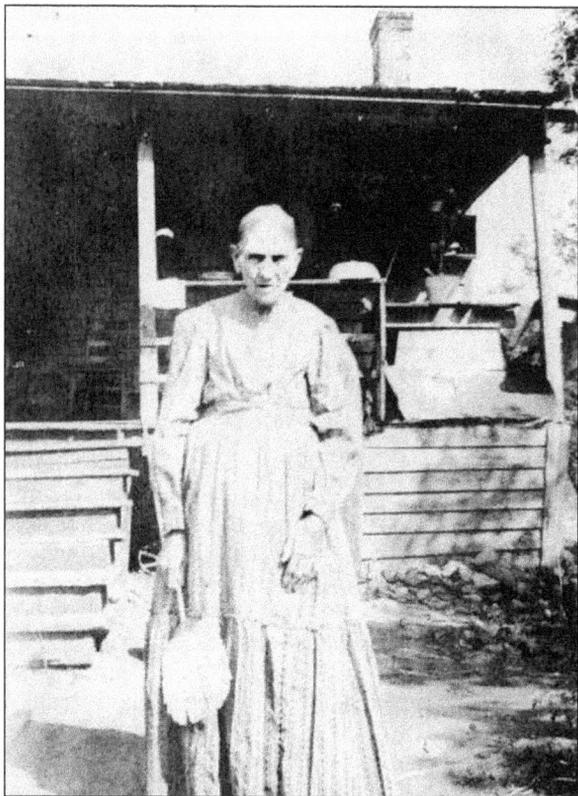

Scyntha Hammett Walker stands in her backyard at 406 Hill Street in LaGrange. She holds a palmetto fan. This photograph was made in 1907, shortly before she died in November 1908 at age 85. She and her husband, Newton Walker, had eight children, including Tony Walker, a well-known early-20th-century businessman. (Georgia Archives, Vanishing Georgia Collection, TRP-61.)

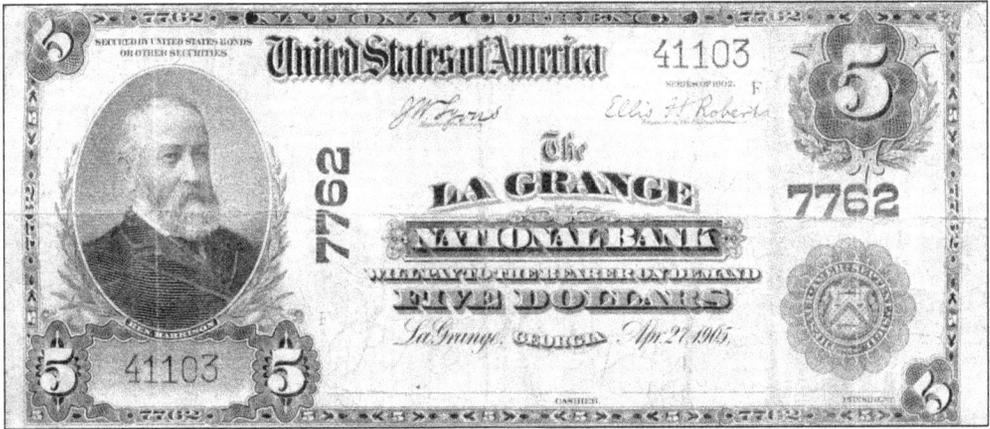

Local banks originally had the authority to issue currency valid throughout the United States. The LaGrange National Bank issued this $5 bill on April 27, 1905. Cashier Robert C. Key and Pres. Henry D. Glanton hand-signed the notes. Until the coming of our modern monetary system in 1934, the holder of this bill could demand payment in gold from any authorized bank.

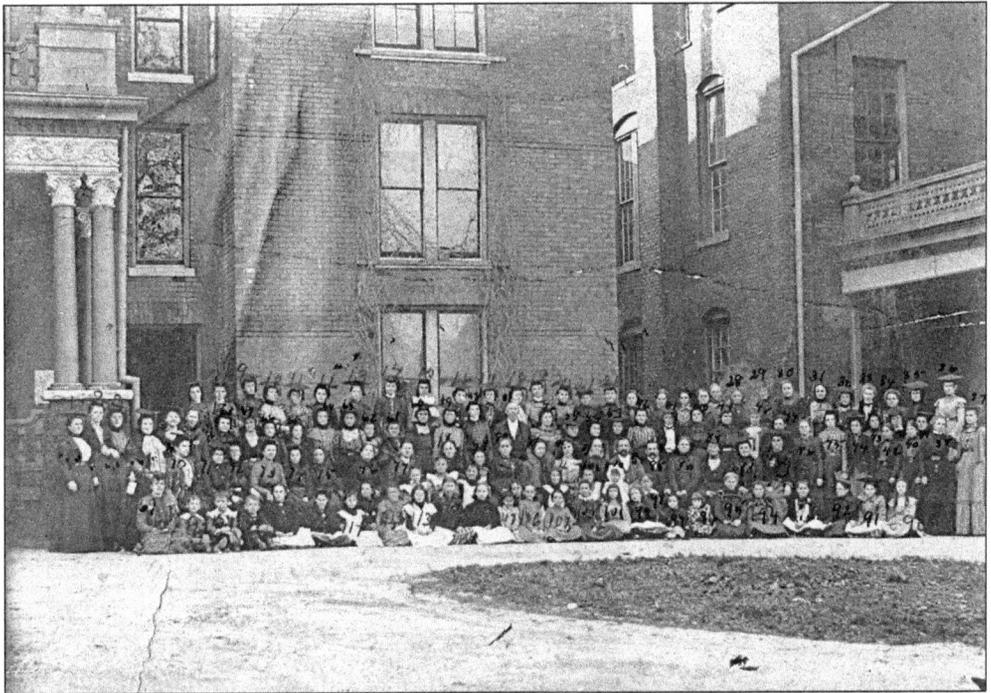

Southern Female College students and faculty gathered in a courtyard for this photograph sometime before 1908, when a disastrous fire struck these massive buildings. The young children on the front rows attended the primary department at the college, which served as teacher training for the college students. Increasing financial problems caused by this fire, competition from the public school system beginning in 1903, and other difficulties led to Southern's demise in 1919.

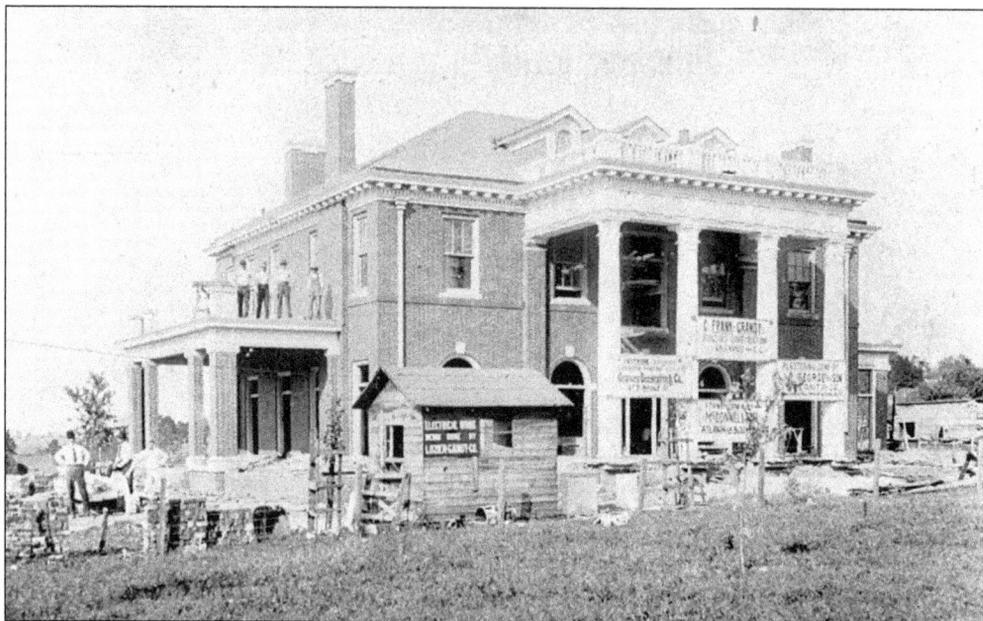

Cornelius Vanderbilt Truitt and his wife, Nannie Abraham Truitt, built this home at 306 Broad Street in 1914. Local contractors proudly display signs on the almost completed structure as several men pose for the photograph. P. Thornton Mayre served as architect of this neoclassical structure. Mary and Nasor Mansour bought the home in 1939, and family members continue to live there. The home is in the Broad Street National Register Historic District.

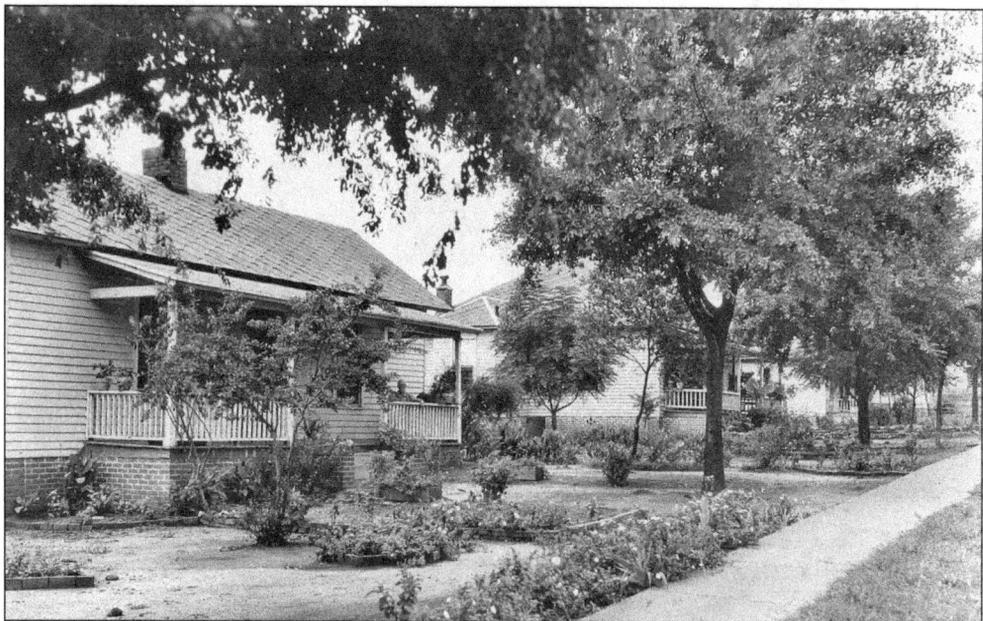

Snelson Davis photographed this street scene in southwest LaGrange, which was a separate Troup County city from 1916 until January 1, 1920. Mill workers were furnished flowers and shrubbery to plant in their yards. A company-operated greenhouse gave them a place to store houseplants during the winter. Residents took great pride in the appearance of their homes. This is the kind of neighborhood pride that DASH and community residents are helping revive.

Five-year-old Eleanor Sledge Dunson poses for this picture in 1901. The flowers are from her mother's garden, located on the site now occupied by West Georgia Medical Center. As the oldest of four sisters, Eleanor grew up a tomboy despite her very feminine appearance. Her father, Edgar Dunson, even called her "Son Eleanor" and taught her to hunt, fish, and ride horses. She married Forrest C. Johnson in 1914.

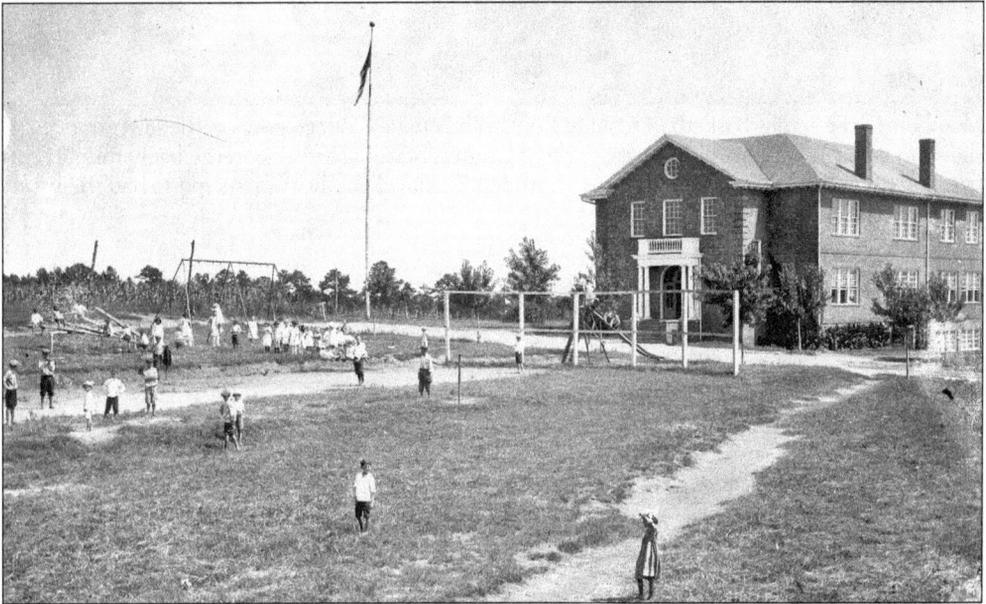

Dunson Mills built this elementary school in 1912. The mill operated the school with assistance from the Troup County Board of Education until 1920, when the area was annexed into the city of LaGrange. The school stood at the corner of U.S. 29 and Cary Street. A new school on Barnard Avenue opened in 1939 and served the community until 1986. Two old school standards, playtime and patriotism, are clearly evident.

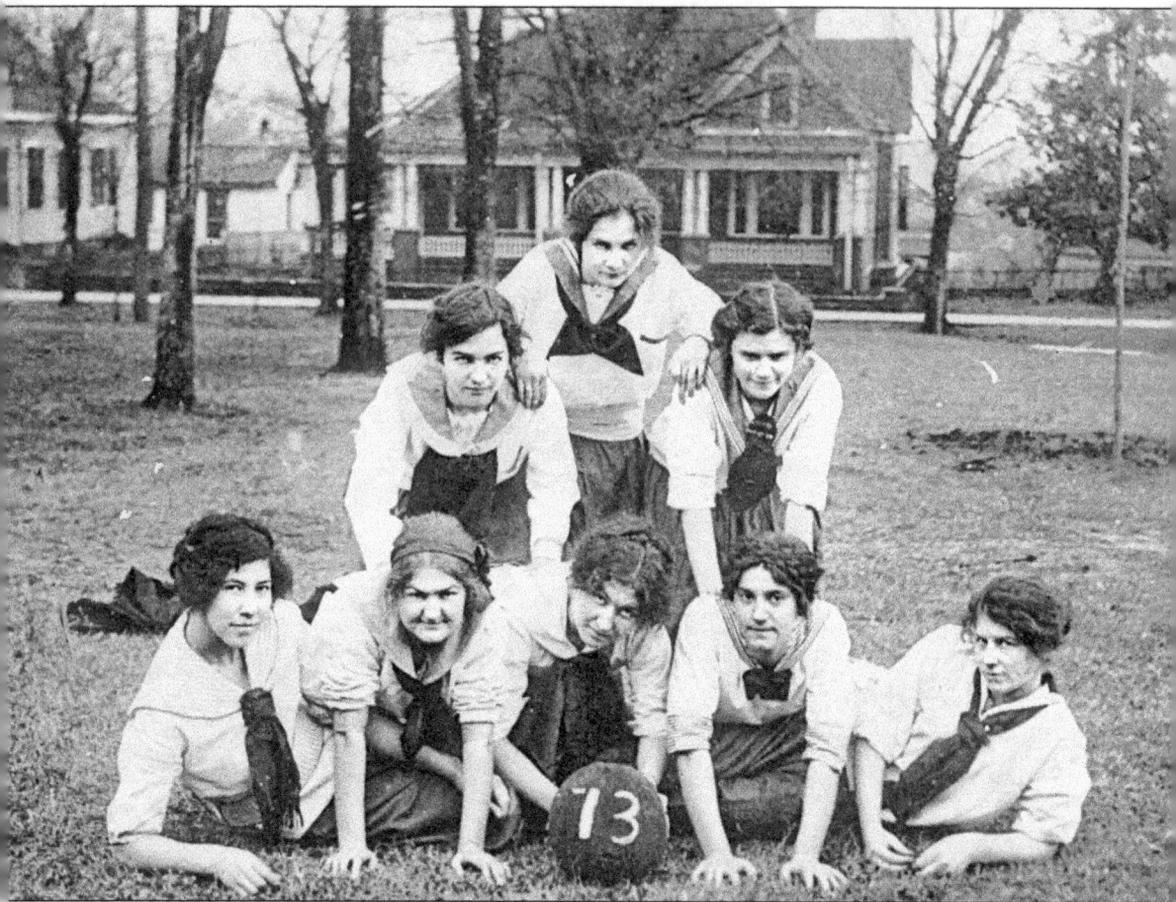

Members of the senior basketball team at Southern Female College pose on the lawn in front of the school in 1913. Houses on the east side of Church Street are visible in the background. This pyramid pose continues to be popular with students today. Locally women's sports had their start in our female colleges.

Four

WORLD WAR I AND THE ROARING TWENTIES
1916–1929

Although local residents initially opposed U.S. involvement in what they viewed as a European war, they strongly supported their troops and the military effort once war became a reality on April 6, 1917. Troup County repeatedly earned national recognition for support of bond drives, Red Cross, and number of men in service. By the end of the war on November 11, 1918, over 8,000 Troup County men and women had served in uniform. One of them, Carl Winzor Edmondson, served as a sergeant in the U.S. Army during World War I. Born in 1888, Edmondson grew up on Broad Street across from LaGrange College. He and his family developed the area north of their home, between Springdale Drive and Waverly Way. They cut three streets and gave them family names: Virginia, Winzor, and Edmondson. Through the years, Edmondson became involved in several local businesses before his death in 1975.

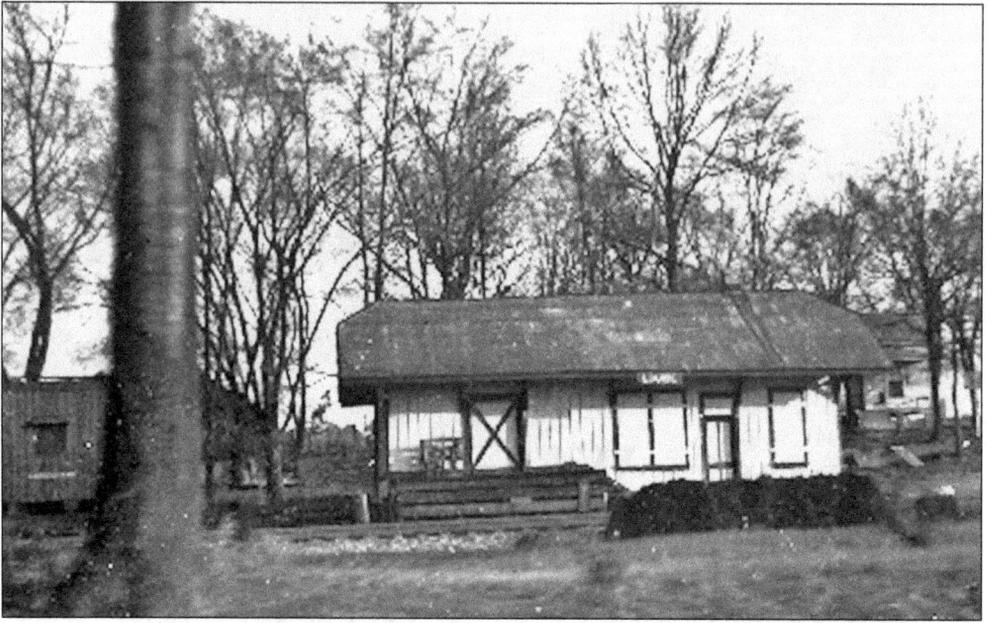

The Louise Depot served the A&WP Railroad midway between LaGrange and Hogansville. Different theories exist as to how the small town got its name. One story says the town was named for Louise Hudson Leman, a resident of Hill Street in LaGrange. Another source says the honoree was Louise Dallis Park, wife of World War I veteran Dr. Emory Park, a local doctor. (Photograph by Stanley Hutchinson.)

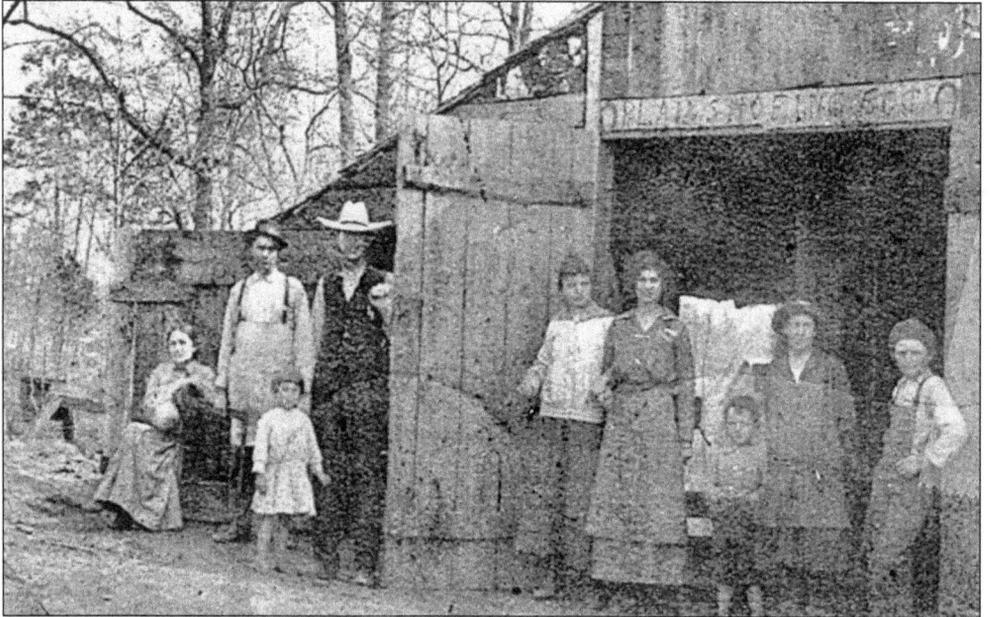

In 1917, the Pleasant Grove community, located at the junction of Salem, Hunt, and Hamilton Roads, consisted of houses, a Methodist church, a school, the Rock Store, and this blacksmith shop. The sign over the entrance reads "Plain Shoeing 50¢." A natural spring and rock reservoir served as a gathering place. Members of the Cadenhead and Smith families, shown in front of the shop, represent two of the oldest families in the neighborhood.

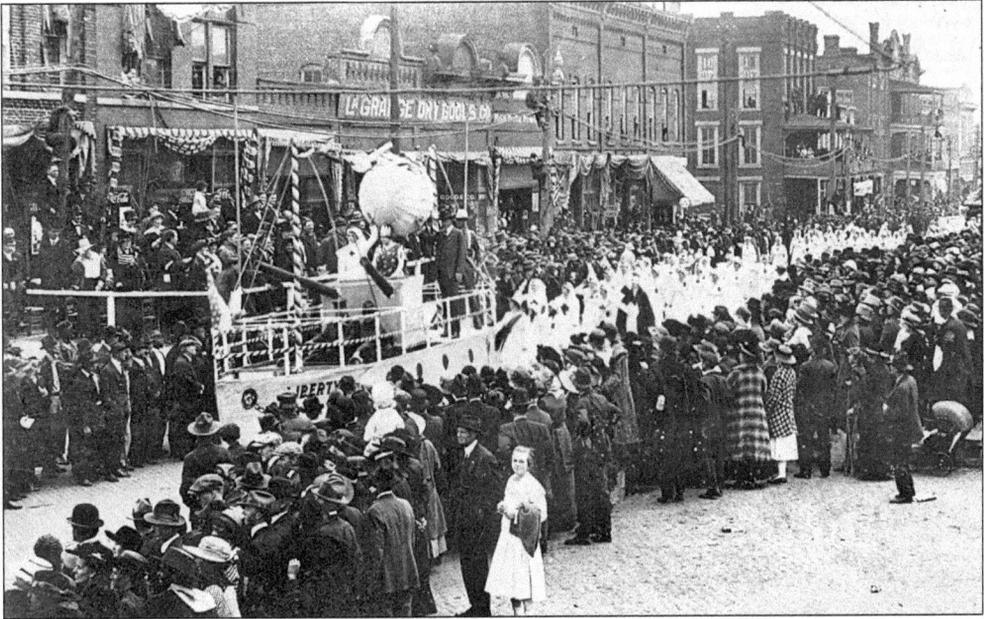

Through the years, the Square in downtown LaGrange has been a focal point for hundreds of parades, including the "Parade of Americans" held on April 6, 1918. The Red Cross entered this float representing the ship *Liberty*. Mrs. Ely (Loula) Callaway and Mrs. I. C. (Sarah) Doe rode on the float. The parade boosted support for the U.S. effort in World War I and encouraged people to buy war bonds. (Photograph by Snelson Davis.)

Callaway established Southwest LaGrange School in 1916 to serve the children of their mill employees in the Hillside area. The school faced Washington Street and became part of the City of LaGrange school system in 1920. In 1953, Callaway Community Foundation provided funds for a new school built on the playground facing Forrest Avenue. In 1974, they renamed the school for Berta Weathersbee, who served as principal for 41 years.

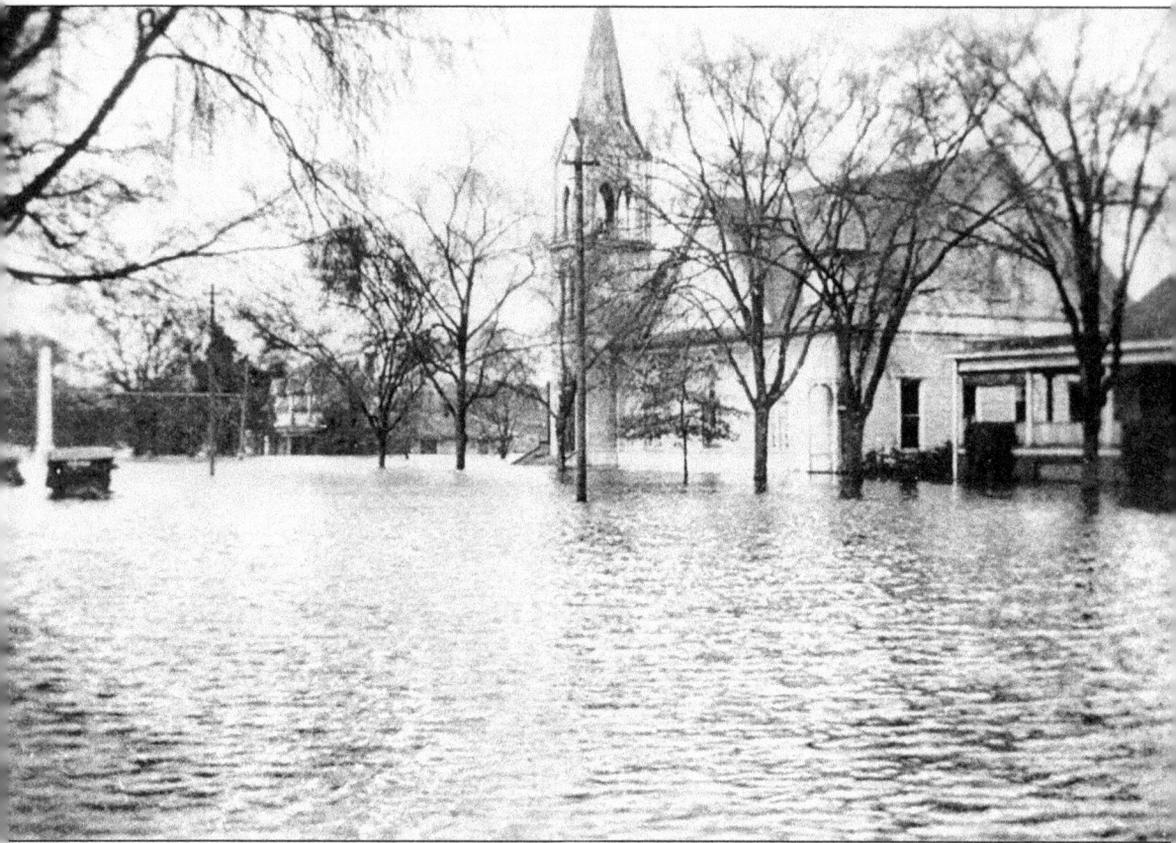

West Point periodically suffered from major flooding. Water reached its highest levels during floods in 1919, 1929, and 1961, causing much destruction. Floods often washed out bridges and divided the town while inundating homes and businesses for blocks on either side of the Chattahoochee River. The 1919 flood stranded cars two blocks from the river near First Baptist Church. The Confederate monument shown here has been moved to the base of Fort Tyler Hill.

This unidentified Troup County Red Cross worker joined many other women in serving their country during wartime. Several LaGrange women, including Jeannette Wilhoite, Antoinette Ward, and Daisy Jackson, drove Red Cross ambulances in France during World War I. Others worked at home, aiding servicemen's families or as nurses in hospitals. Some made bandages and knitted socks and gloves. Red Cross chapters existed for whites, blacks, schoolchildren, and for rural communities. (Georgia Archives, Vanishing Georgia Collection, TRP-306.)

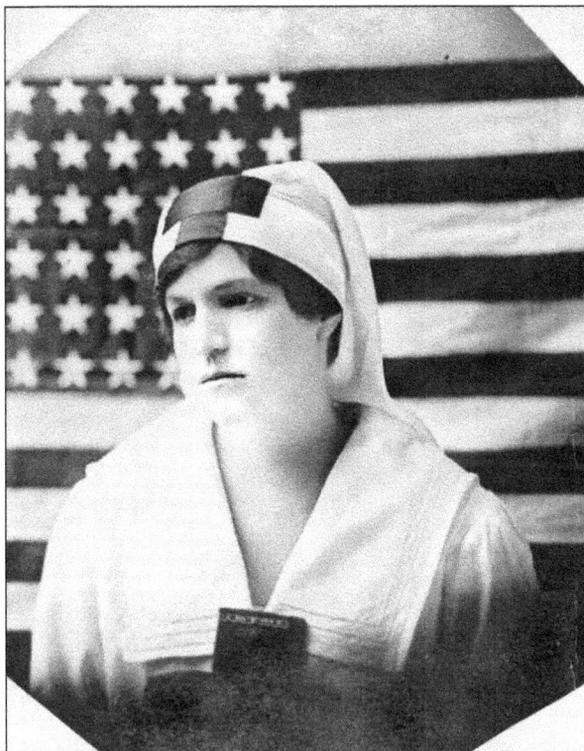

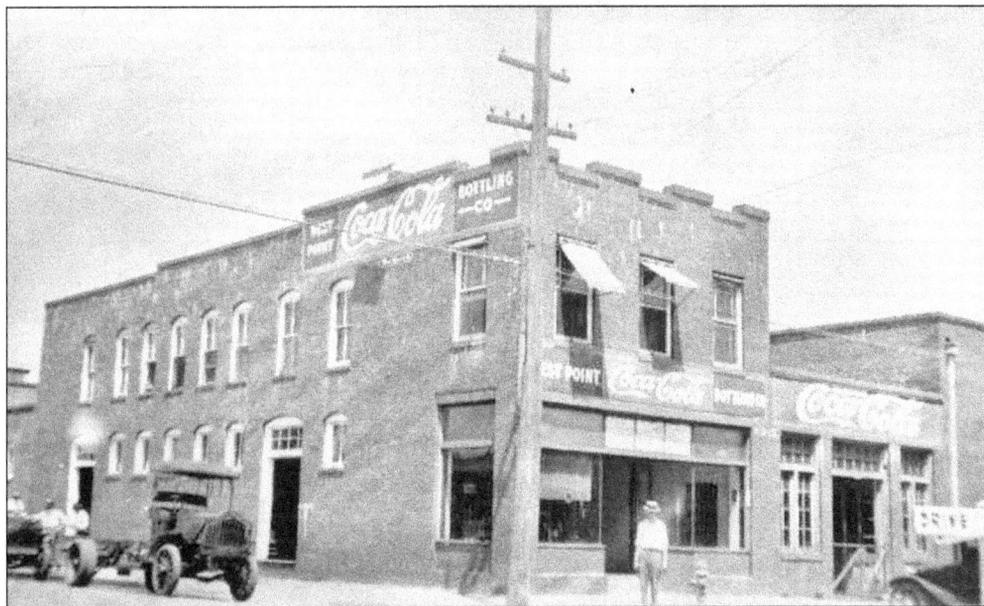

George Cobb owned the LaGrange and West Point Coca-Cola franchises beginning in 1908 and was a pioneer in bottling and distribution. The building, shown here c. 1919, still stands on the corner of Eighth Street and Third Avenue (then called Montgomery and Gilmer Streets) in West Point. The family operated the business for three generations. The George S. and Edna L. Cobb Foundation funds worthwhile projects in LaGrange and the Valley area. (Georgia Archives, Vanishing Georgia Collection, TRP-136.)

Located south of downtown LaGrange, Swift Fertilizer Company was once one of the largest employers in the county. The plant started in 1905 as the fertilizer manufacturing division of Troup Company. Swift and Company, based in Chicago, bought the plant in 1917. They bought other local enterprises, including LaGrange Cotton Oil Mill (later Glass Gin and Warehouse Company). They operated a meatpacking facility on Morgan Street for a number of years. The mill operated until 1957. The manager blamed the closing on "changed agricultural conditions and new modern plants at Atlanta and Albany which can serve the LaGrange plant customers." (*LaGrange Daily News*, May 21, 1957.)

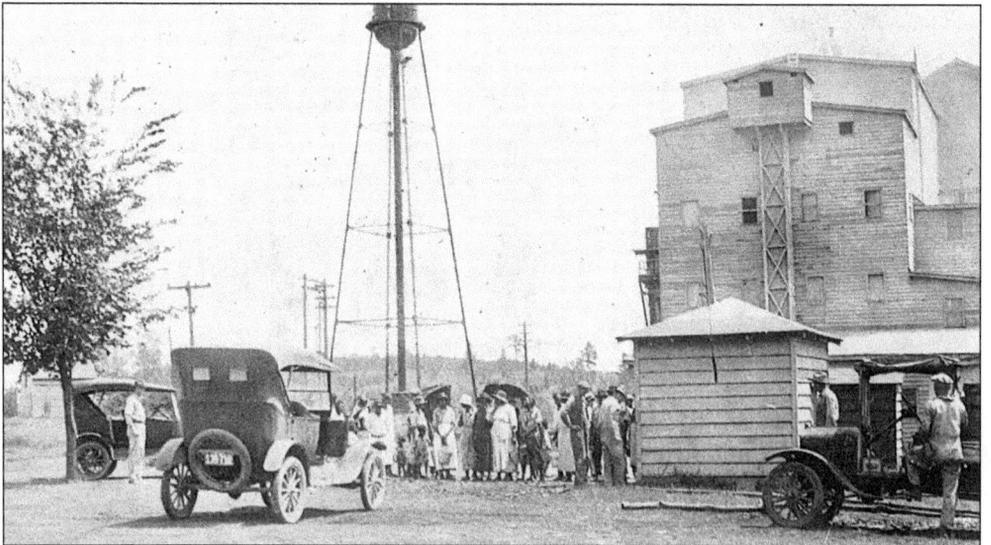

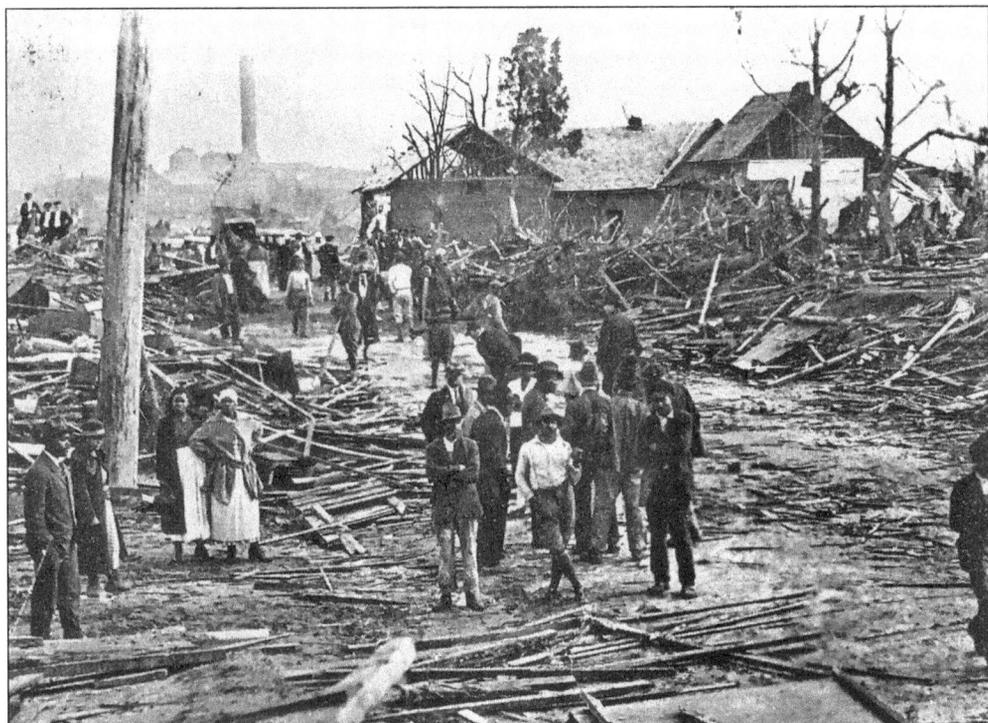

The Swift mill village proved to be a target for the March 28, 1920, cyclone, which caused widespread devastation. The destruction of so many homes led to the erection of tents to house mill employees. Twenty-six people died in the cyclone and hundreds were wounded. That day, cyclones traveled from Whitesville to Hamilton Road and also struck part of Dunson and Unity Spinning mill villages, Mountville, and West Point. Local physicians and citizens quickly organized to help the wounded in one of the worst disasters Troup County has ever experienced. Swift and Company started rebuilding their mill off Swift Street within days of the storm. The new and larger buildings of steel and concrete construction plus the new and more modern equipment cost over $1 million. The photograph below shows the rebuilt structure. (Below, photograph by Stanley Hutchinson.)

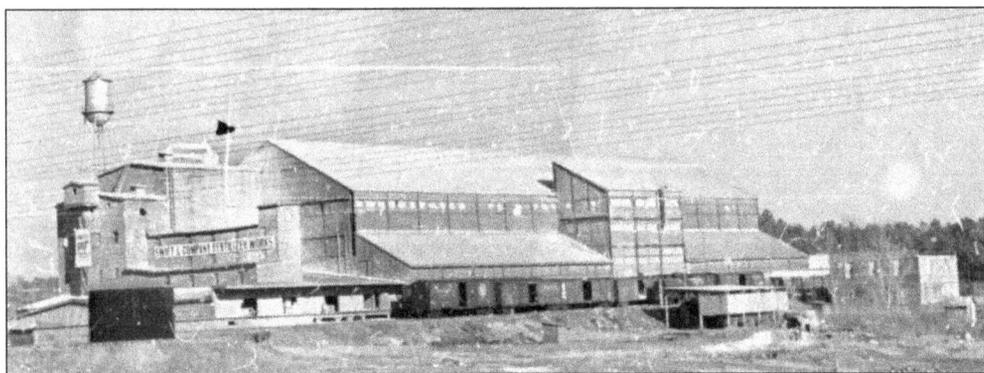

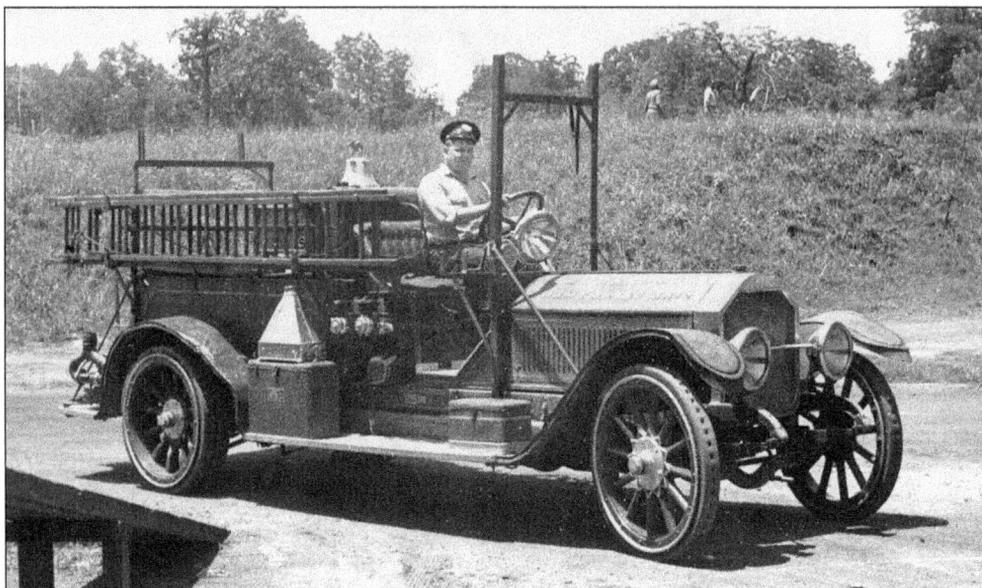

The City of LaGrange purchased this American LaFrance pump-and-ladder truck in 1917. The first volunteer fire company in LaGrange formed in 1856, while the first paid full-time fire department began operating in 1908. The first firehouse stood next to city hall on Ridley Avenue from 1908 until 1980. The city and county fire departments often cooperate when needed to fight fires. (Photograph by Stanley Hutchinson.)

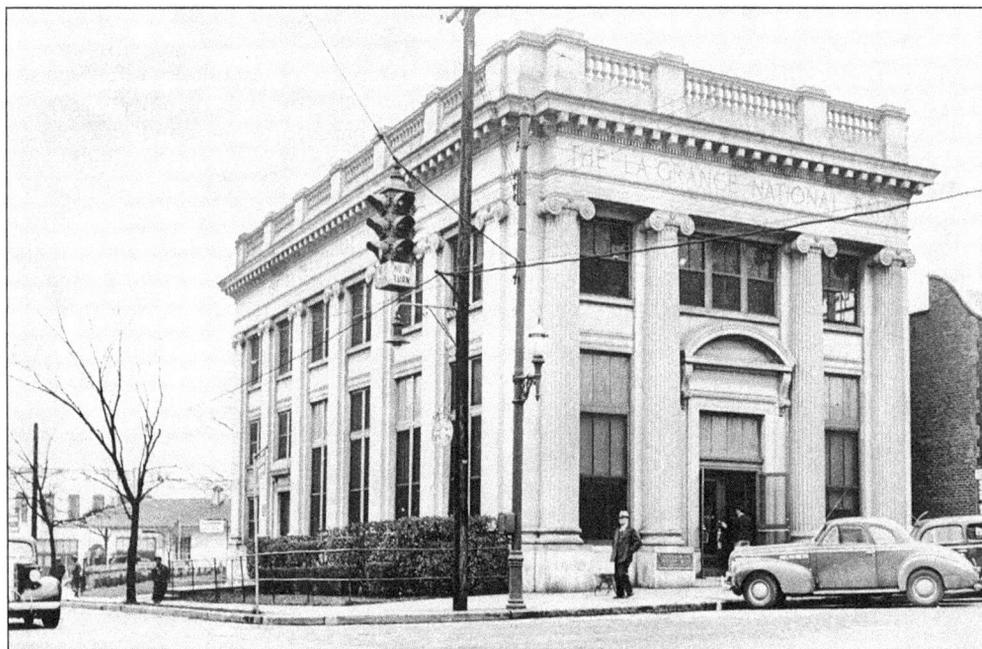

Since this photograph was made in the 1930s, almost everything from Broome Street south to Depot Street has disappeared, while everything visible here between Broome, Main, and Bull Streets has stayed virtually the same. Built in 1917, LaGrange National Bank became Citizens and Southern Bank. The Troup County Archives and Museum on Main now occupy the site. Traffic moved north and south on cobble-stoned streets while the early traffic signal warned "No U Turn."

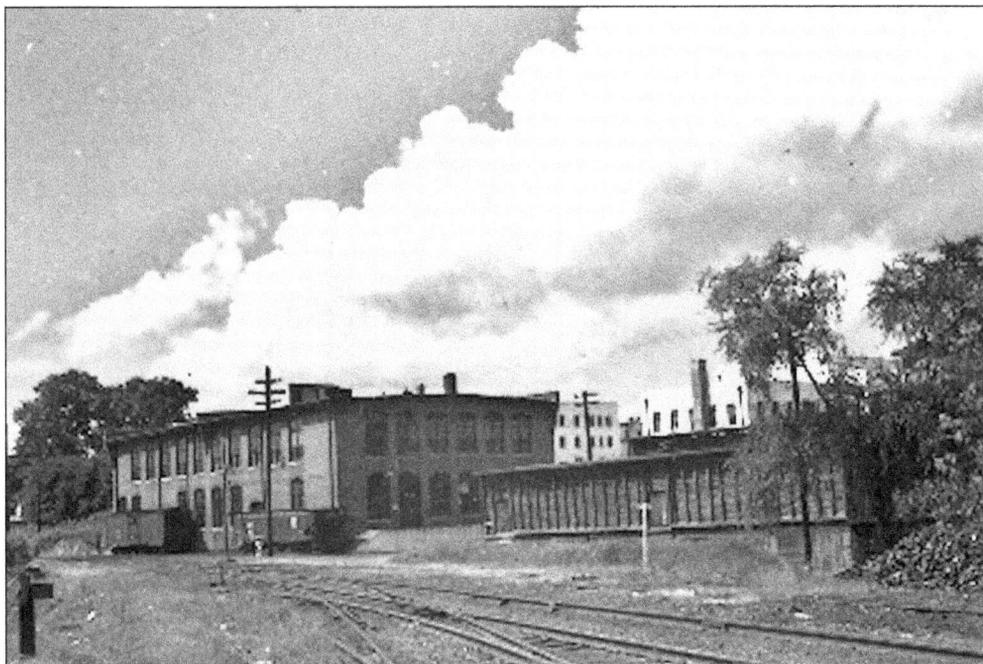

Industrial Suppliers served as a support business for local industries, especially textile plants. Built c. 1915, this brick store and warehouse stood along Morgan Street. This was a good location, since the store had a sidetrack that connected to the AB&C and the A&WP rail lines. Industrial Suppliers operated until 1992. The parking deck for the new Troup County Government Center now occupies the site. (Photograph by Stanley Hutchinson.)

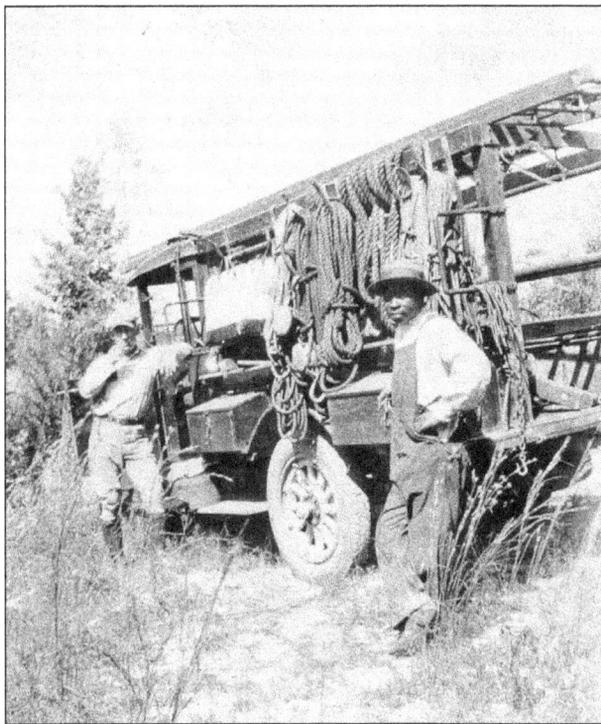

Olin Ellis, left, and an unidentified worker stand next to a LaGrange Light Department truck in 1921. Ellis served as a city electrician for several years. The truck is equipped with much of the equipment needed by linemen today: ladders, ropes, toolboxes, and water coolers. The city had electric lights beginning in 1889, while many county residents had to wait until the 1930s and the coming of the Rural Electrification Administration.

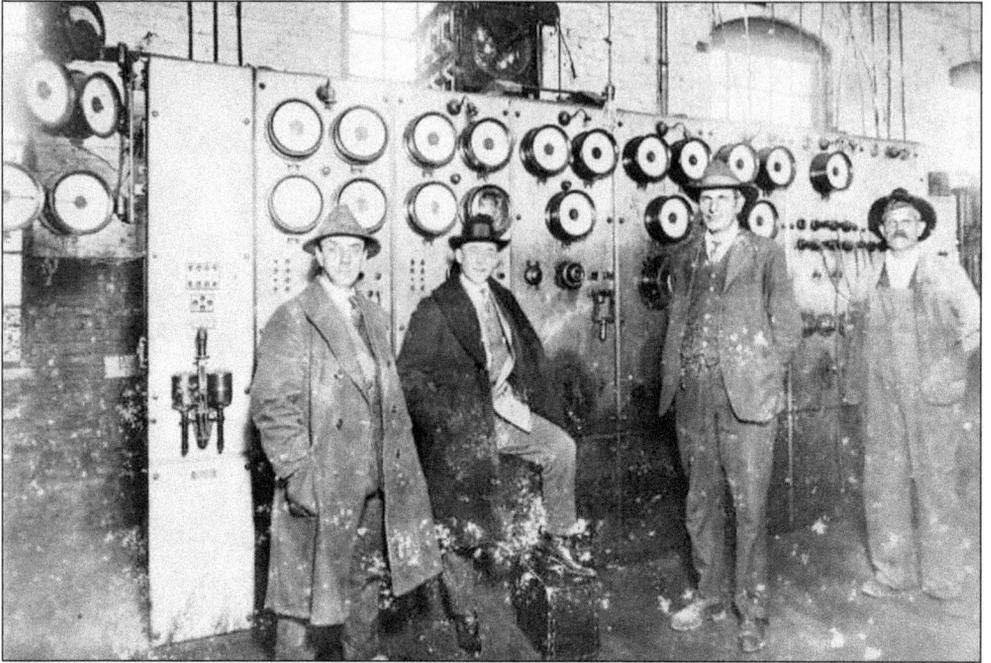

City engineer George Sargent, left, and H. W. Caudle, second from right, stand in front of what must have been a very modern panel of gauges and meters. This 1920 photograph was made at LaGrange Light and Gas. LaGrange Cotton Mills owned and operated the first electric plant in the city beginning in 1889. The city opted to build its own facility in 1906 and provided power to businesses and residences alike. (Georgia Archives, Vanishing Georgia Collection, TRP-45.)

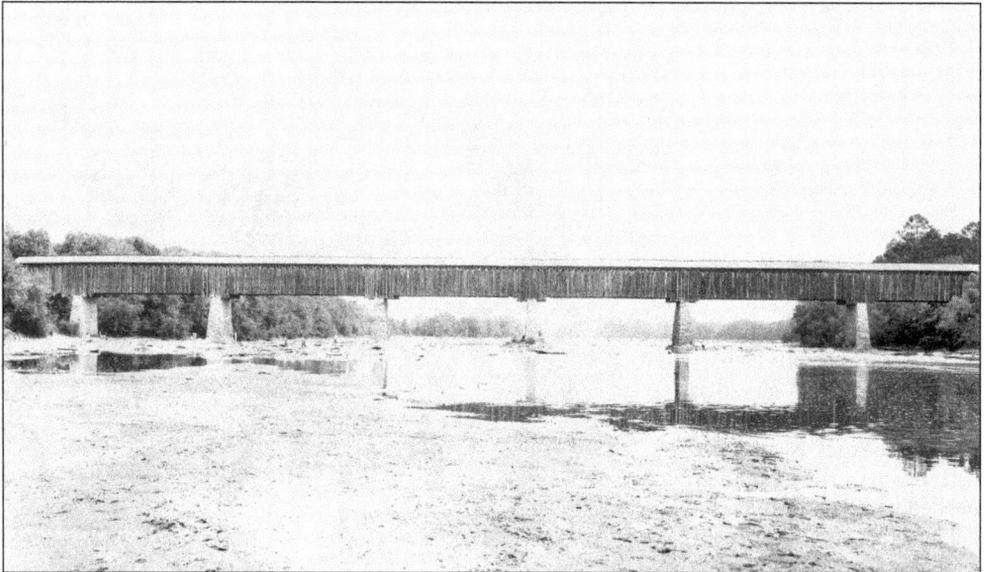

A severe draught made 1925 "the year you could walk across the Chattahoochee." The long expanse of Glass Bridge, built in 1896 by John and George King, dramatically illustrates the low water levels. In LaGrange, water had to be delivered in tanks to many neighborhoods. Rains finally came that fall. Just four years later, the Chattahoochee River flooded, causing extensive devastation in West Point.

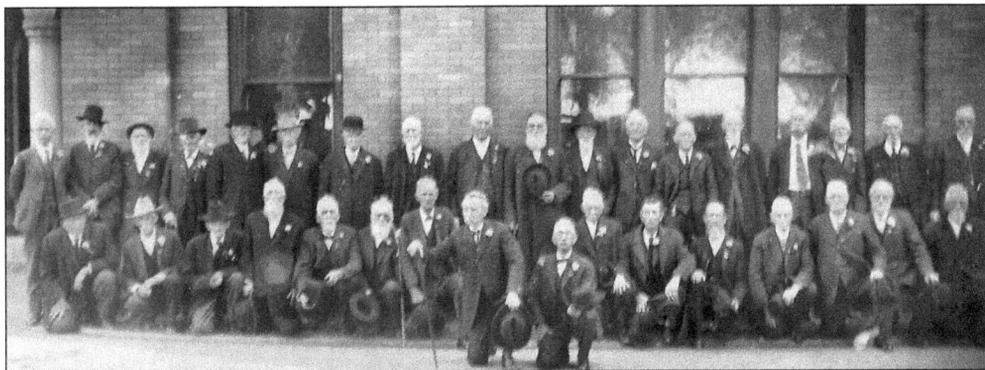

Confederate veterans gathered annually for reunions at the Troup County Courthouse. As evidenced by their long beards, the veterans were showing their age in this 1920s photograph, made over 50 years after the end of the war as their numbers began to dwindle. The last known Confederate veteran to die in LaGrange was John T. Hunter, who enlisted at West Point and died in 1939 at age 92.

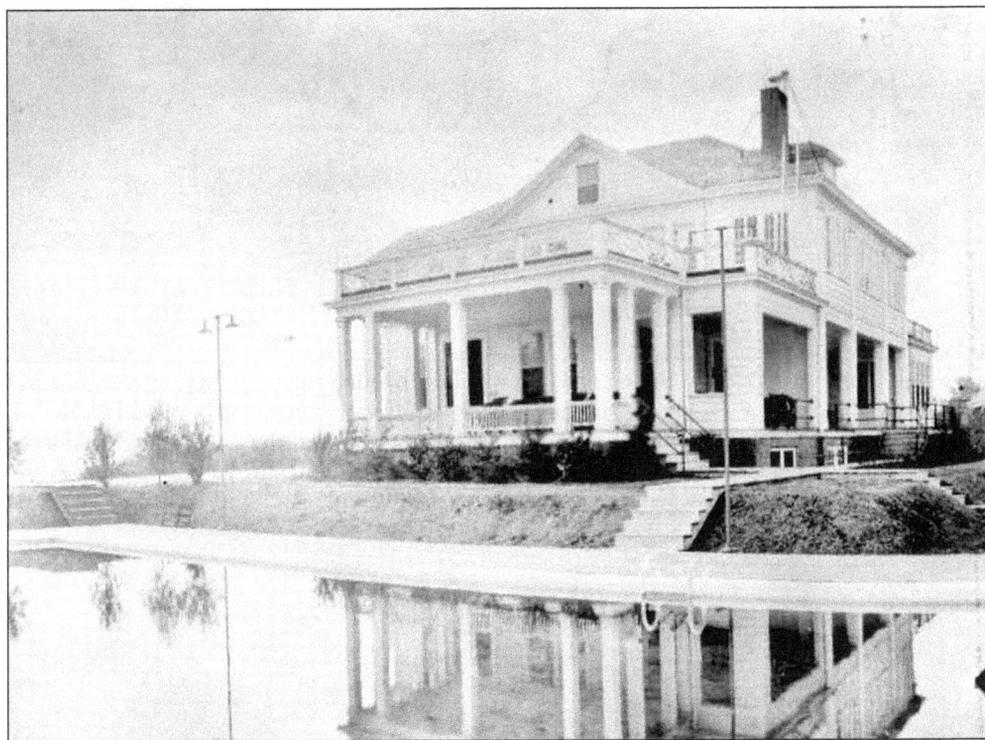

Highland Country Club opened in LaGrange in July 1923 with a golf tournament featuring famed golfer Bobby Jones. This unusual view shows the back and northeast sides along with one of two Olympic-sized pools that once enhanced the facility. Highland's board engaged Atlanta architect Neel Reid to design this clubhouse. Reid had earlier developed plans for Hills and Dales, home of Mr. and Mrs. Fuller E. Callaway. This building stood until 1966. (Georgia Archives, Vanishing Georgia Collection, TRP-32.)

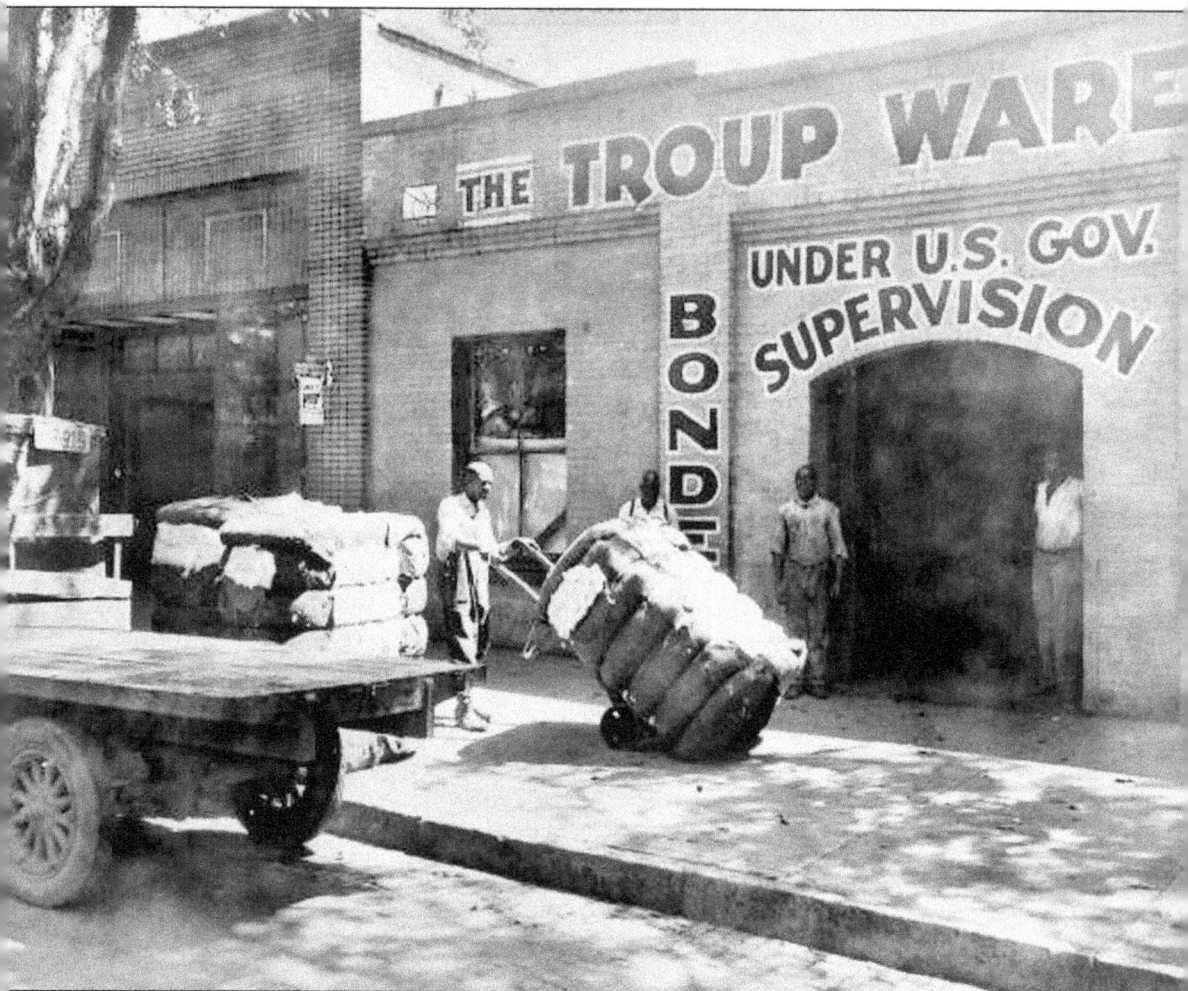

Each year from August to October, workmen stayed busy hauling bales of cotton into warehouses before going to market. Cotton could mature as early as July and then had to be picked and baled. Once at the warehouse, graded samples of fibers largely determined the price. Fair to middling, indicating average-quality cotton, was one grade. LaGrange Cinemas 10 now stands on the Main Street site previously occupied by the warehouse. (Georgia Archives, Vanishing Georgia Collection, TRP-278.)

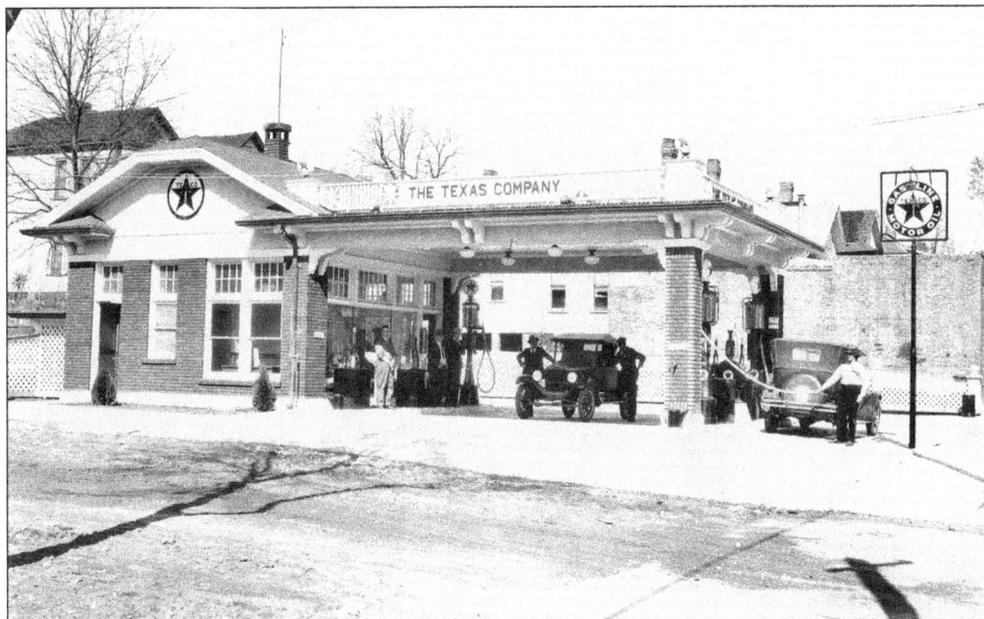

Service stations used to be attractive features of downtown LaGrange. This Craftsman-style station operated at the corner of Ridley Avenue and West Haralson, opposite LaGrange City Hall, from the mid-1920s, when this picture was made, to 1990s. Gas in that day sold for 23¢ a gallon. Well-dressed attendants pumped gas, washed windshields, and checked air pressure and under the hood in this era before self-service. Then, as now, signs warned "no smoking." Neither the station nor surrounding residences remain.

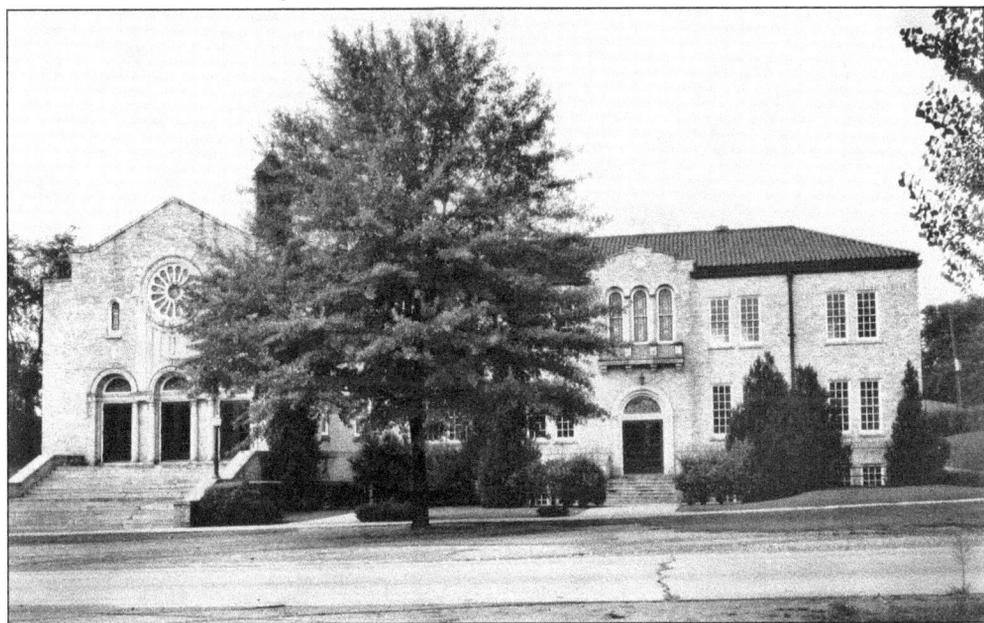

First Baptist Church of West Point organized in 1849 and had two buildings before the current structure, shown here, opened in 1925. The West Point Land Company, which helped develop the town in the antebellum era, gave the land for the church, where they have remained. Like First Baptist in LaGrange, they changed the configuration of their front steps.

Originally located on Vernon Street, Hunter-Owen Funeral Home built this structure in 1927 at 111 Broad Street. Like many funeral homes of the day, they operated a furniture company, which was located on the Square. They also provided an ambulance service. They became Hunter-Allen-Myhand Funeral Home in 1953 and moved to their present location in the old Whitley mansion on Hill Street in 1975. Mansour's parking lot now occupies this site.

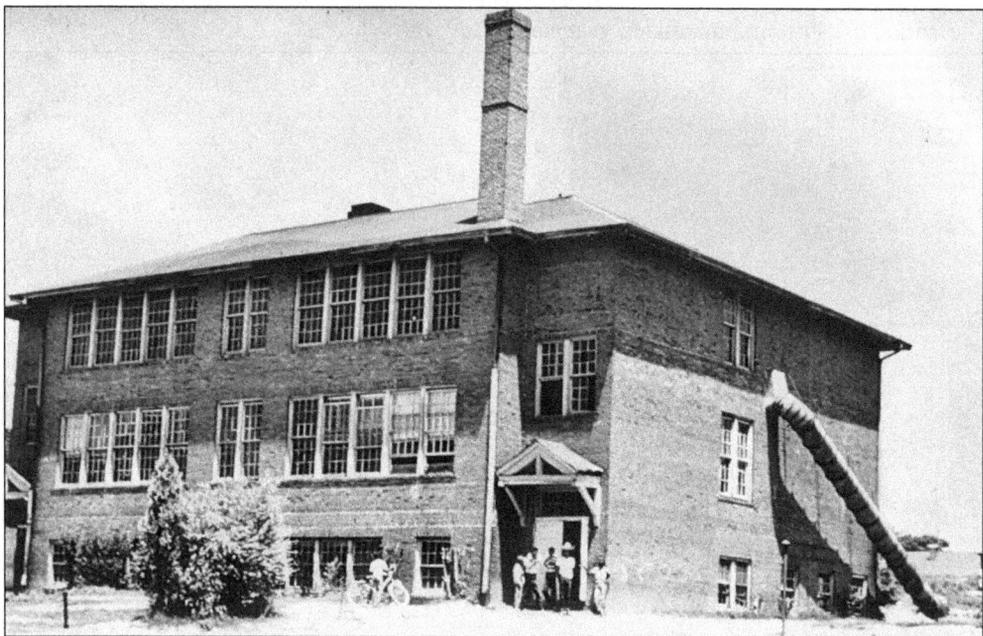

East Depot Street School opened in 1923 as the high school for black students in the city of LaGrange. The modern building replaced earlier high schools at Union Street and King Street. Interesting building details include the very tall chimney and the fire escape slide, which allowed quick escape from the upper floors. This structure stood until construction of a new building in 1951.

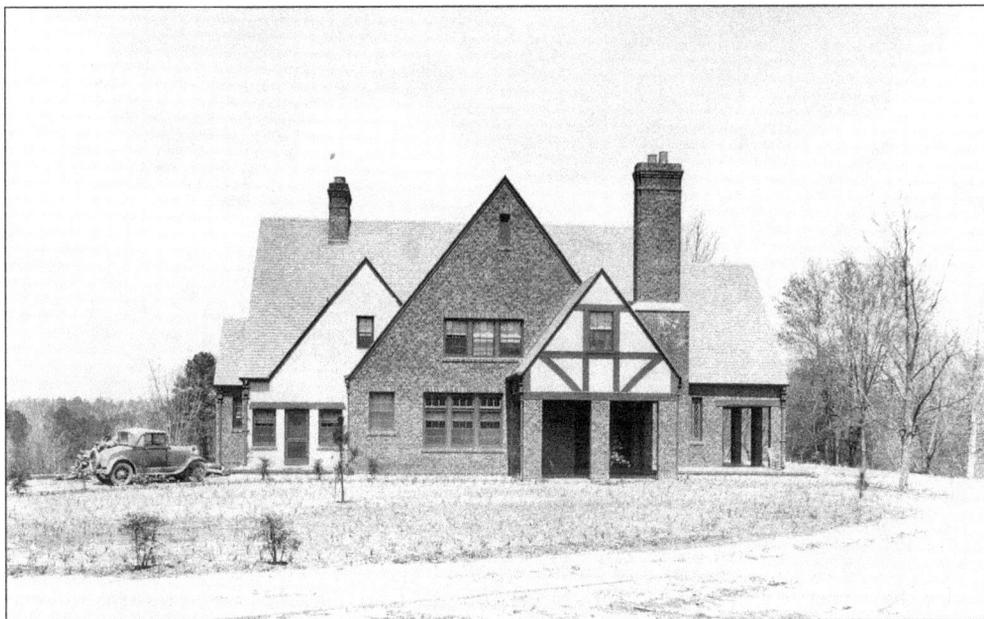

Robert M. Young Jr. built this home, Alta Vista, on Young's Mill Road for his wife, Lottie Guinn, in 1930. Designed by Tom Hutchinson, a local builder/architect, the house reflected an English county manor style. Across the road stood the grist, saw, and flour mills that bore the family's name. It was called Bird's Mill in the 1830s, and the Youngs bought it in 1868. New owners have recently extensively reconstructed the house.

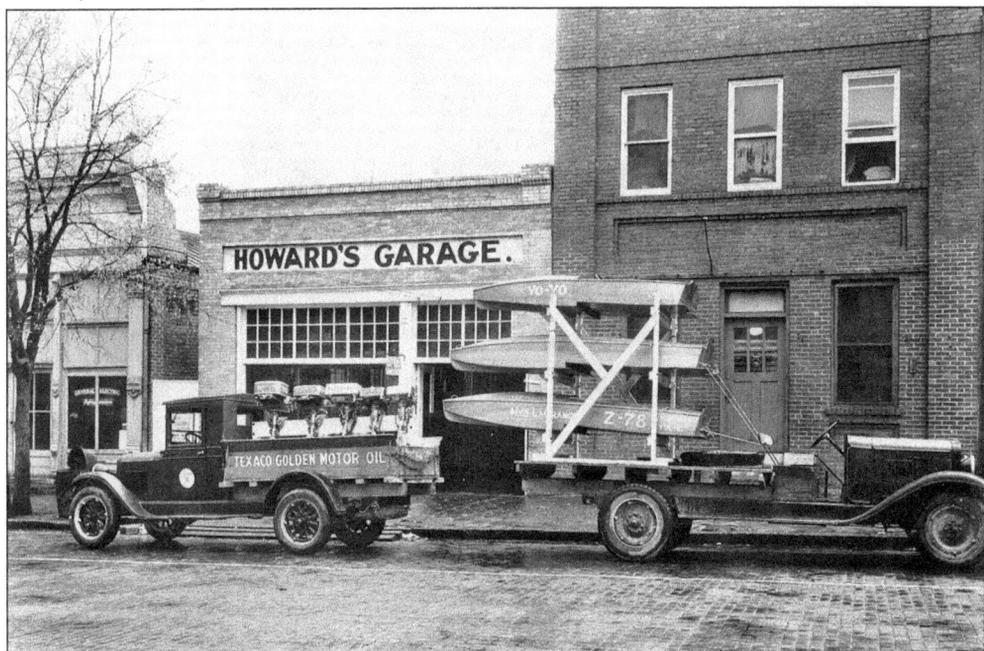

Howard's Garage stood on Church Street just off the Square from the 1920s until 1948. In addition to being a master mechanic, C. M. "Kid" Howard raced boats on the Chattahoochee River and elsewhere. The boats are identified as being part of the Howard and Young Boat Club and bear the names *Miss LaGrange* and *Yo-Yo*.

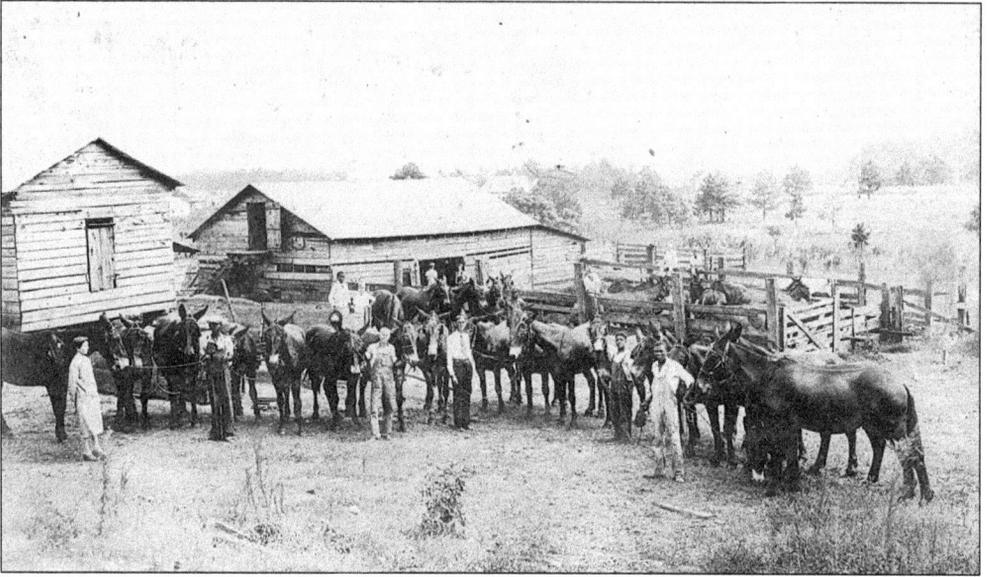

Today the corner of Jenkins and Clark Streets is a residential area located across the railroad tracks from West Georgia Health Systems. This late-1920s scene shows a dramatically different view. Members of the Robert Moore family, including Jennie Nixon Moore on the left, and workers proudly pose in front of the barns with a large number of mules, which were used in Robert Moore's profession as a grading contractor.

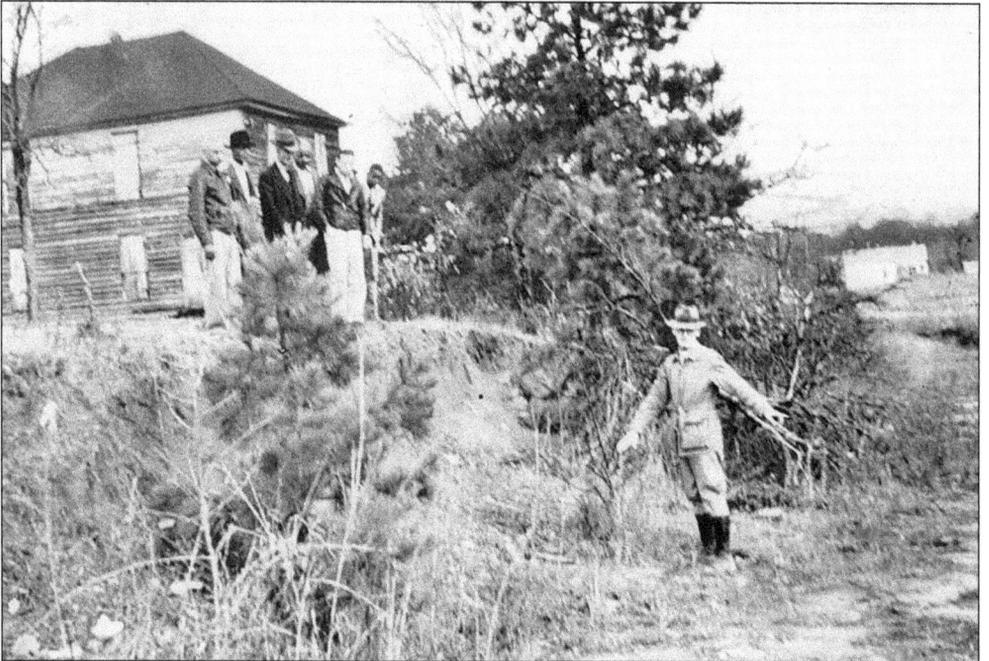

Soil erosion is a problem that transcends the history of Troup County. In this photograph taken near Mountville School, the county agent, probably E. T. Evans, examines lands washed out many years earlier. He is explaining the situation to a group of interested citizens and perhaps suggesting ways to rectify the damage. Terracing and grading were two methods that people often used to avoid such problems.

Founded in 1830, First Methodist Church of West Point built this sanctuary in 1907 and the Sunday school building on the left in 1927. The church has been at this location since 1852, when the West Point Land Company donated the lot. Concrete blocks molded to simulate stone and the two towers give it the appearance of an English country church. Ornate stained-glass windows add a distinctive feature to the building. (Photograph by Katherine Hyde Greene.)

LaGrange Woman's Club, with funds raised by the Rotary Club, constructed LaGrange Memorial Library on Church Street in 1926. The name honors local servicemen who died during World War I. The Woman's Club paid the salary of the librarian and maintained their meeting room in the back. The library eventually became a public facility funded by local governments and moved to Alford Street in 1975. The old library now houses the public defenders' office. (Photograph by Snelson Davis.)

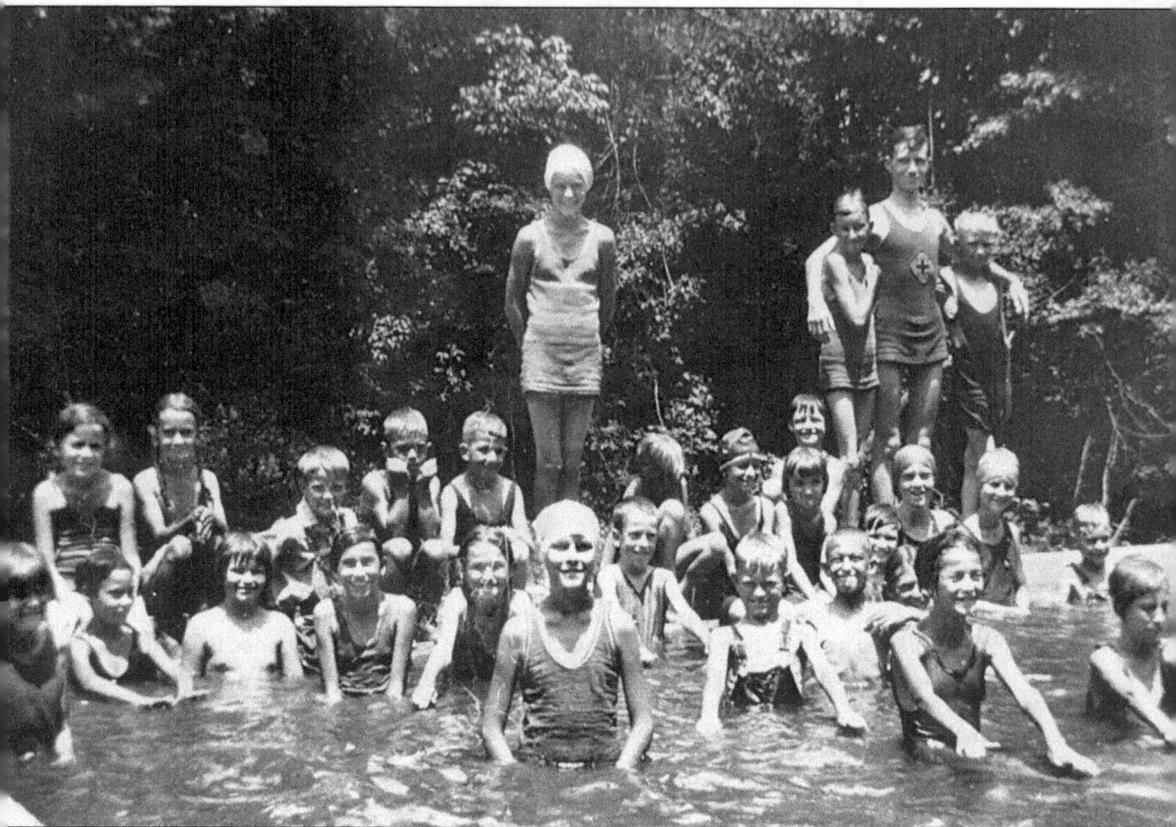

Viola Burks gave land near Mountville in 1928 as a permanent home for a camp she had been operating the previous two years for underprivileged children. Generations of Troup County children have enjoyed life-enriching summer programs, including swimming, boating, games, crafts, and camping. Burks was founder and director of the LaGrange Welfare Association. Camp Viola continues to operate under the auspices of Twin Cedars with assistance from churches and civic clubs. (Photograph by Stanley Hutchinson.)

Five

THE GREAT DEPRESSION
AND WORLD WAR II
1930–1949

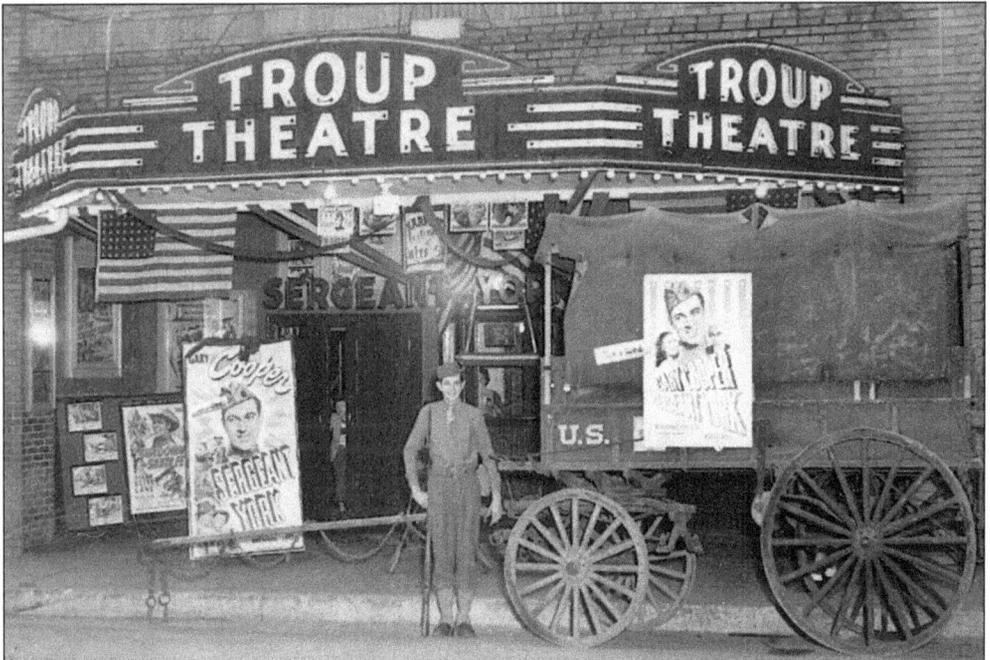

Located on Lincoln Street in the Hillside community, Troup Theatre was one of several neighborhood theaters to operate in LaGrange from the 1920s to the 1950s. In 1941, Gary Cooper was starring in *Sergeant York*, about the United States' most decorated hero of World War I. The subject of the film, Alvin York, spoke in LaGrange in 1932, 1941, and 1942. The coming of television and ready transportation led to the demise of neighborhood theaters.

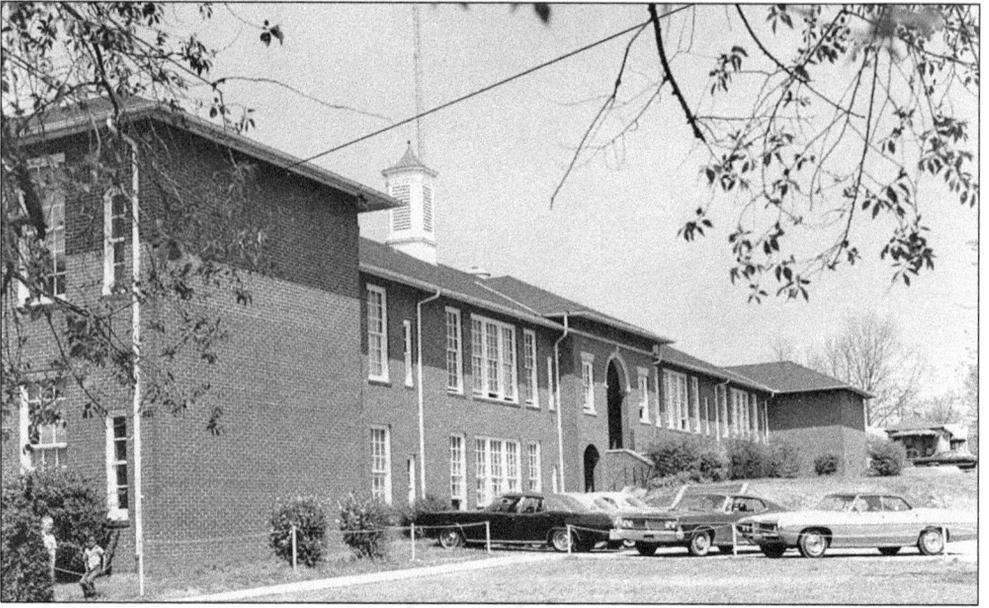

Built in 1938 as McGregor Street School for black students, this building was renamed Kelley Grammar in 1945. The name honors longtime principal C. H. Kelley, who served with the city schools from 1903 until 1939. Much of the building burned in 1972, and students were moved to Cannon Street School. The building now houses Head Start and recreational facilities. Many community events take place here.

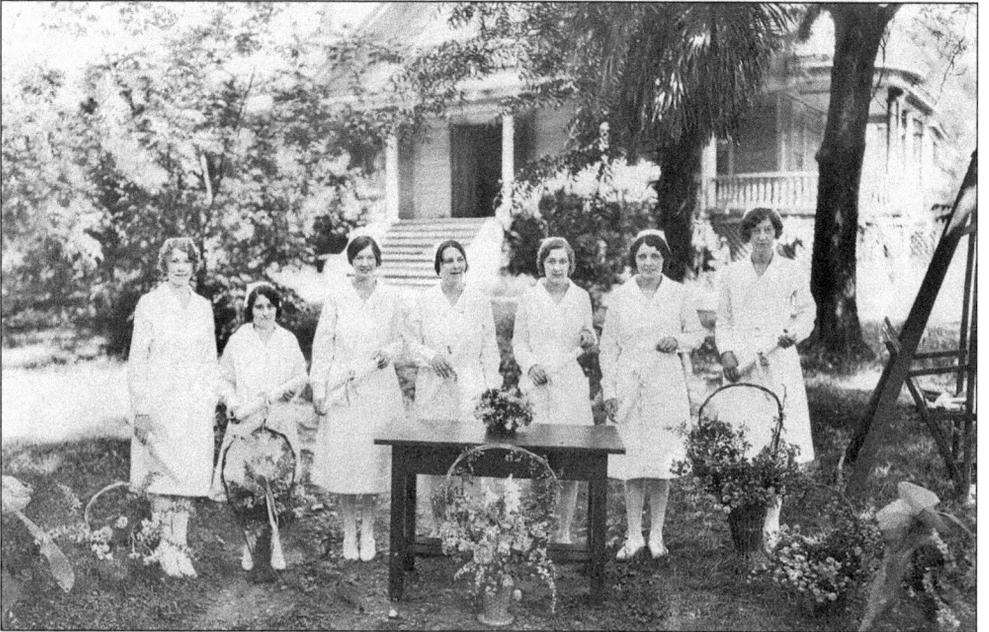

Dunson Hospital, the first public hospital in the county, operated from 1916 until 1937 on Church and Haralson Streets in buildings originally housing LaGrange Sanitorium. Part of hospital operations included training nurses, such as those seen here in a 1930 graduation exercise. They are standing in front of the Dunson Nurses Home located next to the hospital. The house dated to the 1830s and had been home to the Turner and Slack families. (Photograph by Snelson Davis.)

Harold Hardy served as warden of the Troup County work camp from 1928 until his death in 1933. His most famous prisoner was Robert Elliott Burns, who arrived at the work camp in 1929. Burns went on to write *I Am a Fugitive from a Georgia Chain Gang*. The popular book was made into a movie in which Paul Muni won an Oscar portraying Burns. This led to extensive reforms in Southern prisons. (Georgia Archives, Vanishing Georgia Collection, TRP-192.)

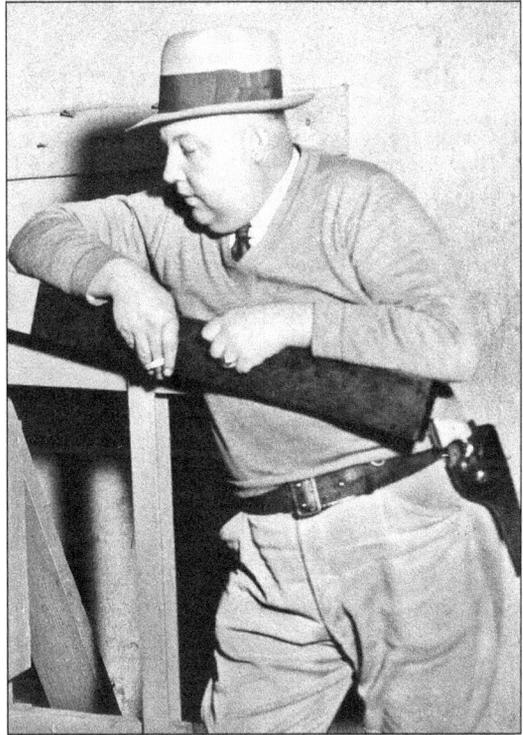

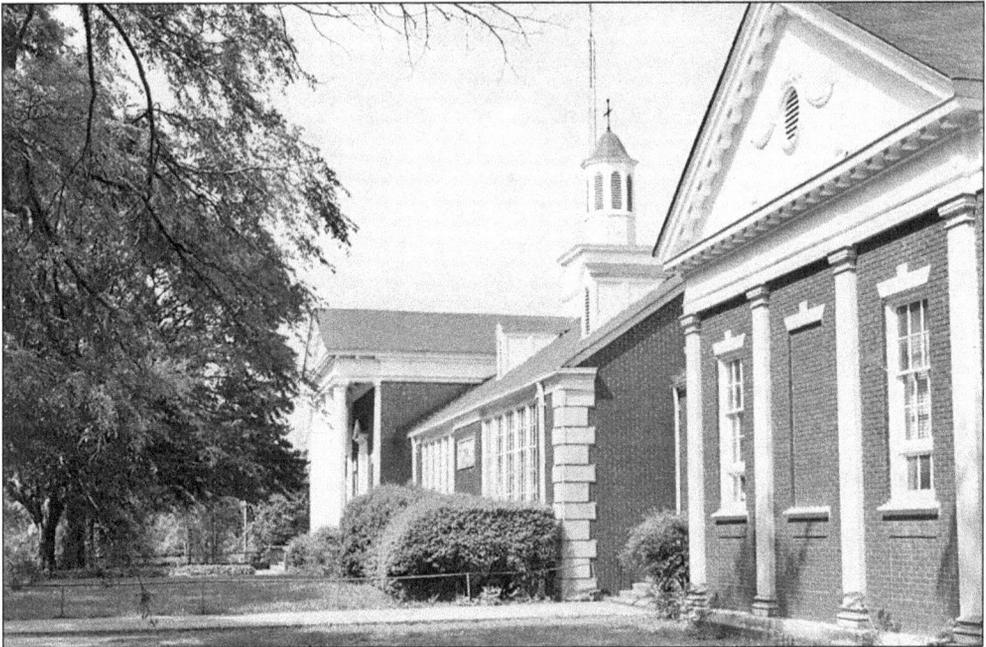

LaGrange Board of Education built this brick neoclassical structure as Hill Street Junior High School in 1931. The school had previously met at a home originally built by Judge E. Y. Hill, for whom the street was named. This became East Side Girls Junior High in 1970. A fire destroyed all but the gymnasium wing in 1978. The renovated gym has been home to Boys and Girls Club of West Georgia since 1992.

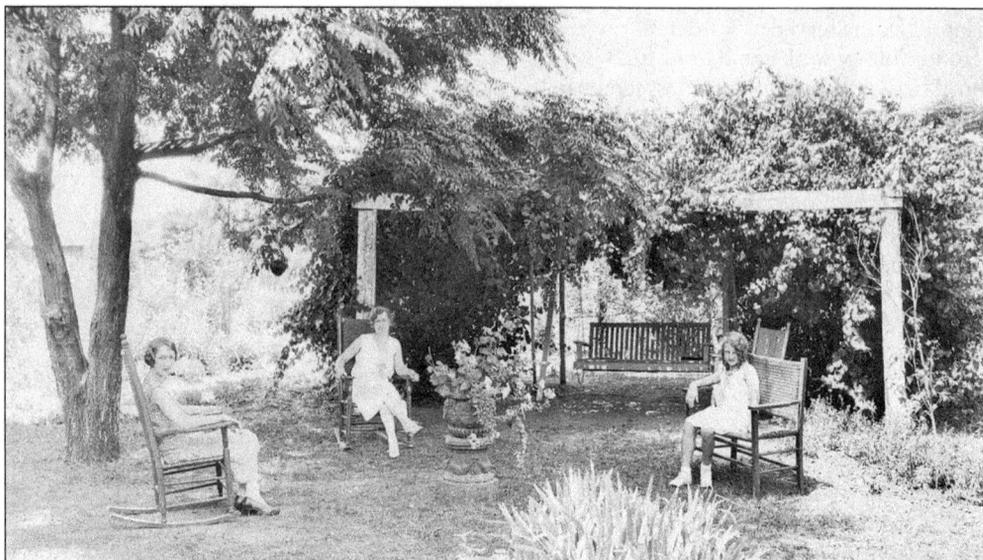

The beautiful garden, with its wisteria arbor, possibly served as the inspiration for budding young artist Joyce Rakestraw (later Jackson), seated on the right. In 1964, she became the first president of the Chattahoochee Valley Art Association. Her sister, Liz, and her mother, Elizabeth Dunson Rakestraw, seem to be enjoying the afternoon with her in their backyard on Hill Street. In pre-air-conditioning days, people escaped the heat by relaxing in shady gardens. (Photograph by Snelson Davis.)

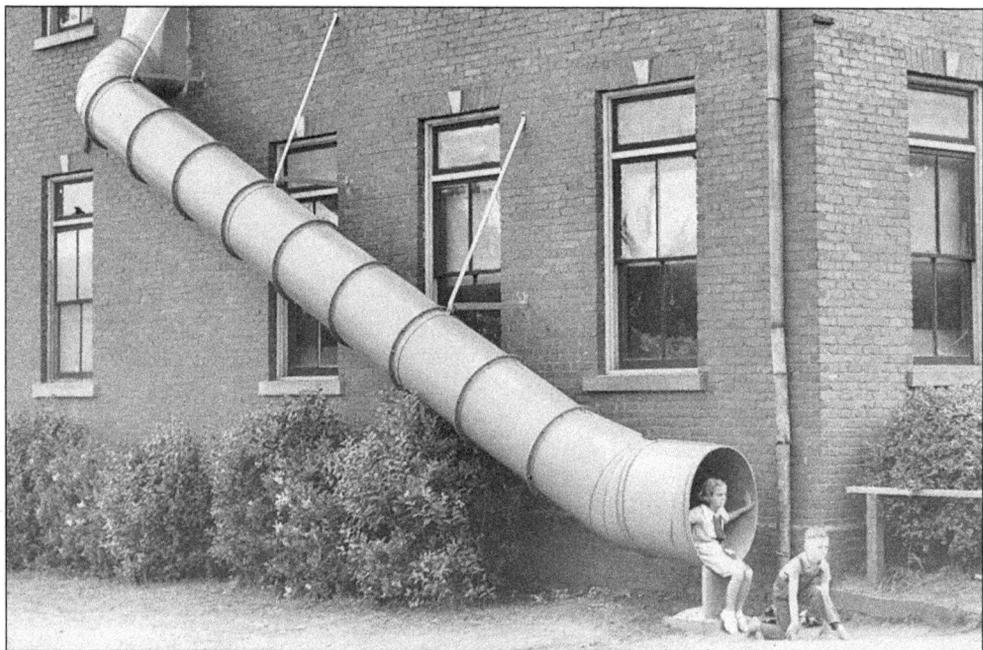

Like many schools of the era, the old Unity School on Wilkes Street had multiple stories. Concern for the safety of students necessitated including fire escapes such as this large slide. The slide, which had a serious and practical purpose, proved to be a source of great amusement for students during fire drills. Some students went back after school and climbed up the tubes to slide down, thus creating great memories.

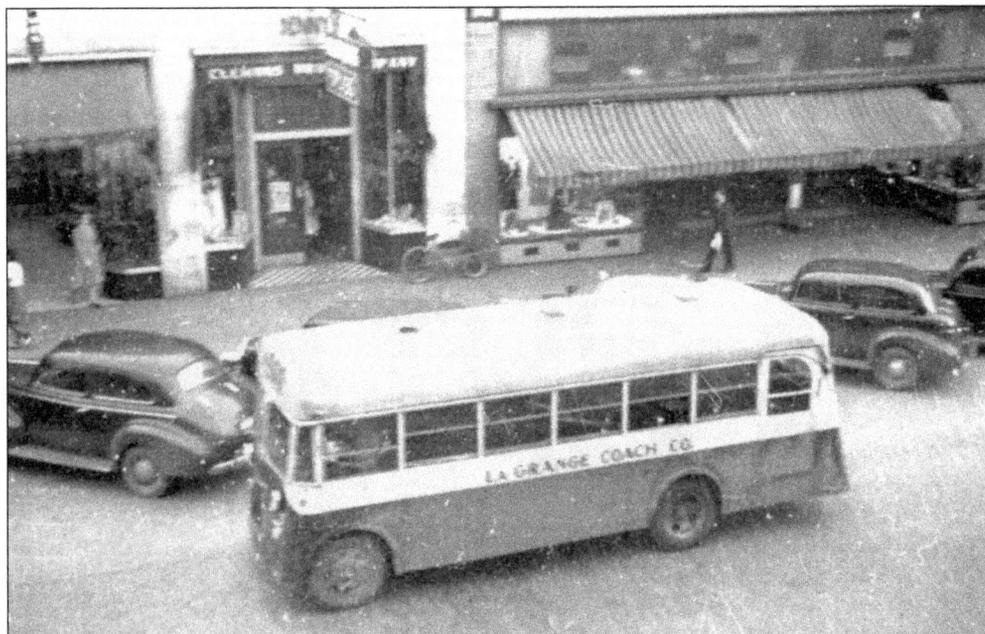

This 1944 photograph provides proof that LaGrange once had a bus system. The LaGrange Coach Company bus is stopped on Main Street in front of Clemons Drug Store and J. C. Penney Company. The remodeled Penney building is now home to Abbott, Jordan, and Koone, accountants; the drugstore, which was later Paul Cole's, now houses Venucci's Italian Restaurant. The bus company operated until 1950. (Photograph by Stanley Hutchinson.)

Clifford L. Smith, one of Troup County's Renaissance men, served in many capacities. He taught at LaGrange Female College and was the first superintendent of LaGrange city schools from 1903 until 1912. He taught Sunday school at First Methodist Church and was an early Boy Scout leader. He had great interest in local shrubs, trees, and minerals. As the first official county historian, he authored *History of Troup County*, published in 1935.

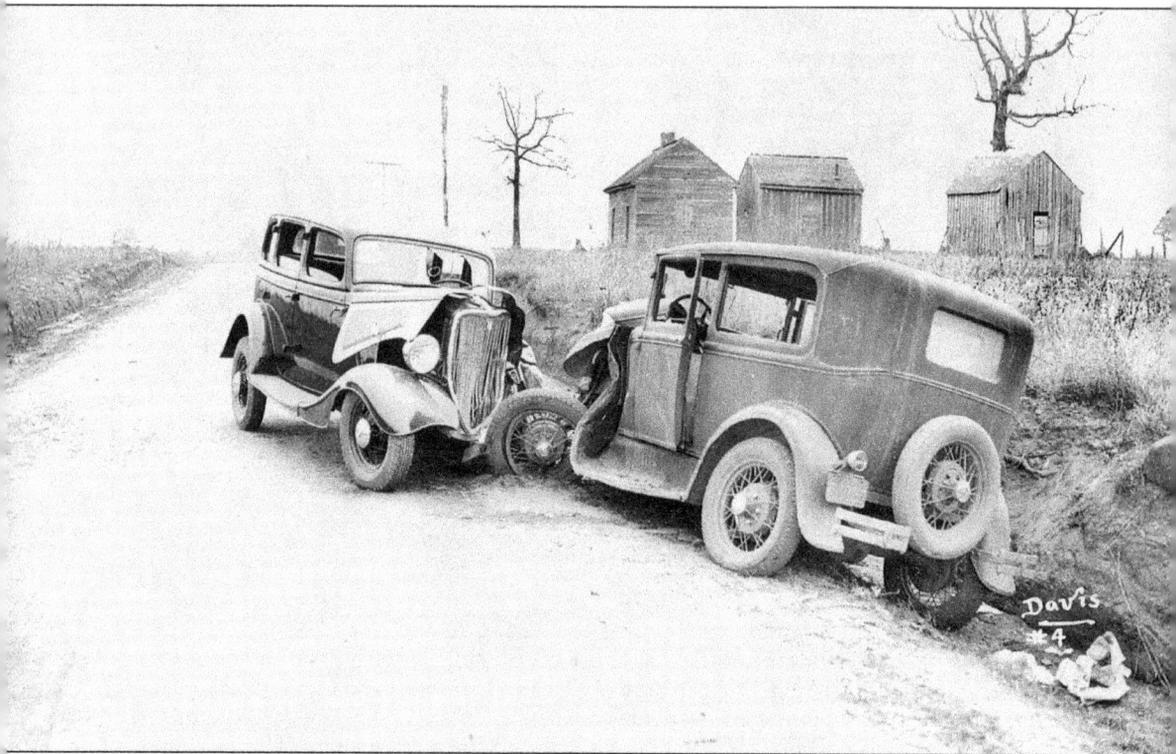

This 1930s photograph by Snelson Davis speaks for itself: wrecks are nothing new. This wreck took place on Whitesville Road. The car on the left was a 1934 Ford, while the other was a 1930 Model A Ford. The picture leaves one wondering where the occupants are: perhaps standing beside the photographer, in the hospital, or gone home. The gangster John Dillinger was killed while in a similar 1934 Ford.

Stark Mill in Hogansville sits across the railroad tracks from a neighborhood. A Methodist/Baptist church is seen on the right, while the roof of Calumet community center is visible in the background. The mill opened in 1924 and continues to operate as ISF (Industrial Specialty Fabrics). For a time when the mill was part of U.S. Rubber, the company sold their shoes in the back of the community center. Efforts are underway to preserve the center.

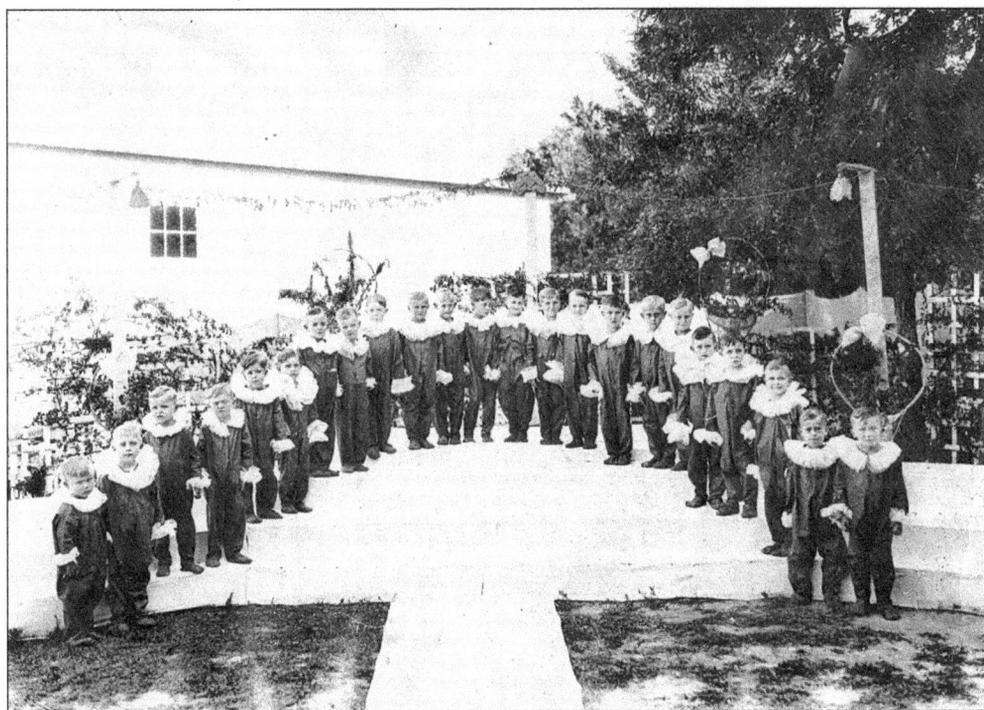

Getting this many young boys to dress in such frilly attire was certainly an accomplishment. This 1930s group may have been presenting a school pageant, recital, or May Day activity. Elaborate costumed plays and pageants were produced throughout the school year, often involving the entire community and drawing big crowds.

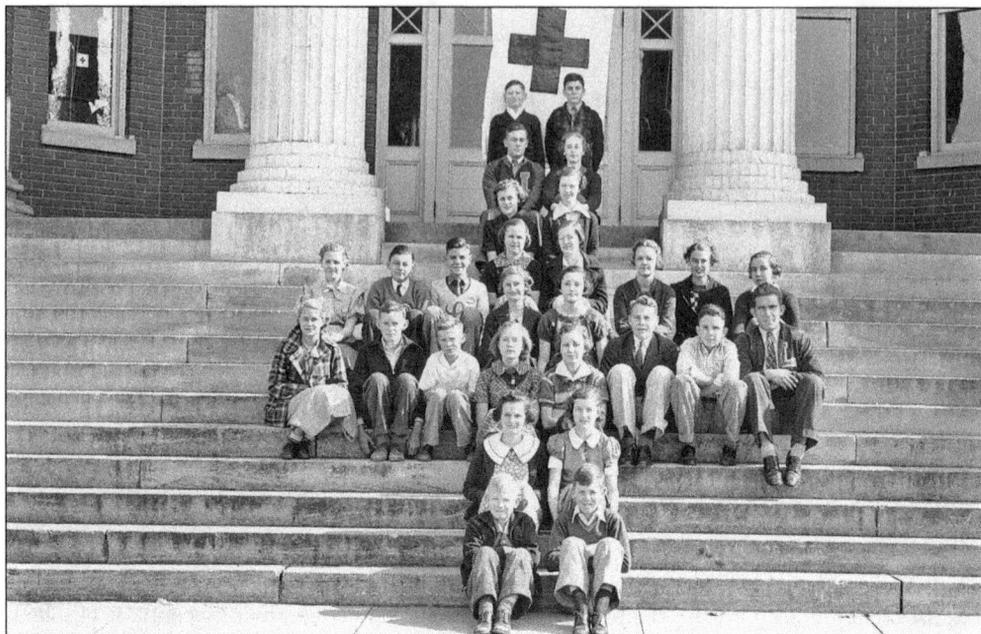

Clubs, athletic teams, and other groups routinely pose for their picture in the school annual. This group, the Red Cross Council arranged themselves in such a way as to mirror their banner. They are seated on the steps of the old LaGrange High School building on North Greenwood Street in 1937. Had the photograph been in color, they might have all worn red!

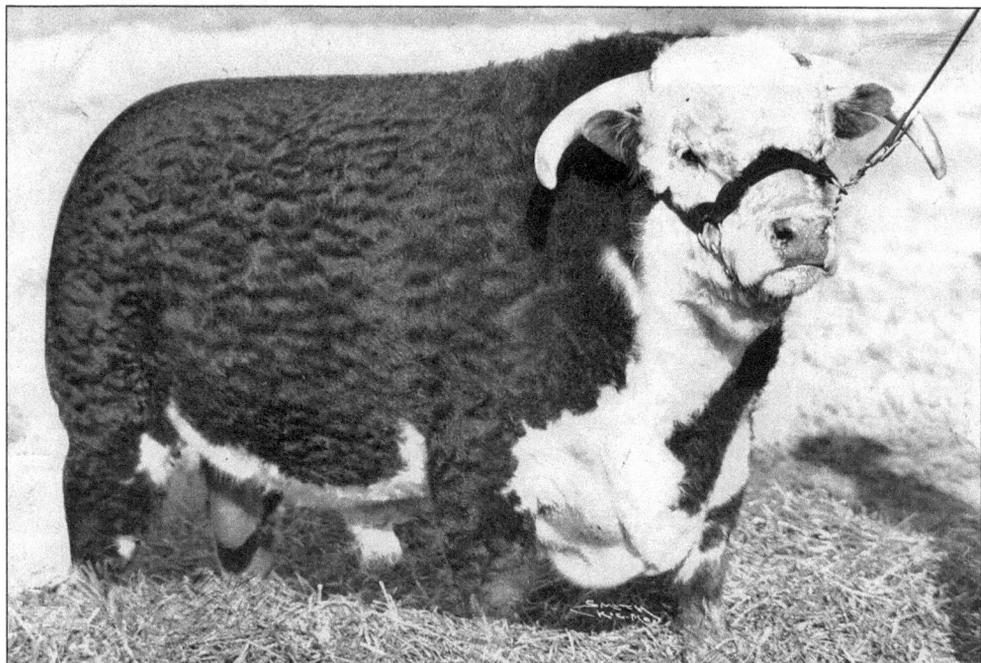

When purchased in 1946, Real Silver Domino 44 was the star attraction at Hills and Dales Farm. Fuller E. Callaway Jr. purchased the Hereford bull from Texas for $52,000. At the time, this was the highest price ever paid for a prize bull. Callaway planned to upgrade the bloodline of the Hills and Dales herd. Alas, cancer prevented the bull from breeding.

Periodically throughout the years, night classes have been held as an avenue of self-improvement for those unable to attend regular school. This photograph shows men and women of all ages taking advantage of evening classes offered by Callaway Mills in the 1930s. They were probably mill employees seeking career advancement. The classes may have been held at Callaway's vocational training center on Fourth Avenue.

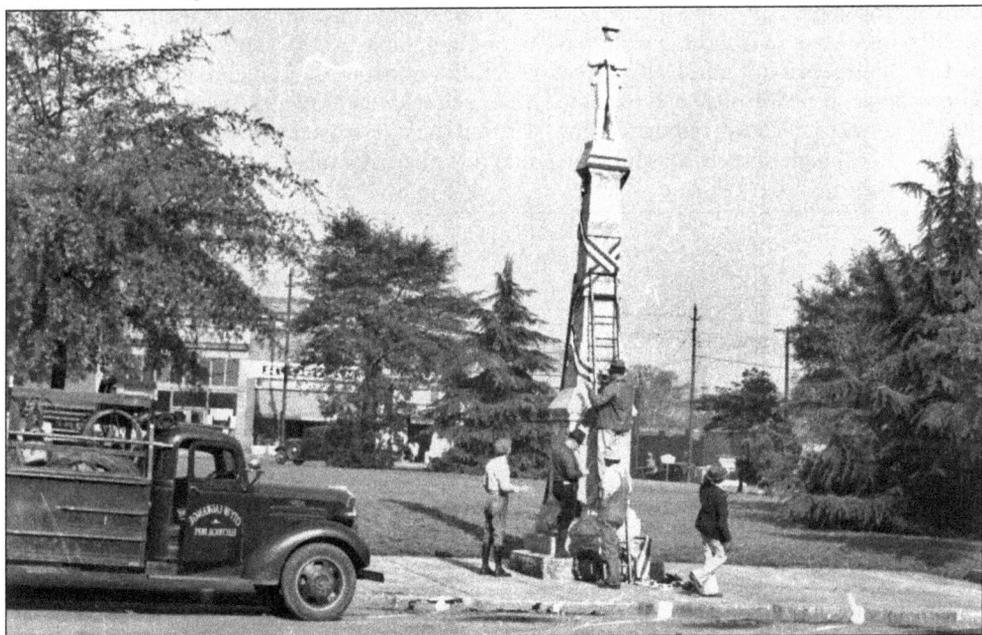

Much the way city workers today hang Christmas lights on the Square, workers in the 1930s draped red, white, and blue cloth on the Confederate monument. They may have been preparing for the town's traditional observation of Confederate Memorial Day on April 26. This photograph was taken after the courthouse fire on November 5, 1936. Erected in 1902, the statue now stands at the junction of Ridley, Morgan, and New Franklin Streets. (Photograph by Stanley Hutchinson.)

Today Callaway Stadium serves as a venue for football and soccer games with concrete grandstands and modern concession stands on both sides of the field. Both of these photographs, however, show that Callaway Stadium was originally a baseball facility, and there are games going on in both photographs. Callaway Mill teams, semi-professional teams, and others used the field. The aerial above shows neighboring Callaway Auditorium, built in 1942, and the pool that is now part of Hudson Natatorium. Dallis Street, which lies north of the stadium, is hidden by trees. The stadium opened in 1929 and remained a baseball stadium until 1959, when football became the major focus. Callaway Foundation, Inc., donated the stadium to LaGrange and Troup County in 1992. Local high schools, youth leagues, and now the LaGrange College Panthers play their games there.

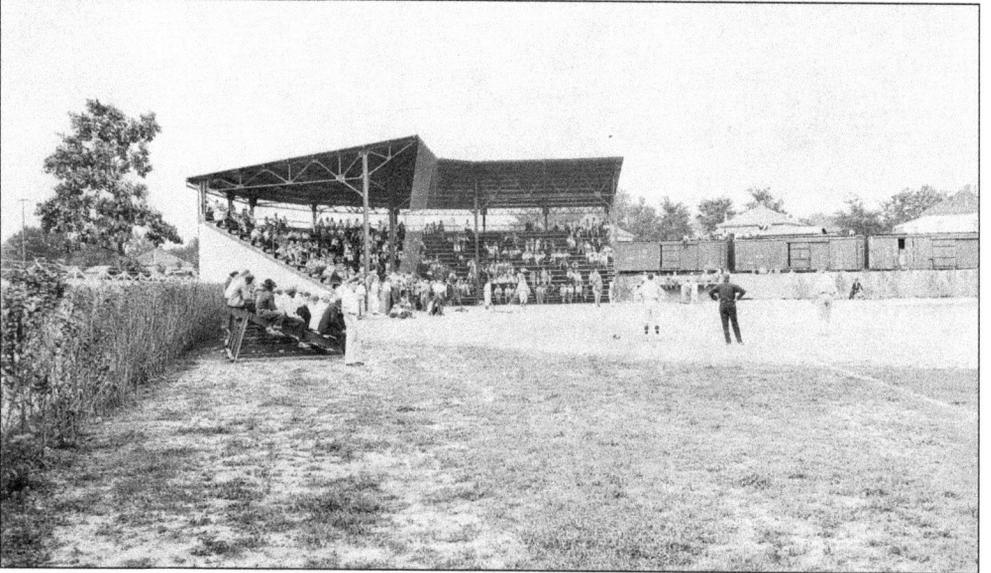

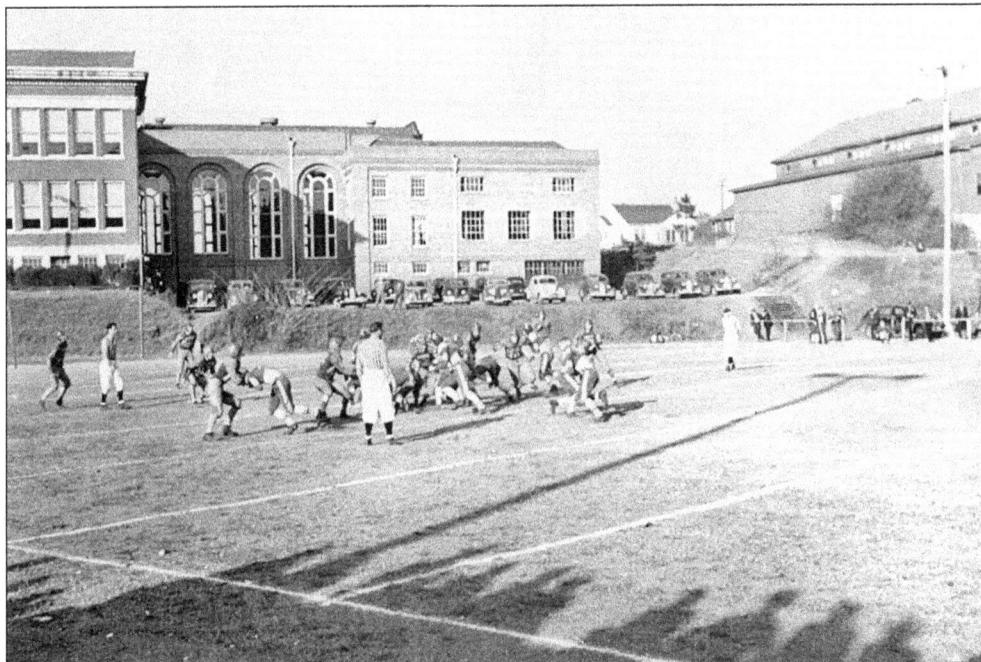

LaGrange High School (LHS) has stood on the same lot on North Greenwood Street since 1914. The photograph above shows LaGrange playing Lanier High of Macon on November 23, 1939. LHS won 20-18. The vocational wing now occupies the playing field on the south side of the old building. The brick section on the left was the original building, while the wing behind it was constructed in 1921–1922. The wooden gym is shown on the right. On December 26, 1942, fire completely gutted the school. Stanley Hutchinson, who made both pictures, stood on the playing field as he captured the post-fire devastation. LHS held classes at Harwell Avenue School and then at First Methodist Church until completion of the new building in 1946. World War II had delayed procuring building materials. Since then, several buildings have been added to the LHS campus.

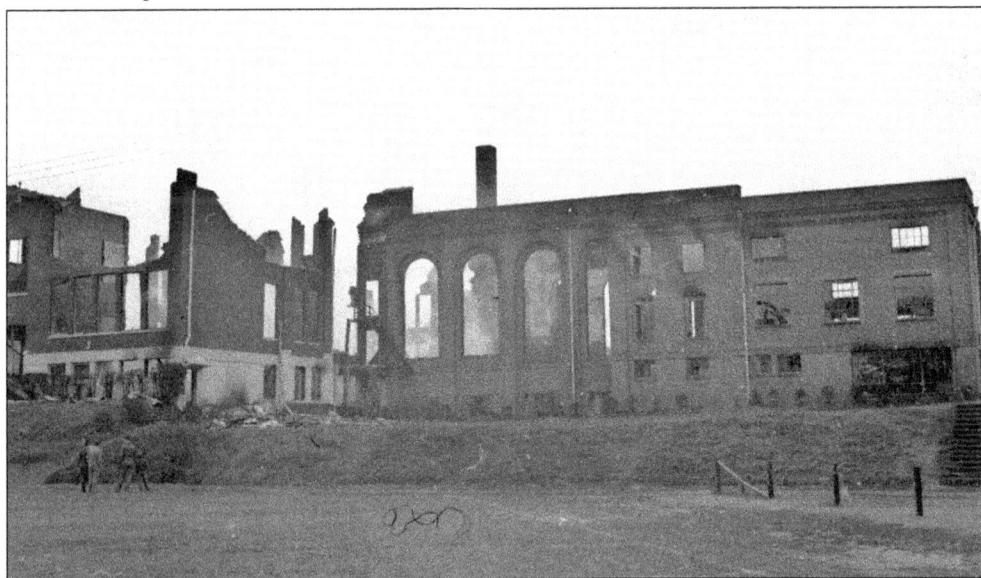

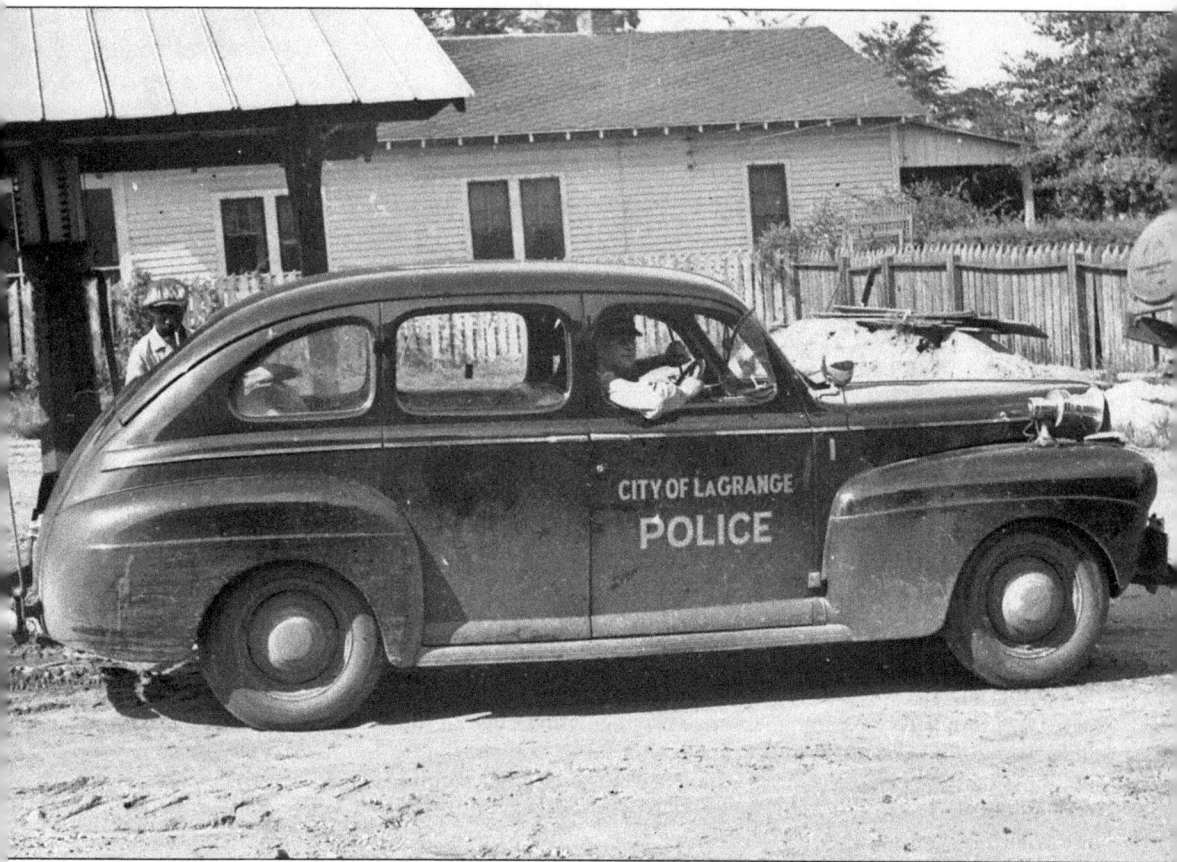

The City of LaGrange Police Car No. 1 is stopped at a neighborhood gas station in the early 1940s. The car has all the modern equipment of the era: a large antenna, a spotlight, and a bullhorn/siren. The streets are still dirt. Originally law enforcement duties in the city fell on a town marshal with needed assistance from militia companies. The City of LaGrange first organized a police department in 1899. (Photograph by Stanley Hutchinson.)

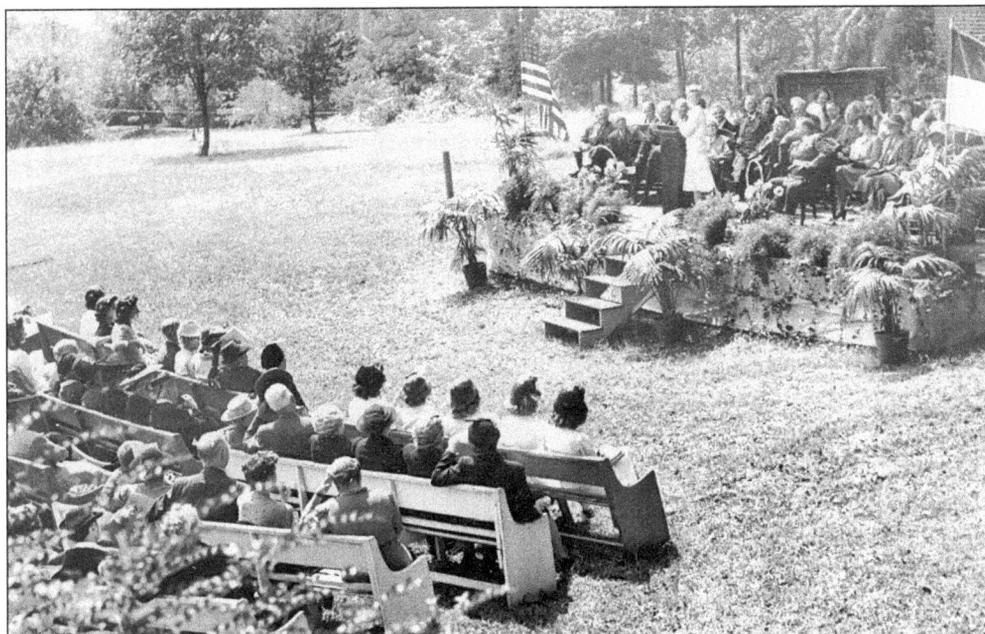

In the 1943 photograph above, a crowd participates in the dedication of Pitts Hall at LaGrange College. Built in 1941, Pitts was the first new building on campus since 1911, when Harriet Hawkes Hall was erected. The Quillian, Turner, and Manget buildings followed in late 1940s and 1950s. Pitts was named to honor college benefactors William I. H. and Lula E. Pitts of Waverly Hall. Their daughter, Margaret, was a college trustee for whom the dining hall was named in 1998. The scene below shows two ladies tending the Maidee Smith Garden at the south end of Smith Hall, just north of Pitts Hall. They are planting and watering new flowers around the reflecting pool. A longtime professor, Maidee Smith was the daughter of Rufus Smith, college president from 1885 to 1915. Smith Hall was named for her mother, Oreon Mann Smith.

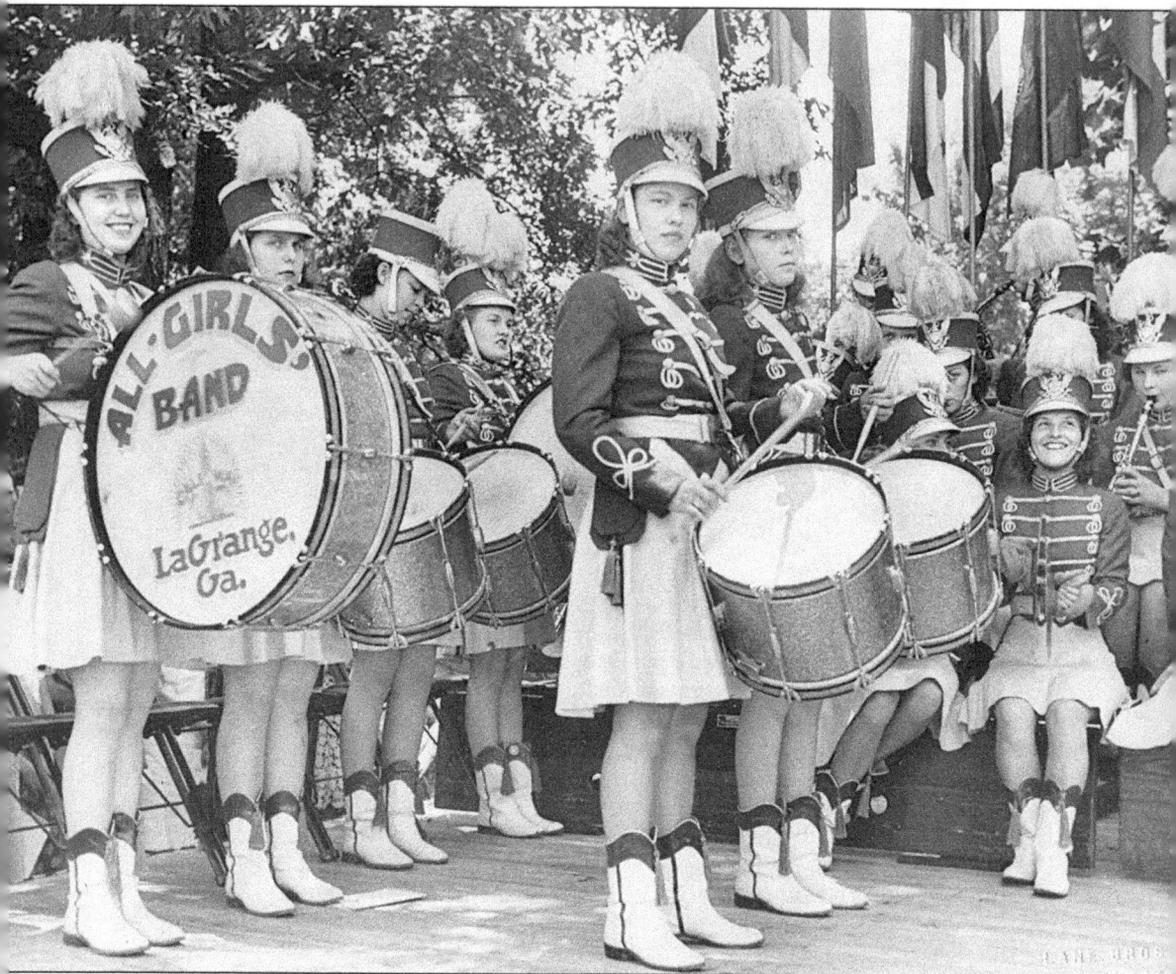

The All-Girls' Band of LaGrange performed at Callaway Mills' Army-Navy "E" Awards program at Callaway Auditorium in 1943. The U.S. government presented "E" awards to businesses and industries for excellence in war support production. All of the local mills received these awards at some point during World War II. (Photograph by Lane Brothers of Atlanta. Used with permission of Georgia State University Archives.)

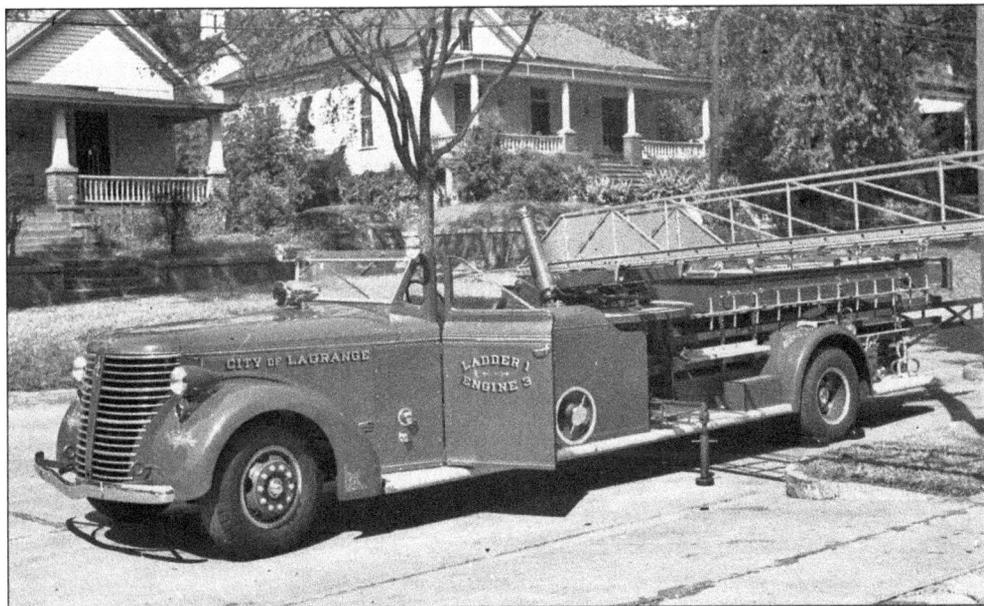

The new fire truck of the City of LaGrange, Engine No. 3, Ladder No. 1, is parked on Ridley Avenue. The home of Fire Chief Charles Corless is second from left, while the fire station is across the street, just out of view on the right. These houses, like many downtown residences, have been replaced with businesses. The history of LaGrange is dotted with dramatic fires, illustrating the need for well-trained firefighters. (Photograph by Stanley Hutchinson.)

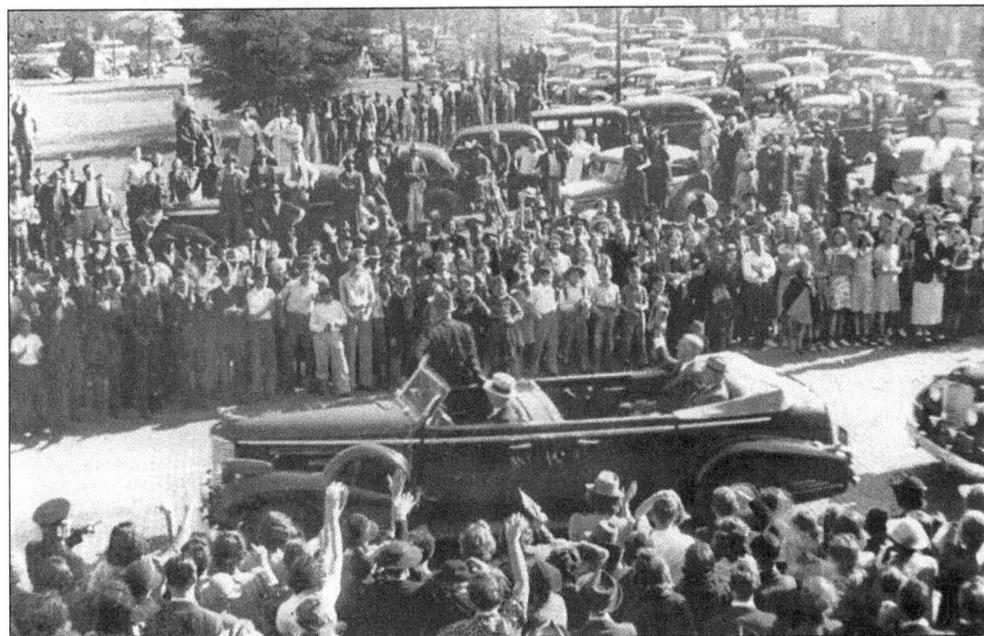

Franklin D. Roosevelt, a frequent visitor to Warm Springs between 1924 and 1945, waves to the crowd at the Square in LaGrange. Roosevelt came to Warm Springs seeking to improve his health after being stricken with polio in 1921. He felt the warm waters made a significant difference. He often drove through Troup County unannounced, tooting his horn, visiting, and waving. Sometimes advance notice of visits meant large crowds like this one gathered.

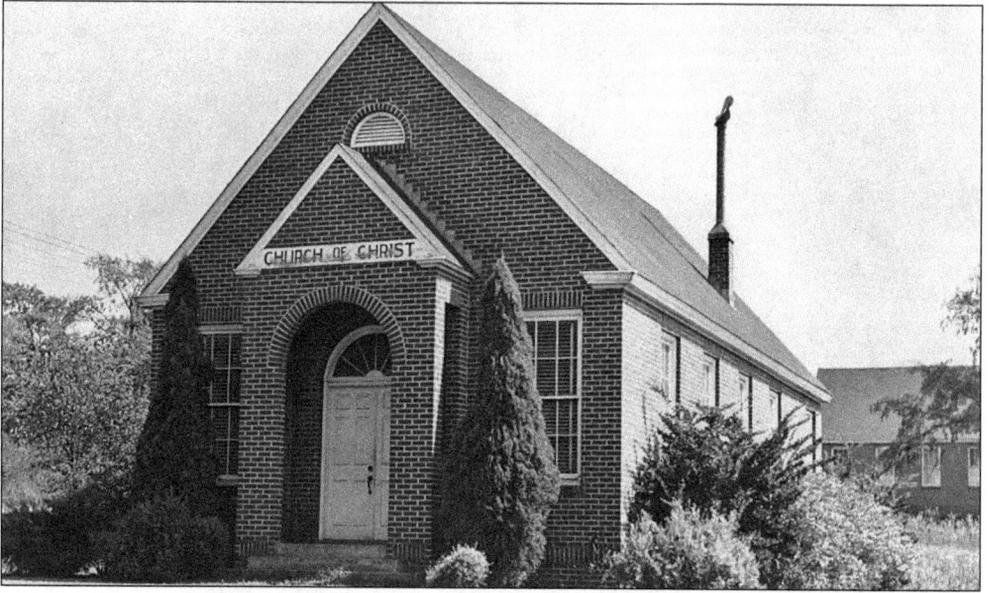

Murphy Avenue Church of Christ organized in the 1930s. The congregation continues to meet at this site on the corner of Fourth Avenue in a newer building. Churches such as this one are common in all sections of LaGrange. Churches in mill villages were encouraged and assisted by the textile mills, which sometimes provided buildings. For many years, Callaway Foundation, Inc., would match the building fund of any city church.

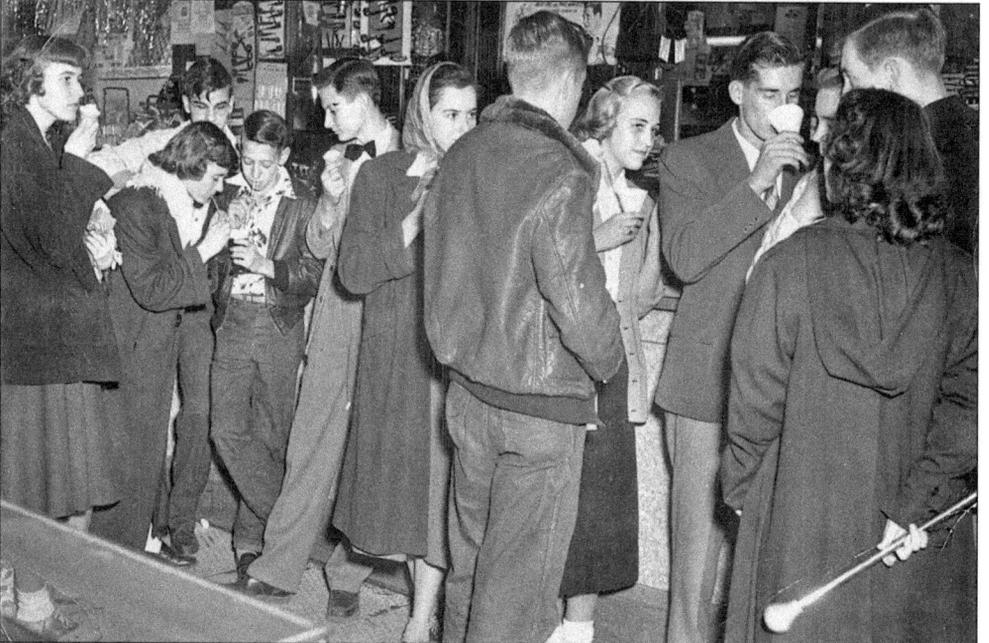

Typical of schools days in the post–World War II period of late 1940s and early 1950s, this LaGrange High group gathered at the old Holmes Pharmacy on East Court Square. Drugstore lunch counters and soda fountains were popular hangouts for teenagers. The fashion of the day is evident in the bobby socks and leather jackets. A couple on the left shares a milkshake with two straws. (Photograph made by Cosco Studio of Columbus, used with permission.)

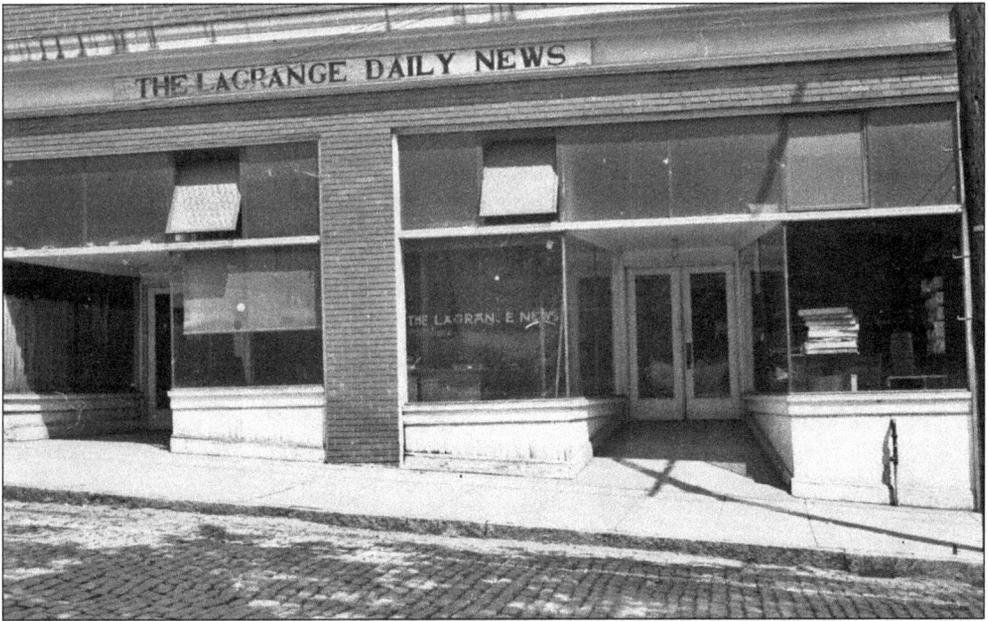

Through the years, buildings in Troup County periodically receive facelifts, as these two photographs clearly show. The building sat on the north side of Broome Street between Morgan and Main Streets. The older photograph above displays a typical commercial storefront appearance, while the 1941 renovation displays a decidedly Federal appearance and looks more like an office building. *LaGrange Daily News* had offices here from the early 1930s until 1957. In the renovated building, they shared space with the fledgling WLAG radio station. WLAG moved across the street in 1958 to their own building. The site is now part of the city parking deck completed in 2006 across from LaGrange Cinemas 10. *LaGrange Daily News* later moved into the old county jail building now occupied by the Chattahoochee Valley Art Museum. The *News* now calls a former bowling alley on Ashton Street home. (Both photographs by Stanley Hutchinson.)

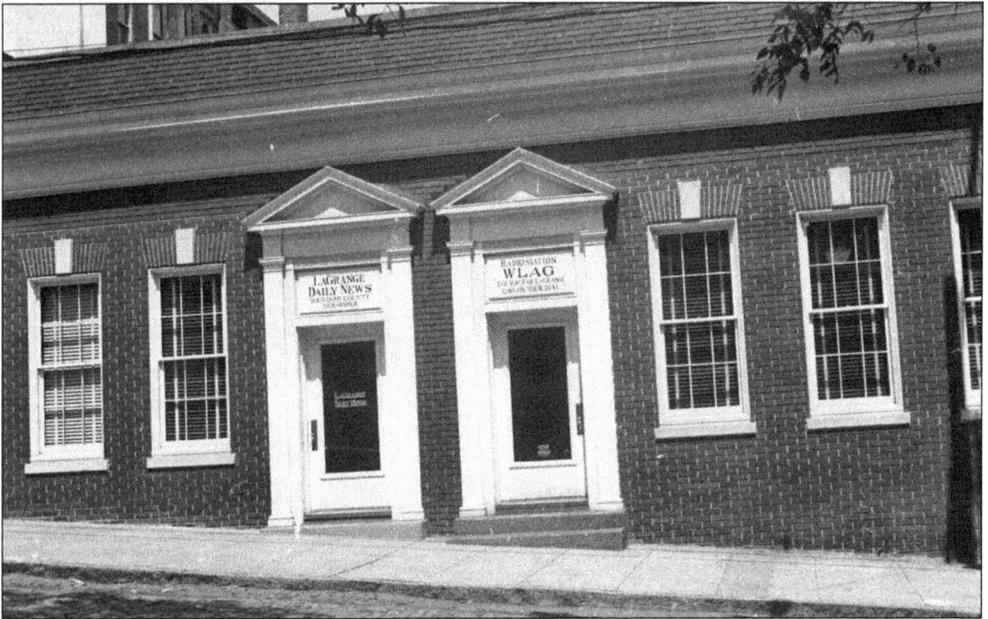

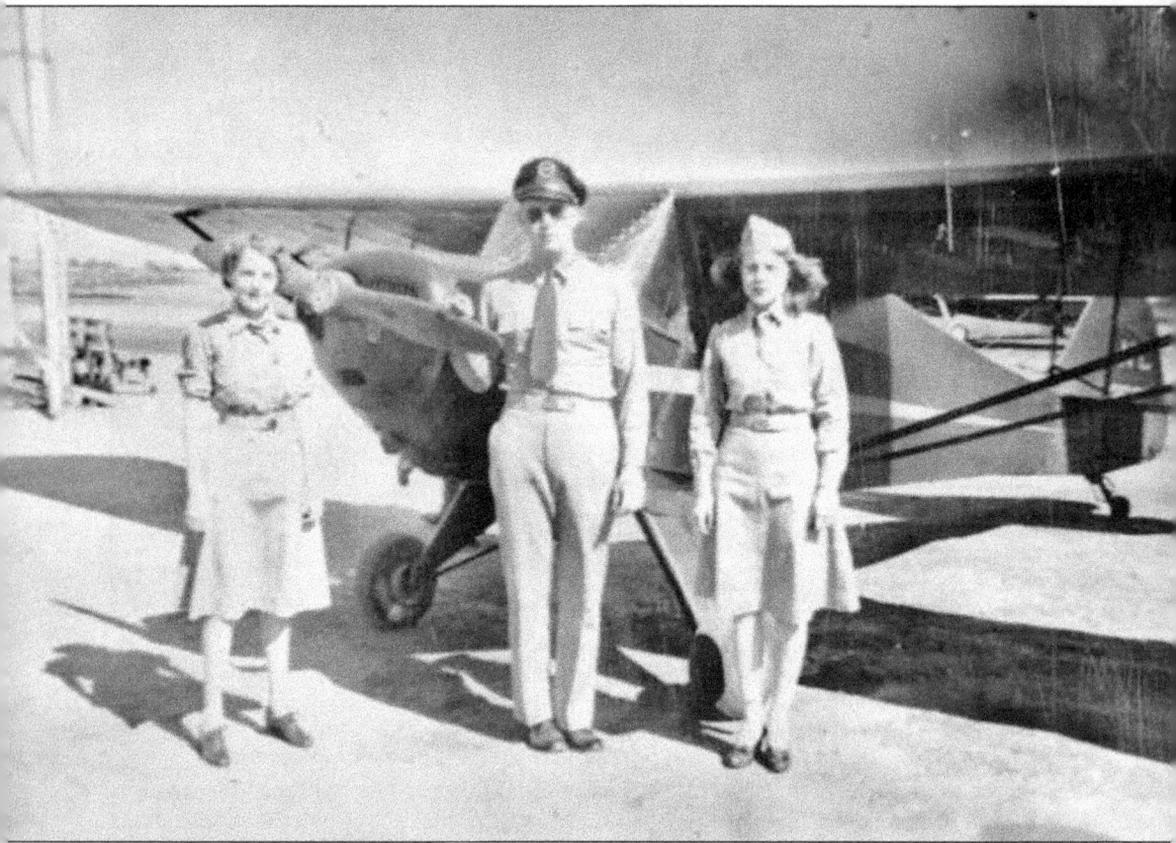

Throughout World War II, many Troup County women supported the war effort, including those who actually served in uniform for the United States. Some served at home while others were deployed in distant lands. Two sergeants in the local Civil Air Patrol are walking with an unidentified man, probably a pilot. Clyde Lovejoy (later Stevens) and Kittie Lashley Moon (right) escort him into Callaway Airport around 1943. (Georgia Archives, Vanishing Georgia Collection, TRP-24.)

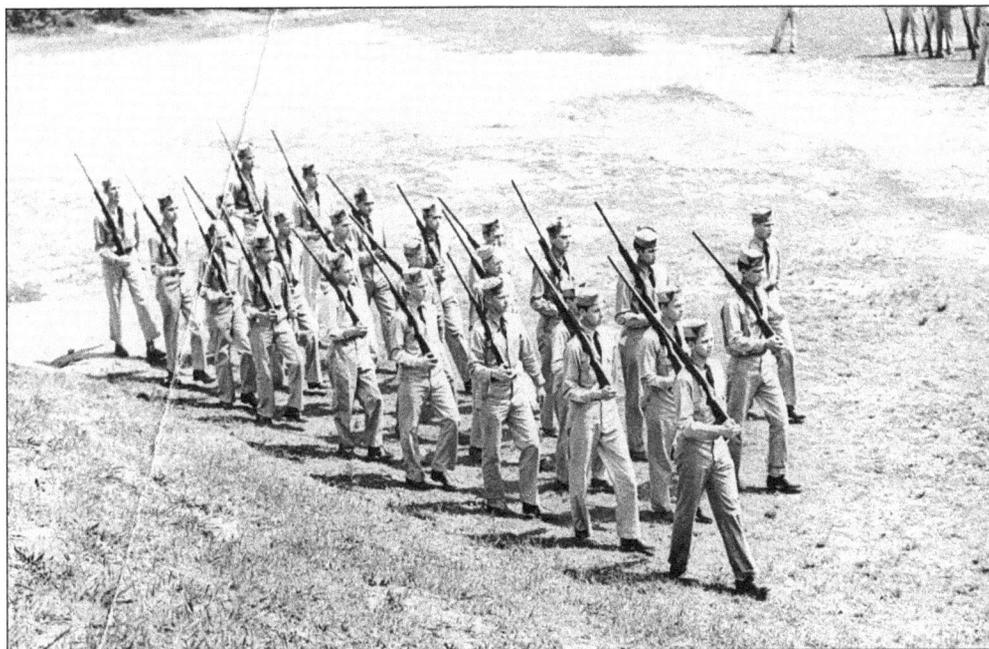

Members of the first platoon of the Victory Corps of West Point High School practiced their drills during the 1943–1944 school year. This is an example of how war efforts permeated every aspect of life. Men and boys throughout the county joined military groups, some of which were statewide organizations. Readiness involved drills such as this and encampments, including ones held on the grounds of Callaway Auditorium.

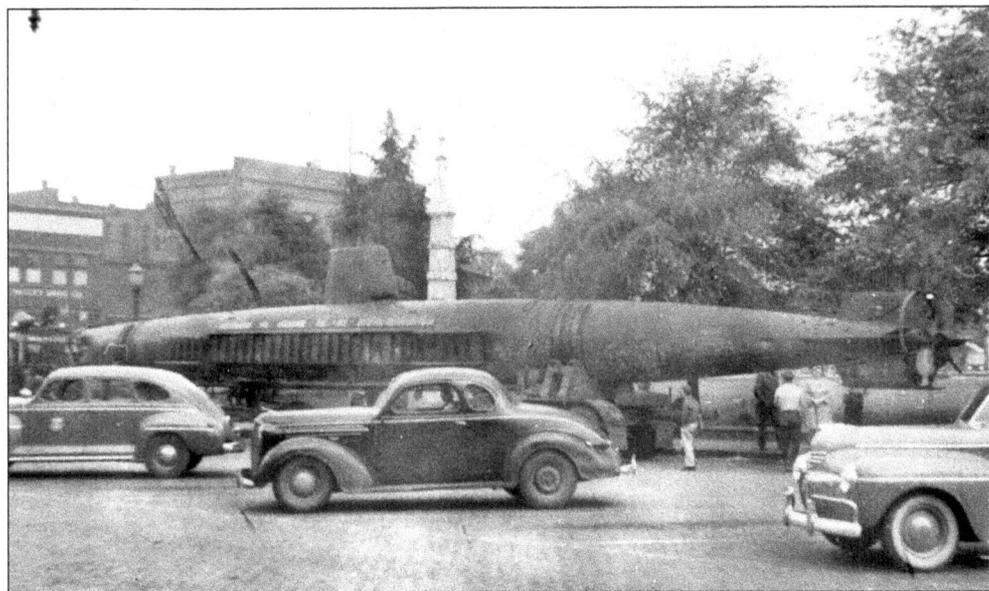

The soldier on Troup County's Confederate monument stands guard over a captured Japanese suicide submarine in 1948. The Navy Club of the USA, a veterans' organization, displayed it around the country. The Japanese navy used this type of submarine late in the war. The submarine had a 150-mile range and carried 1,900 pounds of explosives that would explode when it rammed a ship. People flocked to the Square to see it. (Photograph by Stanley Hutchinson.)

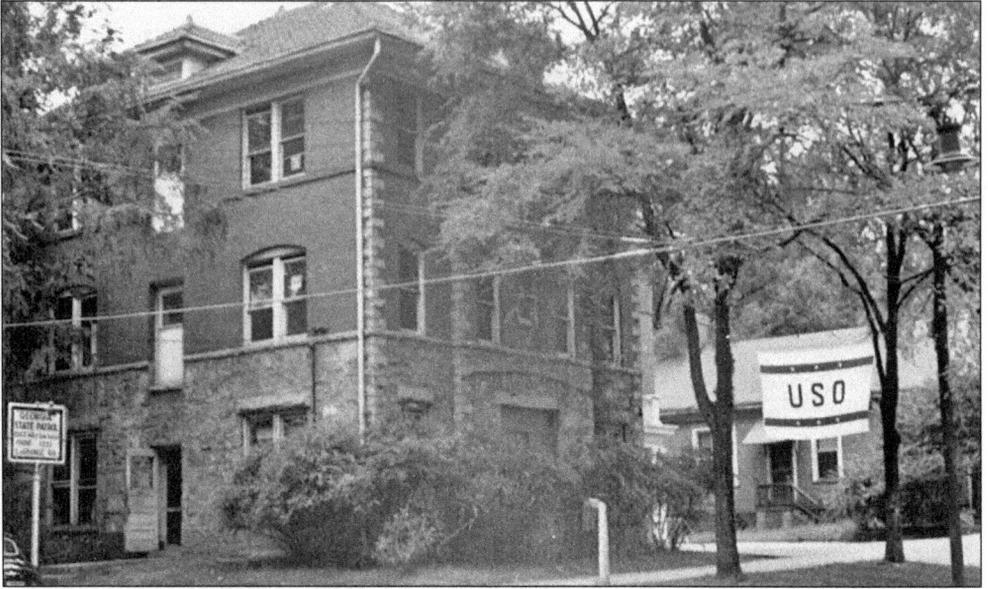

Constructed in 1902 as LaGrange Sanatorium, this building served as Dunson Hospital from 1916 until 1937. The building then housed the Georgia State Patrol and USO. The USO is a nonprofit organization that aims to improve morale among soldiers. The local USO entertained over 61,000 in 42 months. This building was demolished and a Greyhound bus station opened in 1948. The accounting firm of Gay and Joseph renovated and moved into the building in 1986. (Photograph by Stanley Hutchinson.)

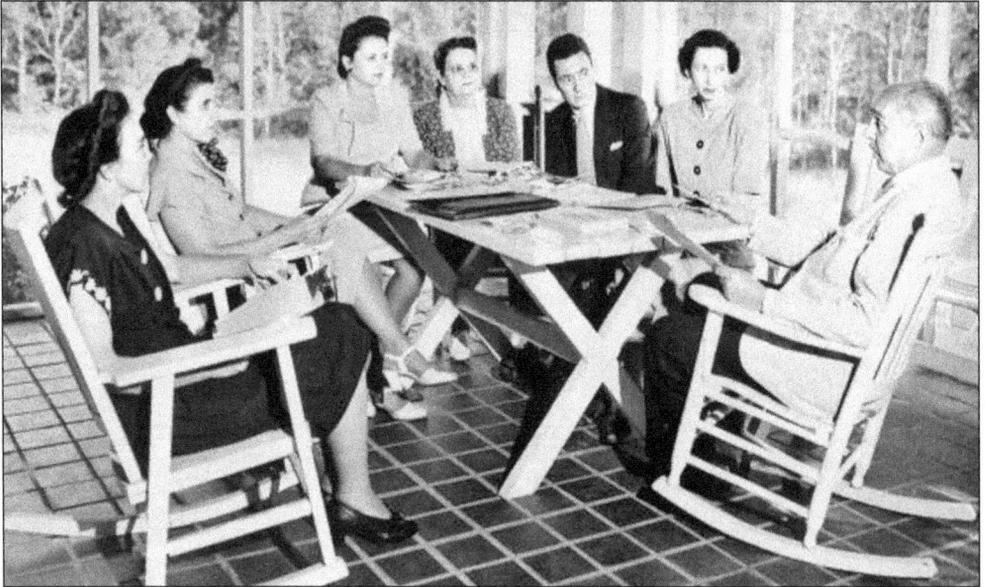

Executive secretaries with the West Point Service Center met with representatives from West Point Manufacturing Company and Lanett Bleachery and Dye Works. They discussed publication of the book *The Valley in World War II*. Dedicated to the memories of 72 Valley men who died in service, the book includes photographs and details the service of 3,515 Valley men and women. The volume also gives insight into life on the home front. (Photograph by Andre Kutesz. Courtesy of Georgia Archives, Vanishing Georgia Collection, TRP-98.)

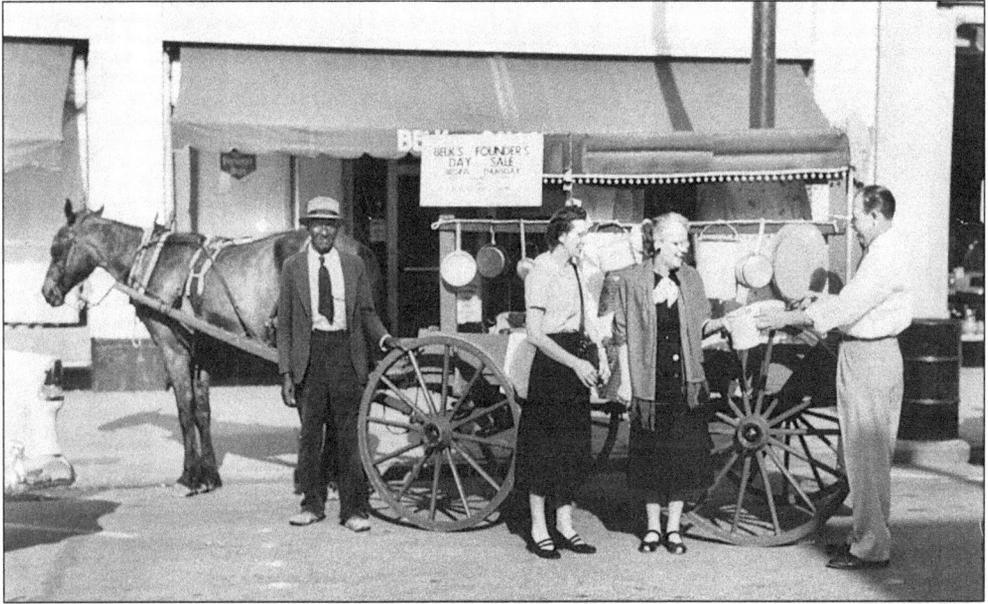

The war greatly affected transportation. Gas was rationed, and automotive parts and tires became almost impossible to purchase. Manufacturers stopped making cars. Some people reverted to using horses and wagons for business and recreation. Marvin Dommissee, a longtime employee of Belk-Gallant on Main Street in LaGrange, supervises a Founders Day Sale during World War II. They are re-creating the old-fashioned way of selling goods by mule and wagon, owned by the man on the left.

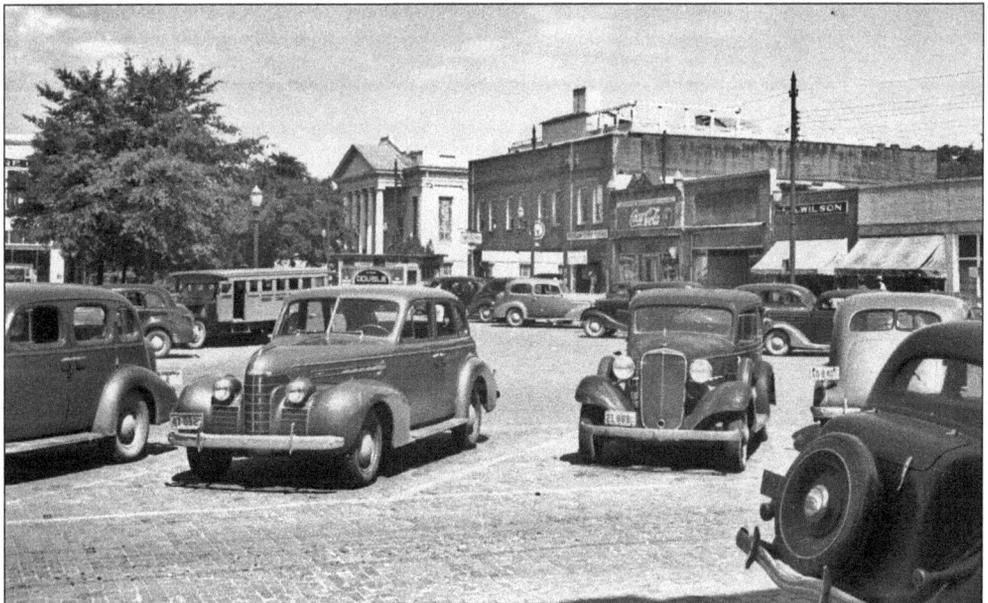

The Square in LaGrange has long been a center of activity. Photographer Stanley Hutchinson stands on the east side looking toward First Baptist Church about 1940. Cars were allowed to pull into spaces in the middle of the street. The center of the Square was a circle, beside which people could park. A photograph of this view today would be significantly different—cars, facades, and traffic patterns have changed.

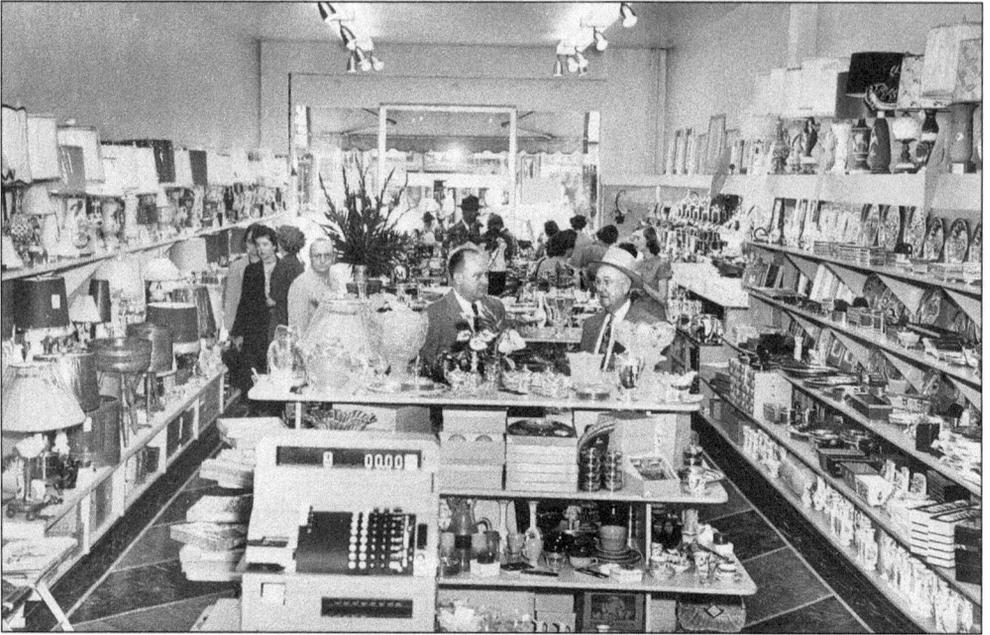

Jimmy Gallant, a local partner of Belk-Gallant Department Store, stands in the center of the store. The store opened on Main Street in 1935 and later expanded into a multi-story business that spread into several other buildings on Main and Bull Streets. Gallant served as mayor of LaGrange from 1962 to 1963. In 1976, Belk's moved from downtown and became an anchor at LaGrange's first mall, located near the newly constructed Interstate 85.

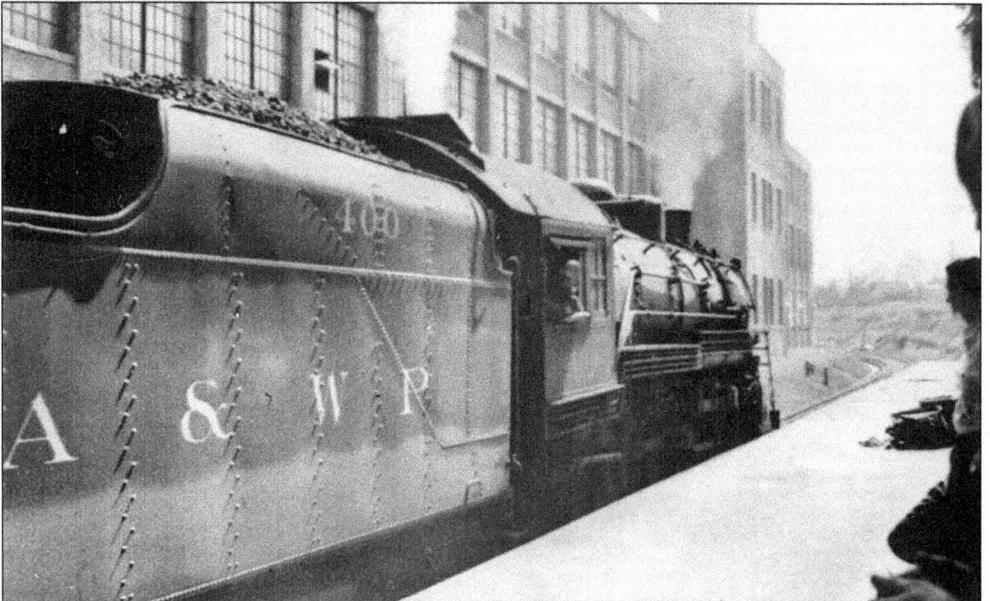

Steam rises from A&WP engine number 400 while stopped at the loading dock beside Stark Mill in Hogansville in the early 1940s. Judging by the level of coal visible in the fuel car, the train had recently been refueled. This must have been a freight train, since a passenger train would have stopped at the depot downtown. At this time, trains were still the nation's major way to transport raw materials and finished goods. (Photograph by Stanley Hutchinson.)

The junior class of West End High School in Hogansville chose "Come to the Cabaret" as the theme for their 1949 junior-senior prom. The elegantly dressed students are seated around tables, just as they would in a real cabaret. Ida Florine Tarver (later Jones) sits on the front left. A longtime teacher, she is active in community affairs. West End High School opened in the 1920s and merged with Hogansville High in 1970.

The West Point High School class of 1945 gathered for a formal class photograph. During this era, white dresses, bouquets of flowers, and boutonnieres were required for such occasions. The soldier at right is Jack Fletcher, who had missed his own graduation while away in service. W. T. Harrison, left, served as principal and superintendent of West Point School System. The black high school in West Point, Harrison High, was named in his honor.

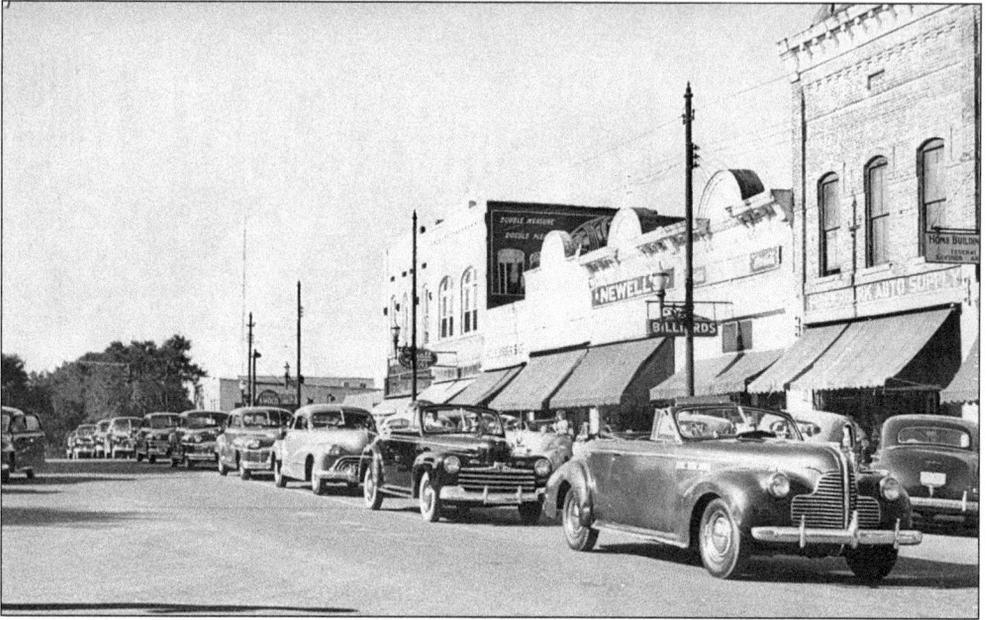

The Southern Peach Swimming and Diving Meet, held annually from 1947 to 1964, took place at Callaway Pool. In the photograph above, made in 1949, a motor parade crosses East Court Square to celebrate the opening of the competition. The Lions Club sponsored the meet, which drew competitors from around the country and included many local swimmers. This motorcade, if held today, would be traveling the wrong way on a one-way street. Swimmers below appear to be set and waiting for the official start of their freestyle race. Participants from Georgia, Alabama, Louisiana, Texas, Wisconsin, Florida, North Carolina, and Kentucky were among the winners. The pool is now part of Hudson Natatorium at LaGrange College, with indoor and outdoor swimming. (Above, photograph by Q. N. Johnson.)

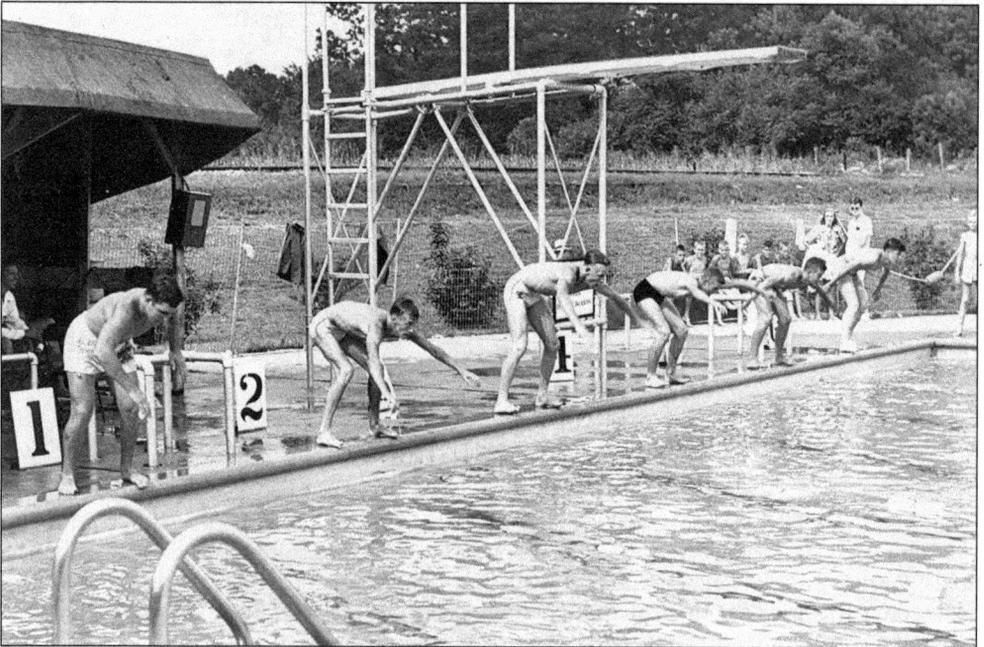

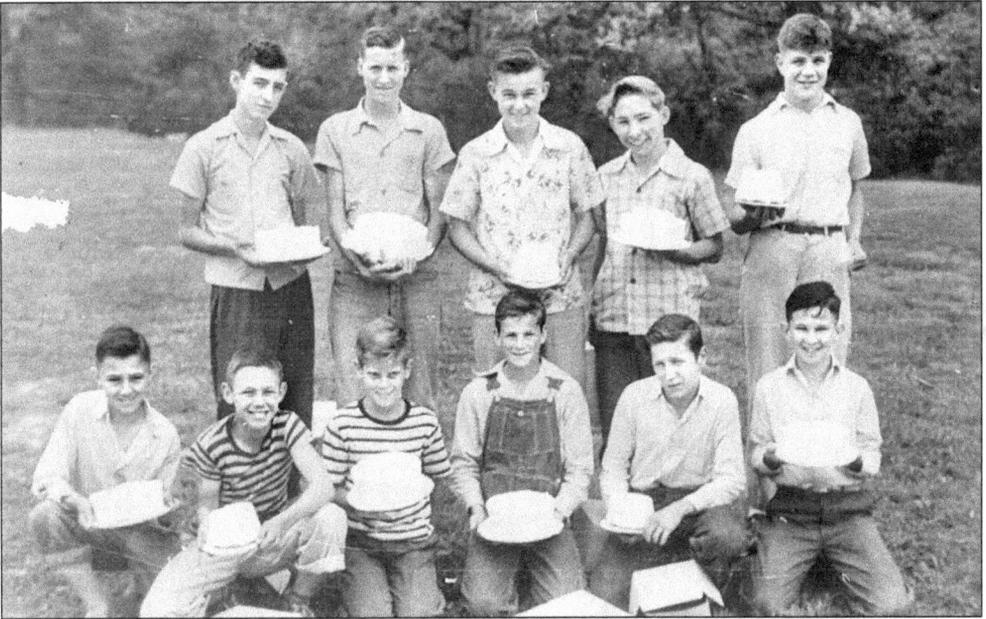

These boys are all smiles after winning athletic events in the Southwest LaGrange School cake races on April 21, 1947. Today students look forward to winning ribbons and medals at Field Day each spring, but in that era, winners received tangible and tasty rewards: beautifully decorated cakes. Events focused on foot races, such as the 100-yard dash. School athletic directors Dexter and Howard Shuford presented the trophy cakes.

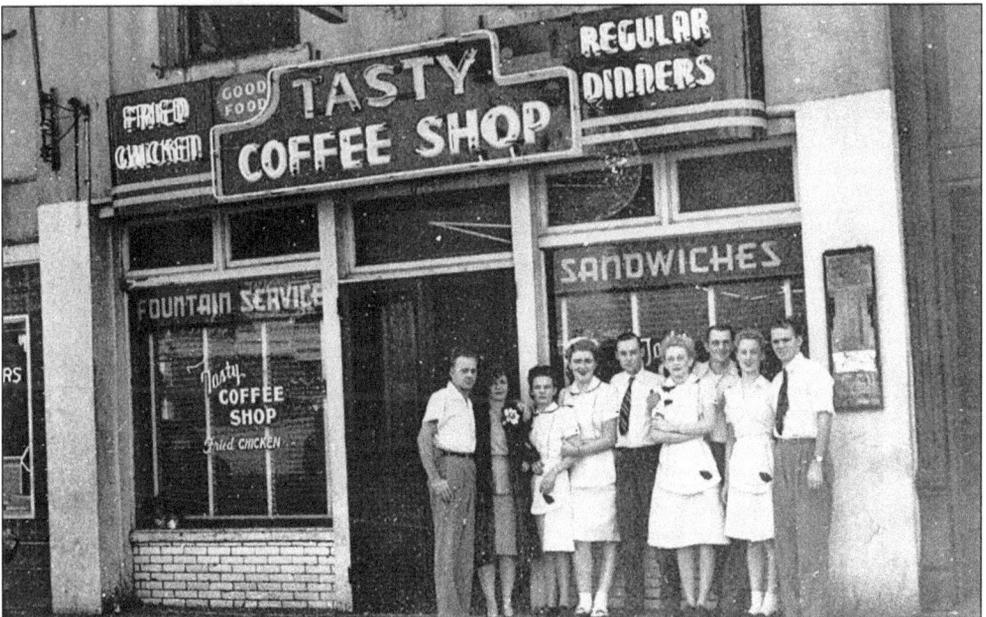

Tasty Coffee Shop served up everything from fast-food sandwiches to full meals and became a popular, long-lasting diner. Located on South Court Square, the eatery also had a sandwich shop on Main Street. The waitresses wore uniforms with heavily starched aprons and caps. Nearby Charlie Joseph's, founded in 1920 as a hotdog stand, gets the title as the longest-surviving restaurant in LaGrange. (Photograph by Stanley Hutchinson.)

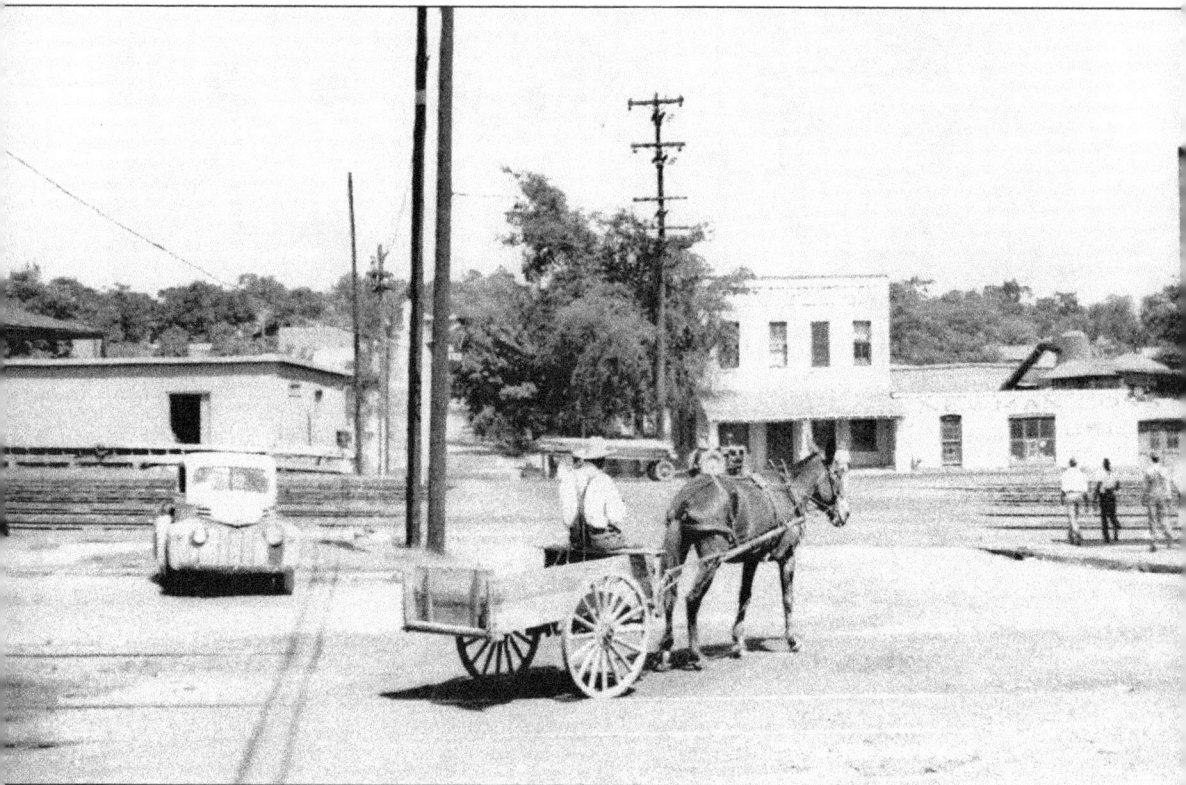

This photograph captures five modes of transportation. A mule pulls a homemade two-wheeled cart while a truck is parked nearby. In the background, on the other side of the railroad tracks, a tractor pulls a flatbed loaded with lumber. Pedestrians are walking past the covered platform of the A&WP passenger depot. They are all converging near Newman Construction Company, located on East Depot Street. (Photograph by Stanley Hutchinson.)

Six

BABY BOOM YEARS
1950–1979

At one time, most towns boasted having a semi-professional baseball team. One that called LaGrange home was the Troupers. Many of these players went on to other teams and leagues, including Ocky Walls, who played for other professional teams. The president of this club, Oliver Hunnicutt, on the left in suit and tie, became a legendary football coach at LaGrange High. He later served as athletic director, and a street in front of the high school bears his name.

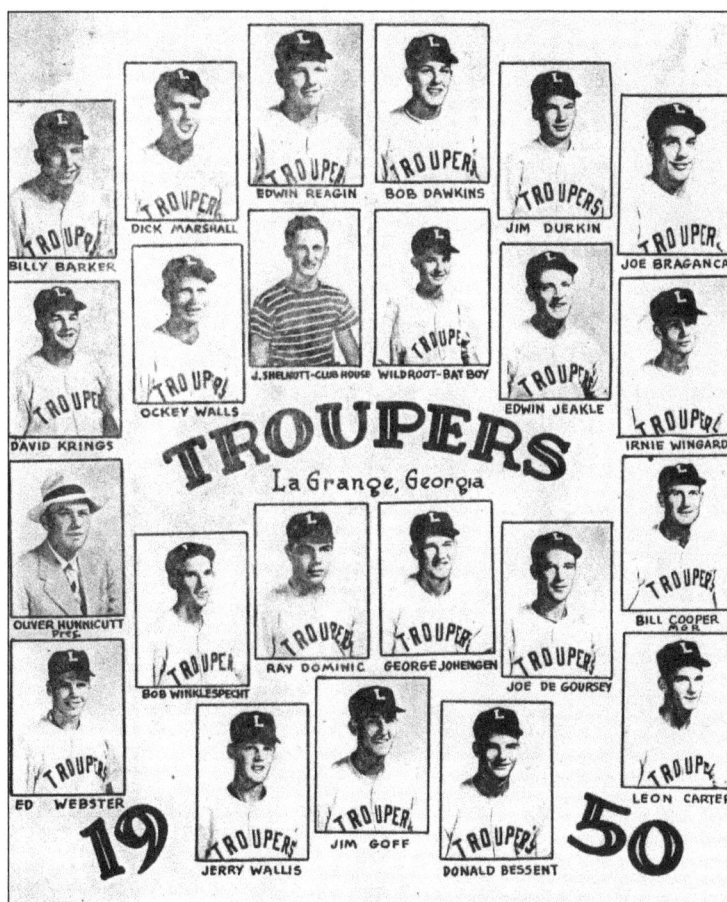

Buildings at Gray Hill typify county schools of the 1950s. Most had brick buildings for the elementary school and wooden gyms from the days when they were a high school. The gyms were built as part of various 1930s New Deal programs. In 1955–1956, Gray Hill High School became part of the new Troup High School. Gray Hill Elementary later merged into Long Cane in 1988. The brick building serves as a community center.

First Baptist Church on the Square presented Thomas Goldwire Polhill a silver service and gave his wife, Mary Park Polhill, a bouquet of roses in 1951. The gift honored his retirement after many years as the Sunday school superintendent. When he died in 1958, Mrs. Polhill, a Sunday school teacher at First Methodist Church, returned the service to the Baptists. He also headed the county school system from 1921 to 1929.

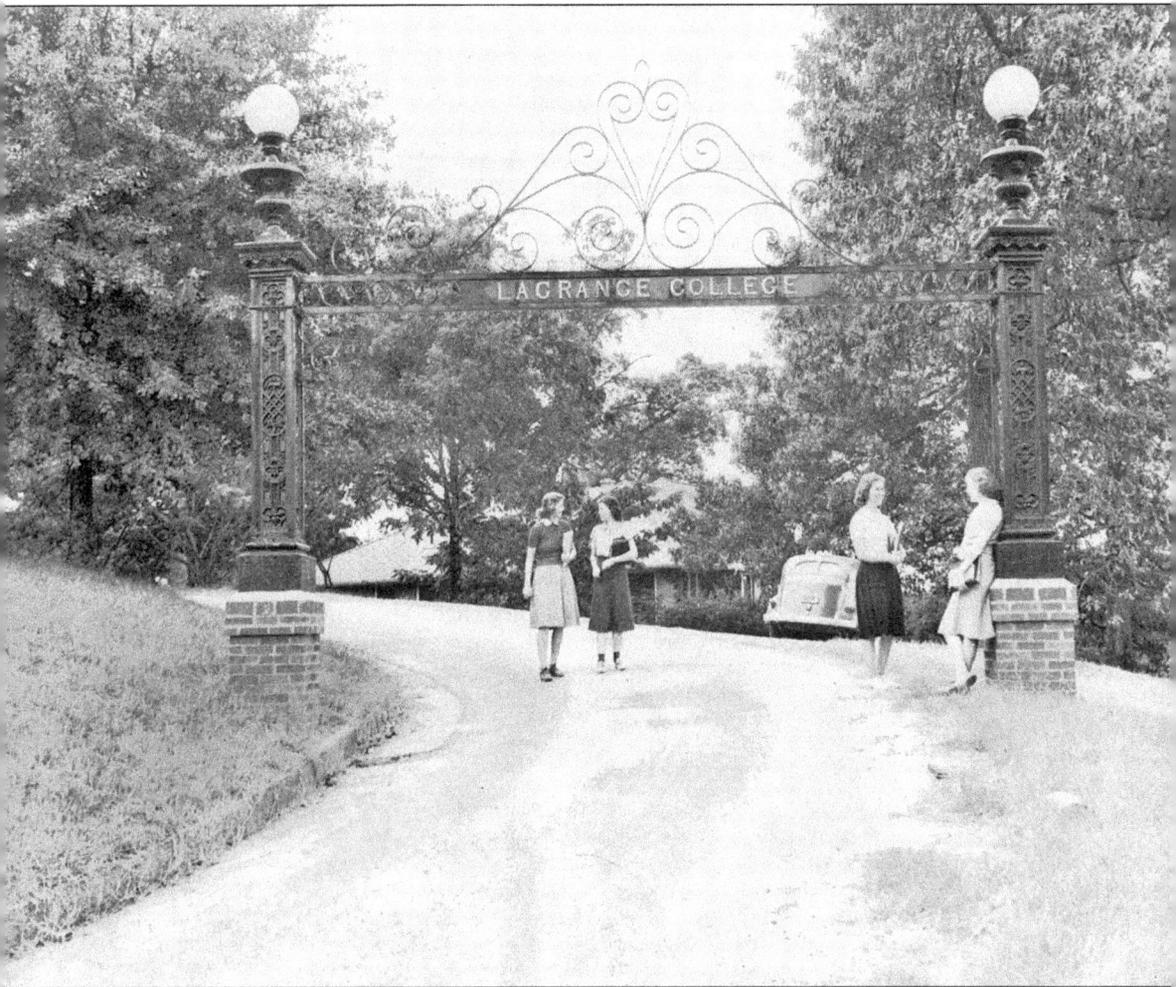

For many years, this archway spanned the main entrance to LaGrange College on Broad Street. The side posts of the arch date from the 1850s and stood where Ben Hill Street now enters Broad. Originally these posts supported the gates for the driveway up to Bellevue, the home of Mr. and Mrs. Benjamin Harvey Hill. The archway now stands near the college chapel, providing a pedestrian entry from Park Avenue.

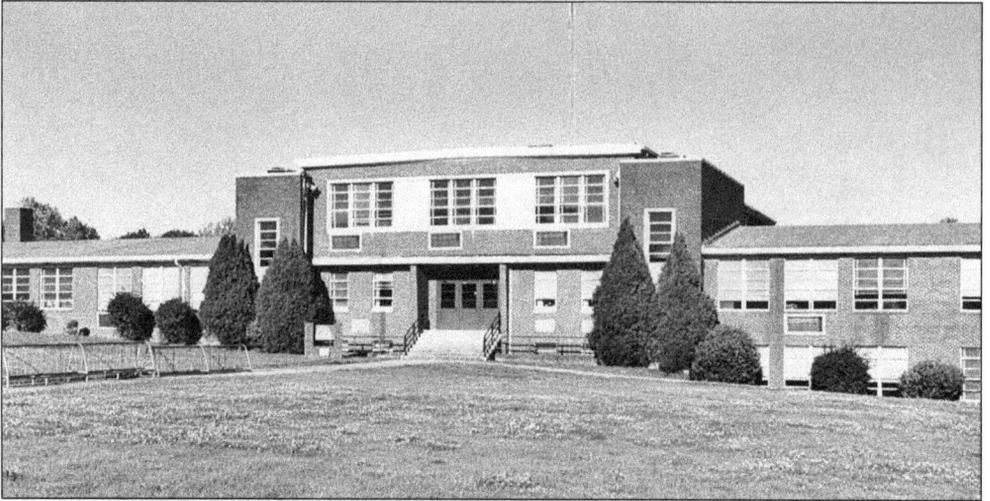

The new building of East Depot High School and Elementary opened in 1951. Other structures included an elementary wing, gymnasium, and football stadium, home of the East Depot Wolverines. In 1970, with the coming of integration, East Depot High School merged with LaGrange High School and the building became LaGrange Boys Junior High. The campus, including the gym and part of the high school building, are now part of Twin Cedars Youth Services.

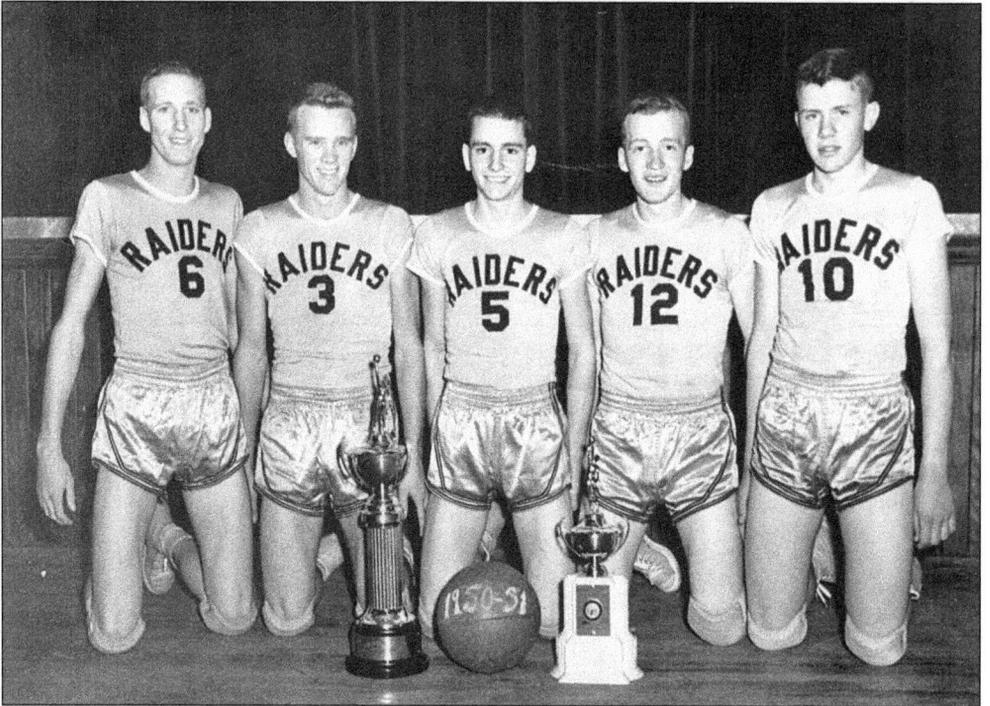

Five members of the Rosemont High varsity basketball team pose with trophies won during the 1950–1951 season. The Raiders had a reputation for consistently producing championship teams. Team members are, from left to right, Bobby Pitts, Murphy McManus, Worth Freeman, Terrell Allen, and Charles Hunt. Hunt later served as chairman of the Troup County Board of Education. Wholesale grocer Hiram Reeves coached this team and later served as a recruiter for LaGrange College and Auburn.

90

The Korean War, which lasted from 1950 to 1953, drew many soldiers from West Georgia. Charlie Jones, shown at a supply depot in Taegu, Korea, served in the army. He stands with South Korean contract workers loading supplies in June 1951. Another LaGrange native, Adm. Albert E. Jarrell, was one of the negotiators at Panmunjon, where the armistice was enacted. In all, 23 Troup County soldiers gave their lives in the war.

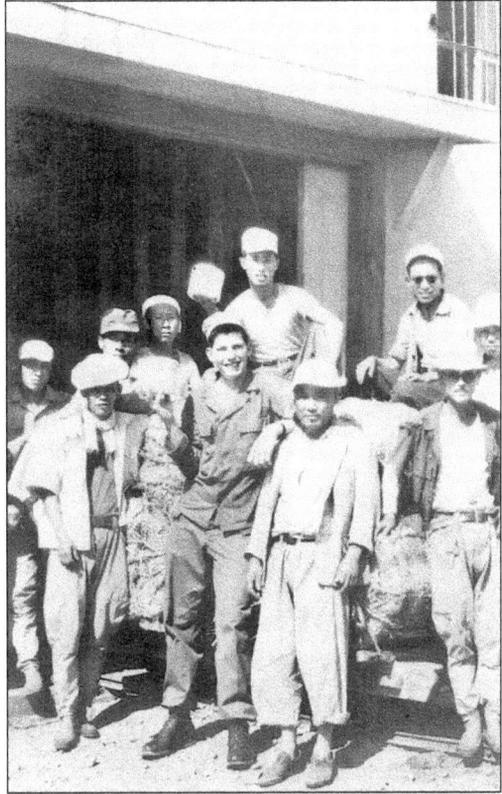

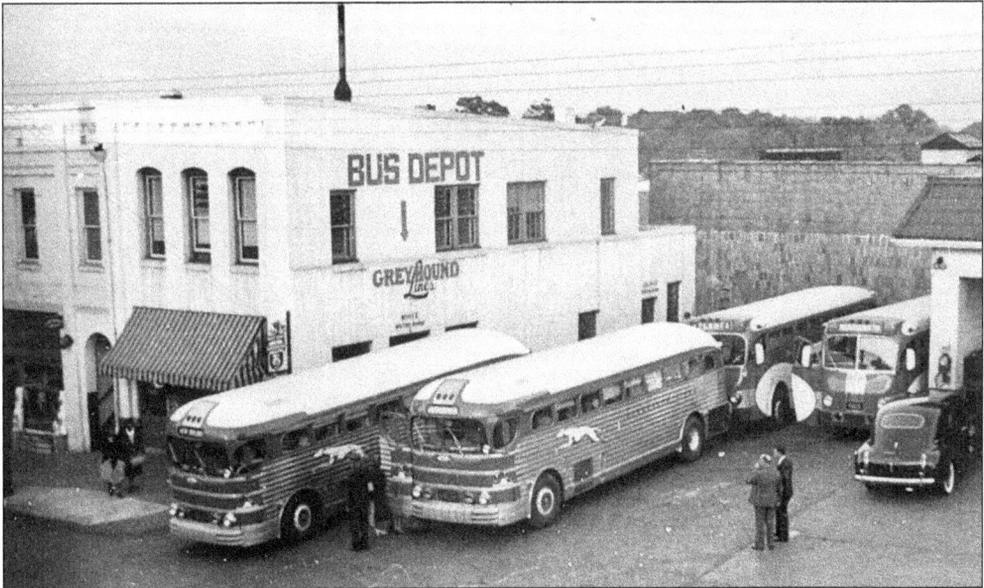

The Greyhound Bus Station opened in LaGrange on Ridley Avenue in 1936. Stanley Hutchinson made this photograph in 1947 or 1948, just before the terminal moved to Church Street in 1948. Prior to the opening of the Ridley Avenue depot, passengers could buy tickets in a local restaurant, and the bus would stop nearby. These buildings were razed in the mid-1970s for a parking lot. This site is now occupied by the Troup County Government Center.

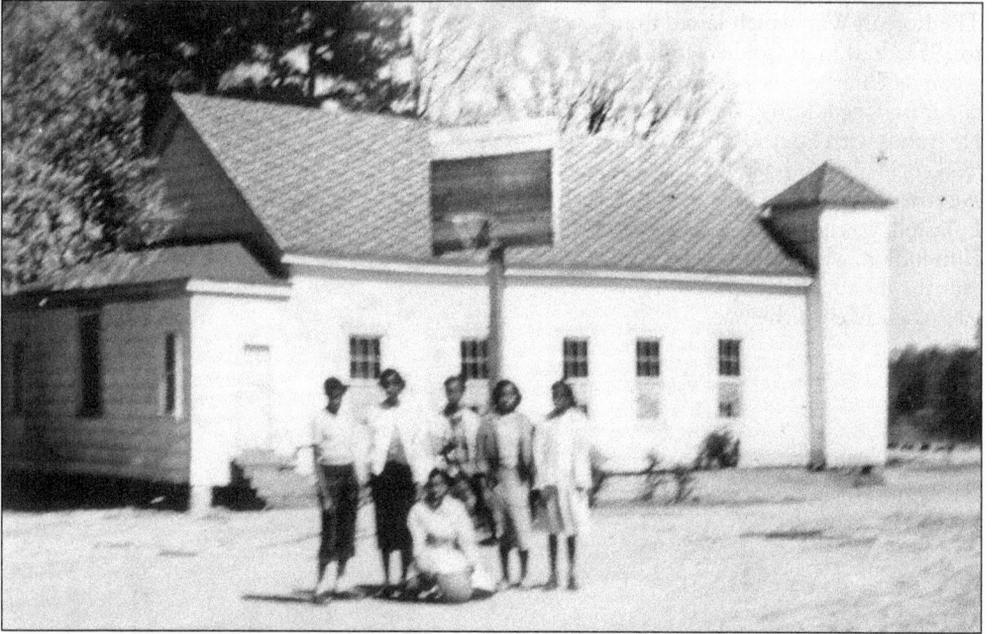

From the earliest days of the county, schools often used church buildings for their classrooms. A few students from the school at Mount Beulah Baptist Church at Lee's Crossing gathered in the churchyard. In 1955, Mount Beulah became the consolidated black school for Troup County. Students of all grades attended the school. Shortly after opening, the name was changed to Ethel Kight, honoring the longtime educator.

Called "LaGrange Negro Library," this building on Union Street opened in 1954, when this photograph was made. Funded by the Callaway Community Foundation, this later became part of the public library system as Union Street Library and finally Ethel Kight Library. The building is now used as a resource center by 100 Black Men of West Georgia. Prominent local civic leader Laura Lewis began her long career as a librarian here.

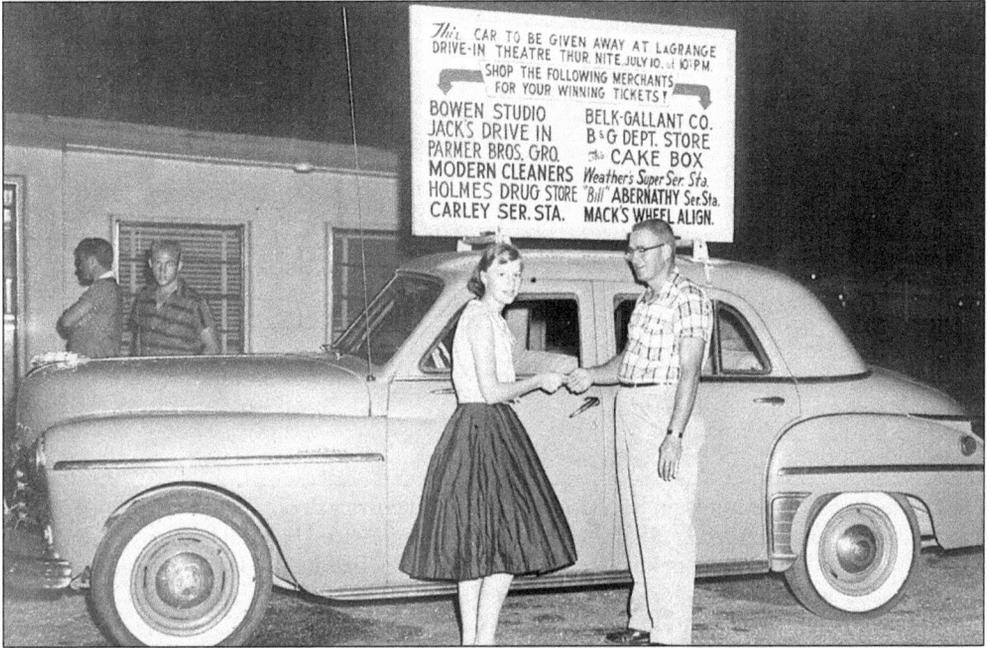

LaGrange Drive-In Theater operated on New Airport Road from 1949 to 1983. Drive-ins were at their height of popularity across America during this era. Mom and Dad could load pajama-clad children in the car ready for bed. Most nights, admission was charged by the person, thus leading some teenagers to hide friends in their trunk until parked. The entertainment usually started with cartoons. Special promotions and gimmicks, such as the car giveaway above in the summer of 1958, helped draw crowds. The car was a 1949 Plymouth. Concession stands were the big moneymakers at the theater. Below, the lady behind the counter serves a group of customers while decked out in pearls. A common problem for theater owners was people forgetting to remove the speaker from their car window when they got ready to drive away.

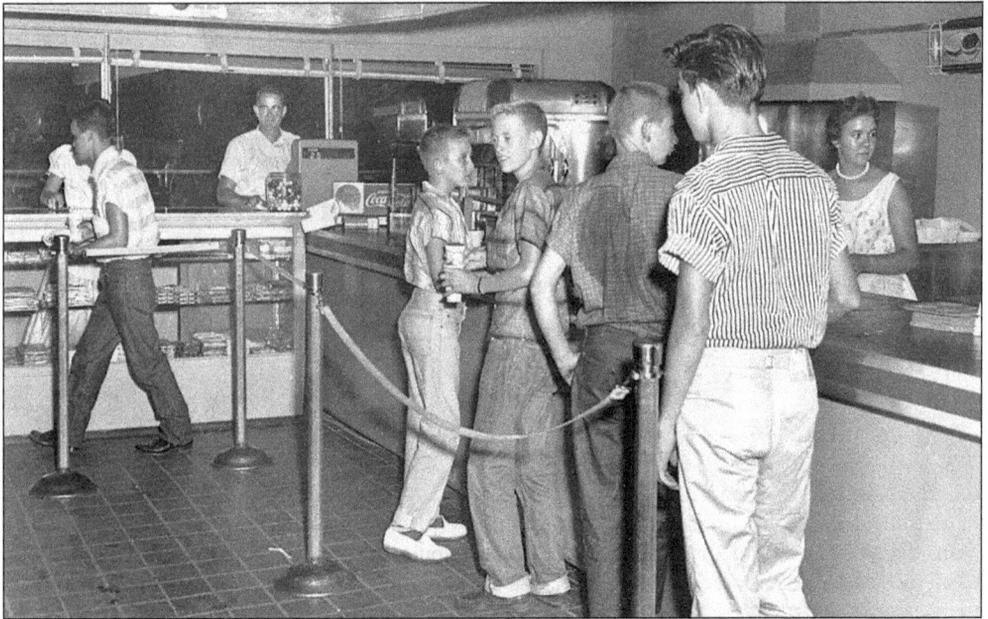

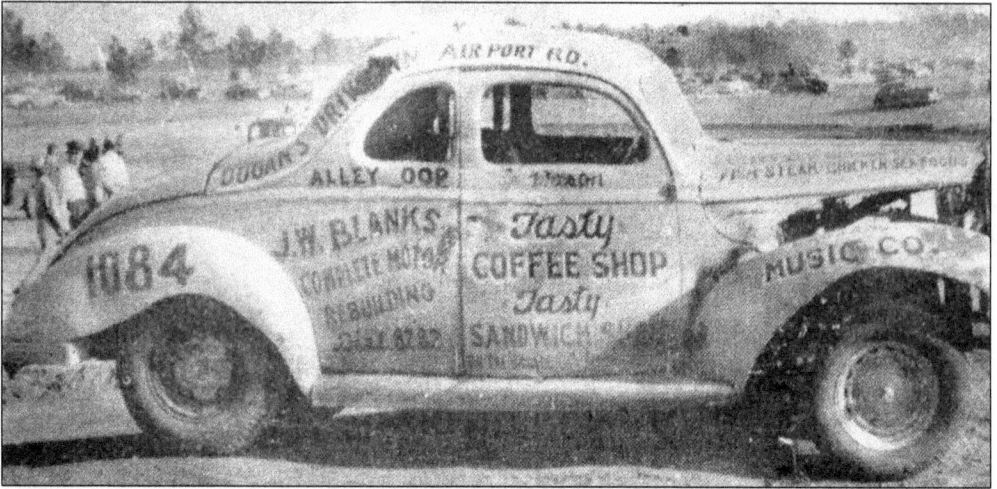

LaGrange Speedway operated on Racetrack Road, just off Bartley Road. This photograph from the speedway program on April 15, 1951, features a race car sponsored by local businesses. Car 1084, driven by Millard Mason, promoted Tasty Coffee Shop, J. S. Blanks Garage, Dugan's Drive-In on Airport Road, and a music company. The car is a 1939 or 1940 Ford with a flathead V-8 engine. The track closed in 1959.

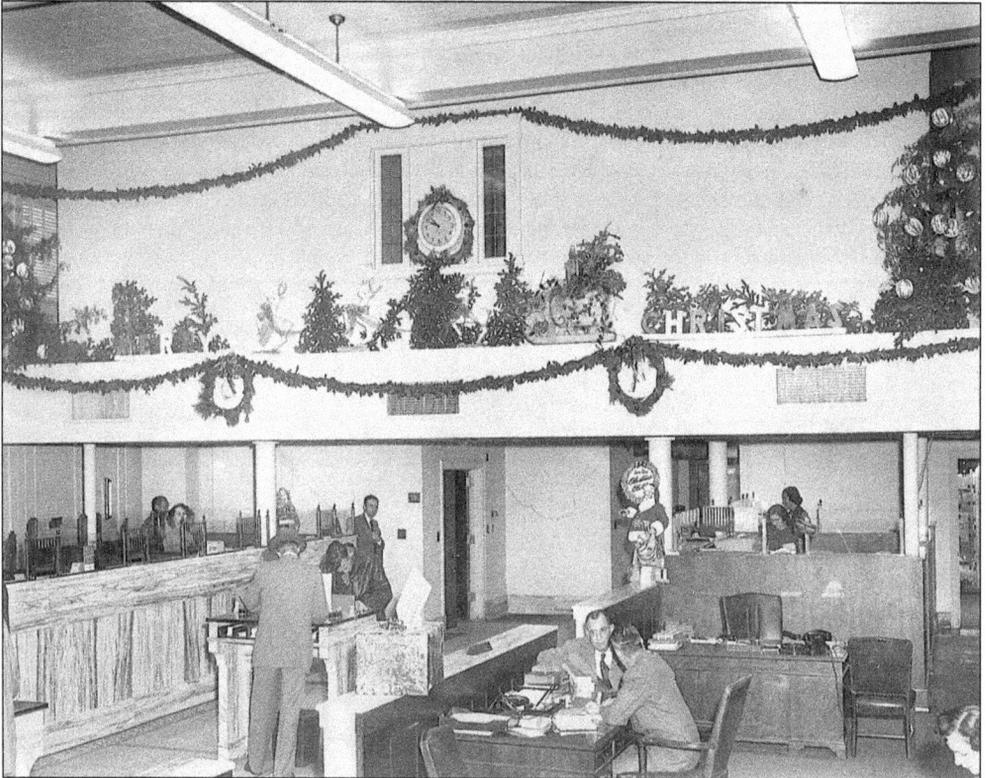

Christmas decorations brightened the interior of Citizens and Southern Bank (C&S) at 136 Main Street in LaGrange in 1955. Built in 1917, the building served as a bank until 1968, when C&S moved across Broome Street. The Santa Claus sign in the background reminds customers to open next year's Christmas Club account, thus encouraging them to save for gift giving.

Mary Will Cleaveland began playing the organ for First Methodist Church in 1898 as a teenager. She continued after marrying local attorney A. H. Thompson until retiring in 1959. She died in 1977. The pipe organ she is playing is a Moeller Organ given to the church in 1918 by Mamie Dunson. The church's 1980 Shantz Organ, which was recently renovated and enlarged, included many pipes from the Moeller.

Lewis Render converted one of Southern Female College buildings into the Render Apartments in 1919 following commencement and the school's closing. Render had been a major benefactor during the college's last years. As one of the few rental units in town, the apartments were highly sought after. Located on the corner of Smith and Church Streets, the apartments were razed in 1962 to make way for a post office. (Photograph by J. Hugh Campbell.)

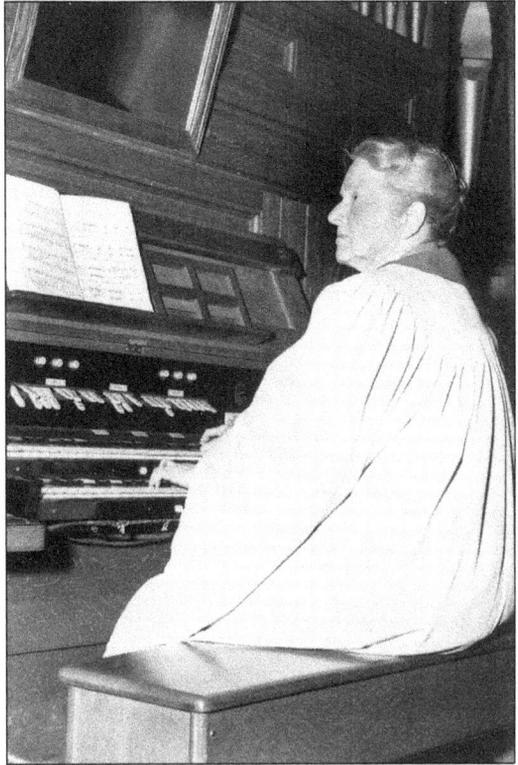

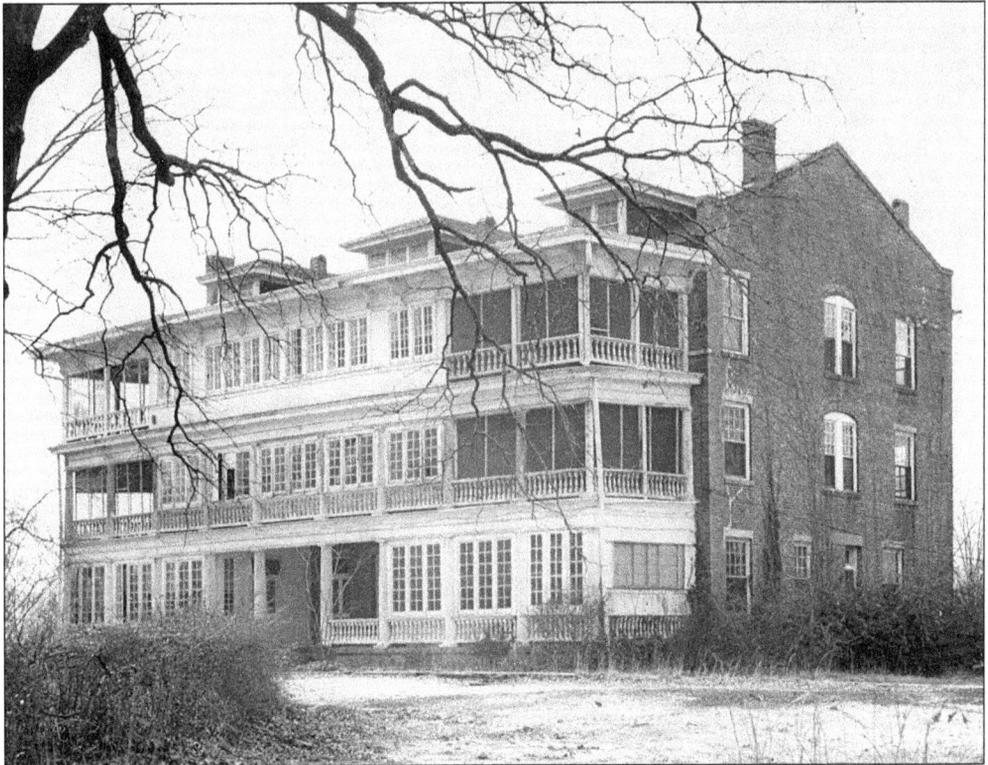

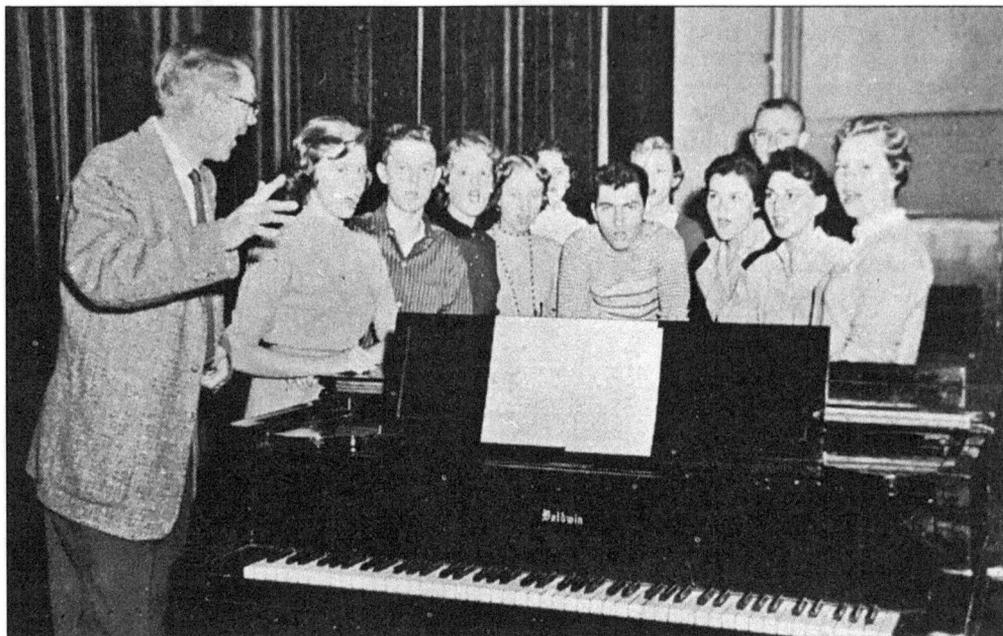

William J. Deal directed the music program at LaGrange High School from 1946 to 1968. He led the chorus, marching band, and concert band, earning much statewide recognition. The group seen here sang for the National Education Association meeting of school superintendents held at Callaway Gardens in 1957. Deal and his wife, Matsy, also a school music teacher, preserved the old Jackson Home on Cameron Mill Road for many years.

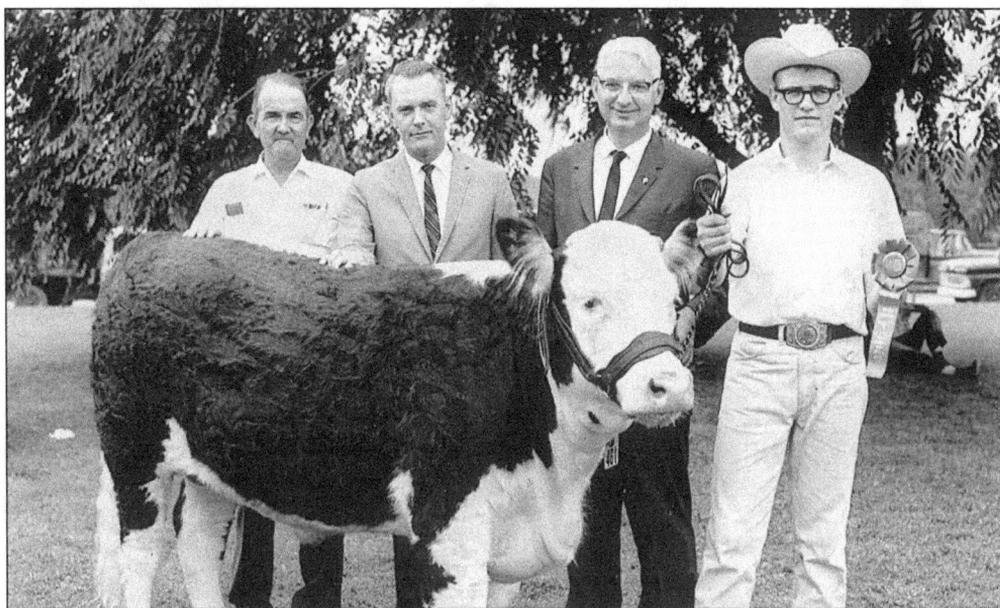

Each year, the Cattleman's Association sponsored the Future Farmers of America Cattle Show. Citizens and Southern Bank purchased the prize-winning steer. Bank board member Buck Birdsong (second from left) and bank president Woodrow Smith (second from right) are in the center; the man on the left and the winning student are unidentified. The steers are judged on the amount of weight gained in a specific time, straightness of their back, grooming, and other things.

96

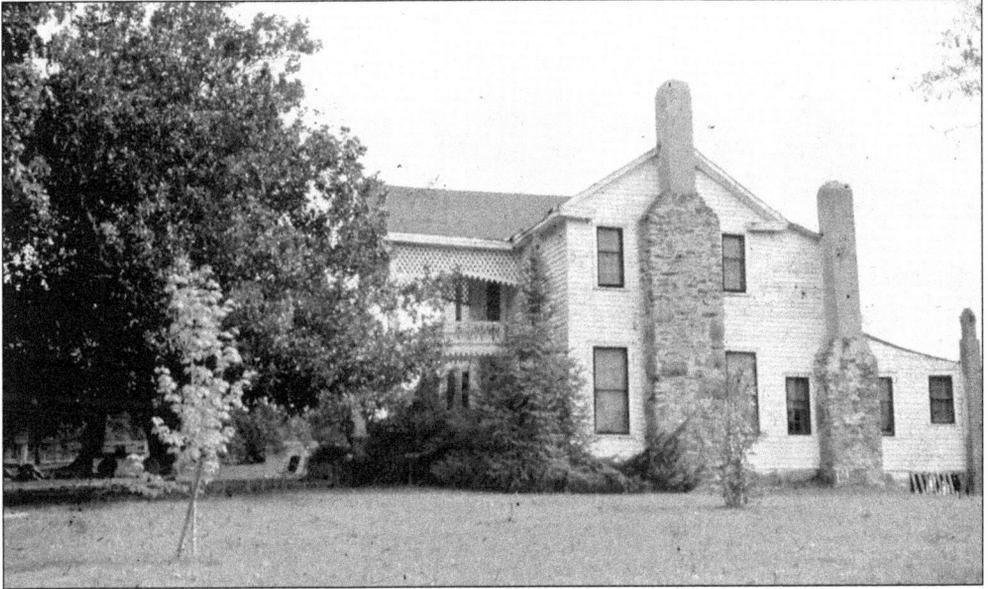

This 1962 side view of the Robert Floyd home in the Salem community illustrates changes that occurred to the house over time. The tall chimney at left served the original two-rooms-up-and-two-down structure. The middle chimney served the original one-story addition across the back, which has been given a second story. The last chimney helped heat what was probably an enclosed porch. Such expansions of old homes were common as families grew. (Photograph by Katherine Hyde Greene.)

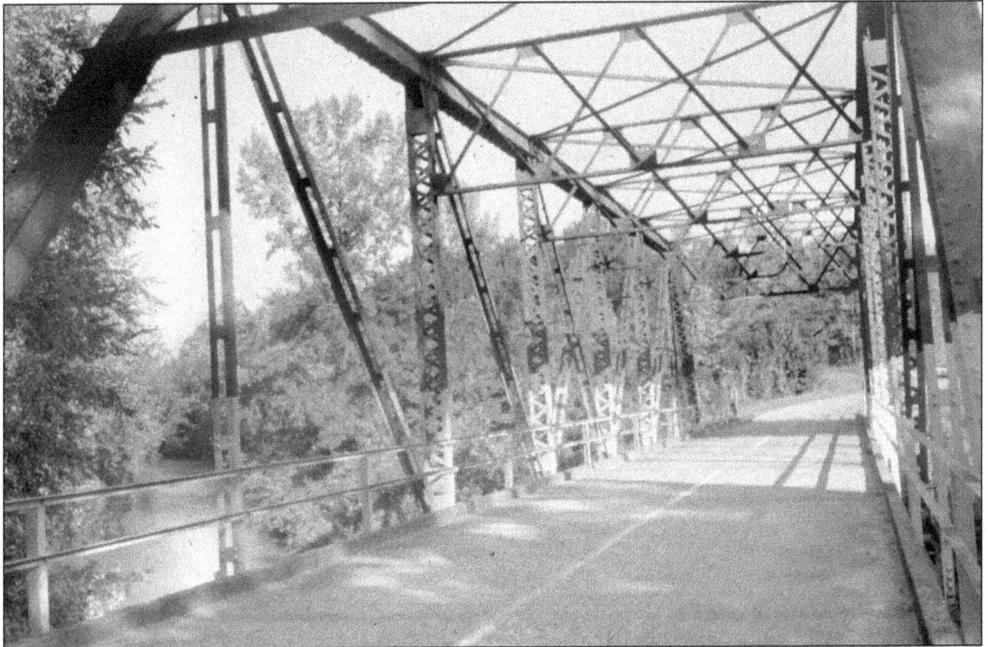

Photographer Katherine Hyde Greene made this photograph of the Iron Bridge on Salem Road in 1964 in the southern part of Troup County. Considered old-fashioned today, the bridge was the height of technology when constructed in 1908 over Pole Cat Creek. The bridge is a very popular local landmark.

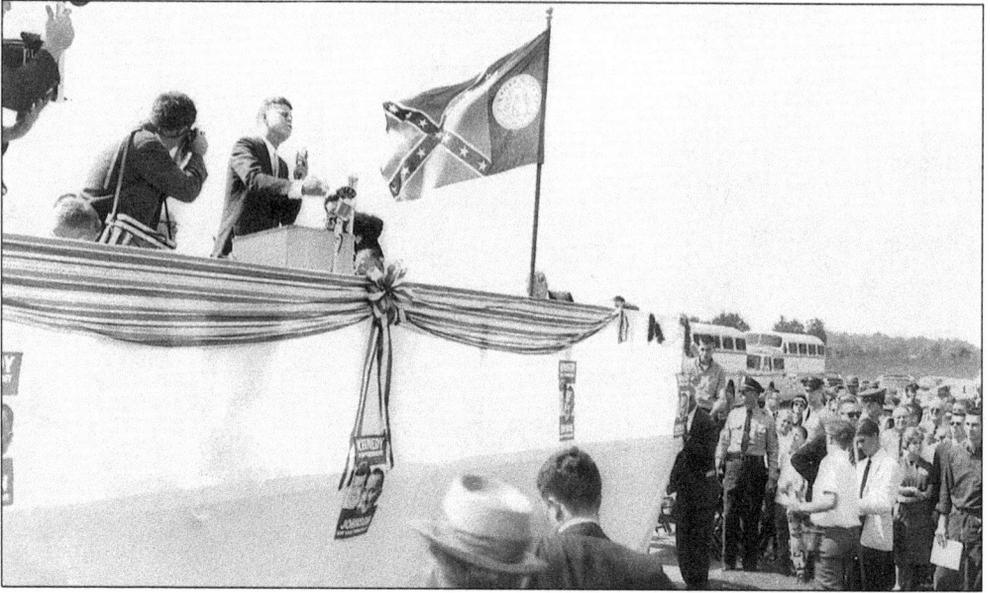

Democratic presidential candidate John F. Kennedy speaks at Callaway Airport on October 10, 1960, just a few days before winning the general election. He traveled by motorcade from Warm Springs through the streets of LaGrange and flew out of the airport. The schools took their students to line the streets to wave at the candidate. Many Democratic candidates visit Warm Springs and West Georgia due to the connection with Pres. Franklin D. Roosevelt. (Photograph by Earl Bowen.)

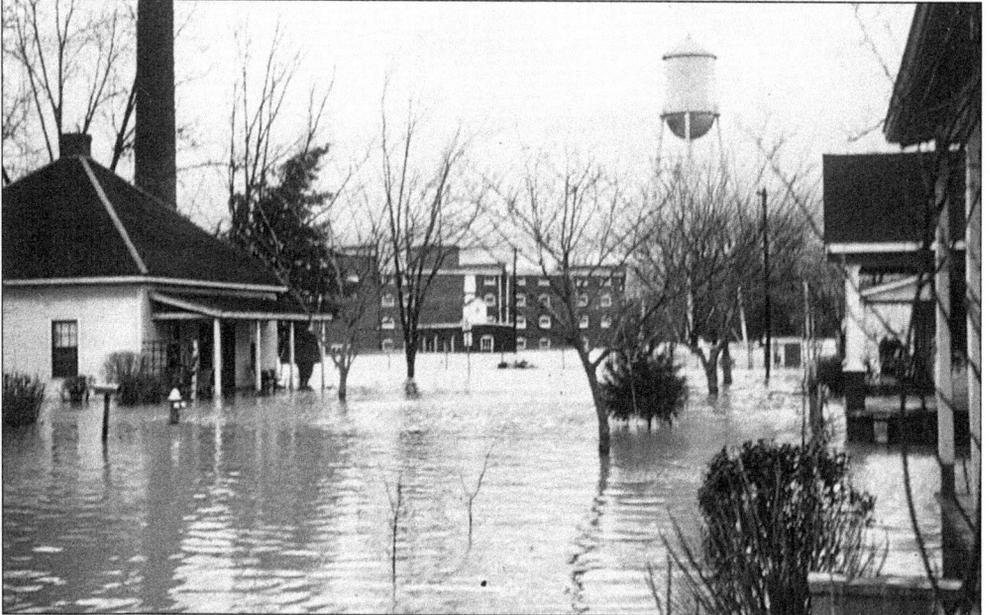

Floods in Troup County are generally associated with West Point on the Chattahoochee River. This 1961 scene in Hogansville dramatically illustrates that floods have occurred elsewhere in the county. Several feet of water from Yellow Jacket Creek rose up into the houses of International Street. Reid Mill, often called the old mill, stands in the background. Covered bridges and gristmills throughout the county have periodically been victims of floods.

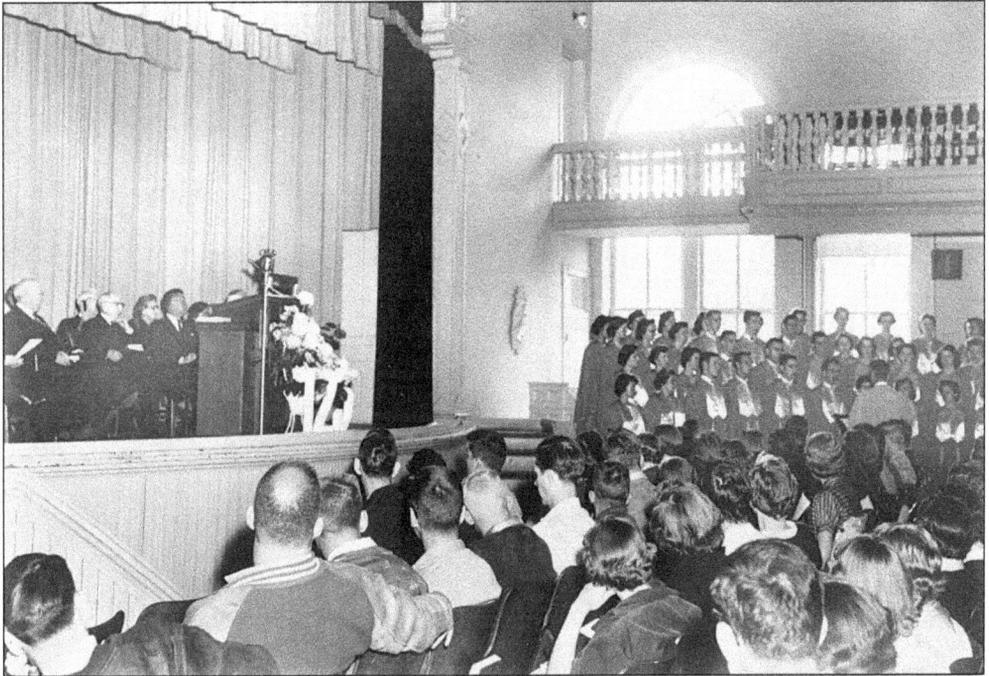

The grace and grandeur of Dobbs Auditorium is clearly evident in this photograph of a LaGrange College graduation c. 1955. Originally billed as "the largest auditorium south of the Potomac," Dobbs opened in 1877. Construction began in 1860, after an earlier building burned, but took 17 years to complete because of a series of setbacks, including the hardships of the Civil War. Concerts, plays, and recitals all took place in Dobbs. Then on Friday evening, November 20, 1970, the entire building burned, leaving only a shell. The cause of the fire was undetermined. The Fuller E. Callaway Academic Building replaced Dobbs and features a similar architectural style. The building now houses the School of Nursing and other departments. (Above, photograph by Q. N. Johnson; Right, photograph by Katherine Hyde Greene.)

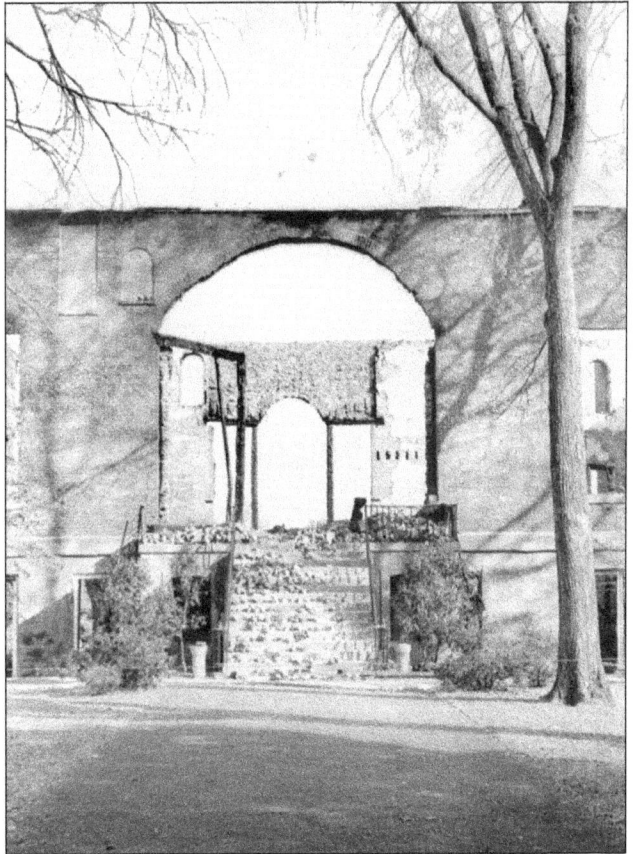

These gangsters at LaGrange College, caught in the midst of a game of craps, were performing a scene from *Guys and Dolls* at Dobbs Auditorium. The drama department has called Price Theater home since its construction in 1975. Built by Callaway Foundation, Inc., the name honors longtime mill executive Lewis Price, whose family was the last to occupy Sunny Gables, now the College Alumni House. Since the late 1800s, local residents have enjoyed attending college plays.

The appropriately named Riviera Theater stood next to the Chattahoochee River. Originally built in 1915 as West Point Auditorium, this became the Riviera 20 years later. The theater closed in 1958, and the building was torn down three years after the flood of 1961 weakened its foundation. West Point City Hall now sits on this site. Recently underwater archeological explorations, with state oversight, have discovered many historical artifacts in the river. (Photograph by Katherine Hyde Greene.)

Graduation exercises for LaGrange College are held in the gymnasium *c.* 1960. Manget Hall and the gym had just been completed the previous year. As the college grew, larger, more adequate locations for graduation have included the Quadrangle and Callaway Auditorium. In 1989, the gymnasium was named in honor of Al Mariotti, the longtime Panther basketball coach and athletic director.

The 1957–1958 LaGrange College *Quadrangle* includes scenes from Callaway Auditorium of Panther cheerleaders, including Elizabeth "Libby" Carlock. She was first lady of Georgia from 1983 to 1991 while her husband, Joe Frank Harris, served as governor. She attended Dunson School, which is being converted to apartments for senior citizens. In 2006, LaGrange College cheerleaders had something new to cheer about with the coming of the first football team in the college's 175 years.

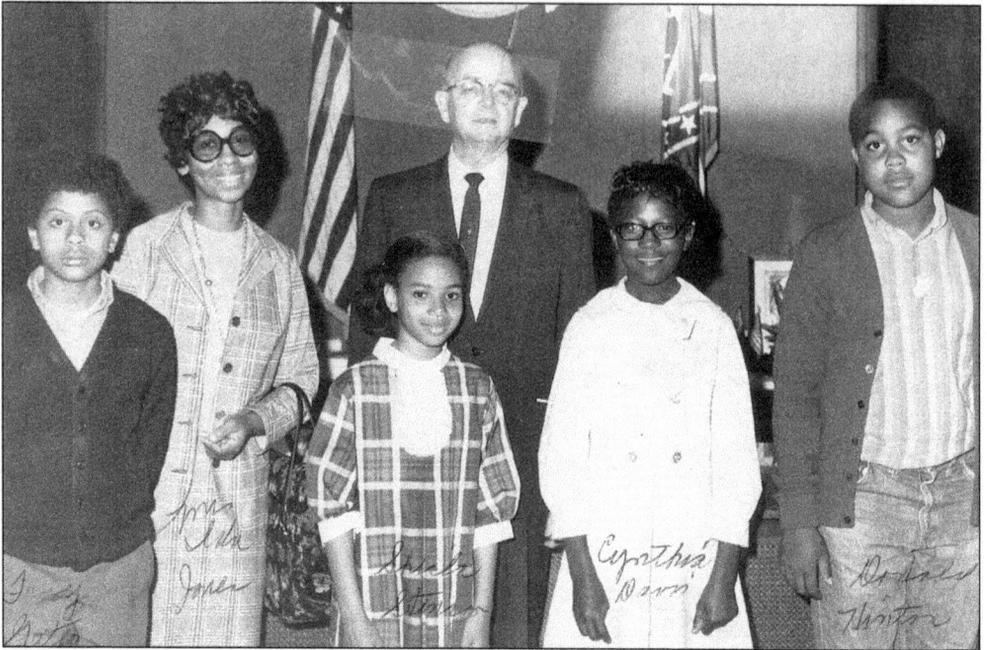

Four 6th-grade students from Mount Pleasant School and their teacher, Ida Tarver Jones, spend a day at the Georgia State Capitol in 1967 and visit with Gov. Lester Maddox. The students are, from left to right, Tony Gates, Sheila Stenson, Cynthia Davis, and Donald Hinton. Three years later, during integration, Mount Pleasant and Mountville Elementary Schools merged. The new school was called Mountville but located in Mount Pleasant's building because it was newer.

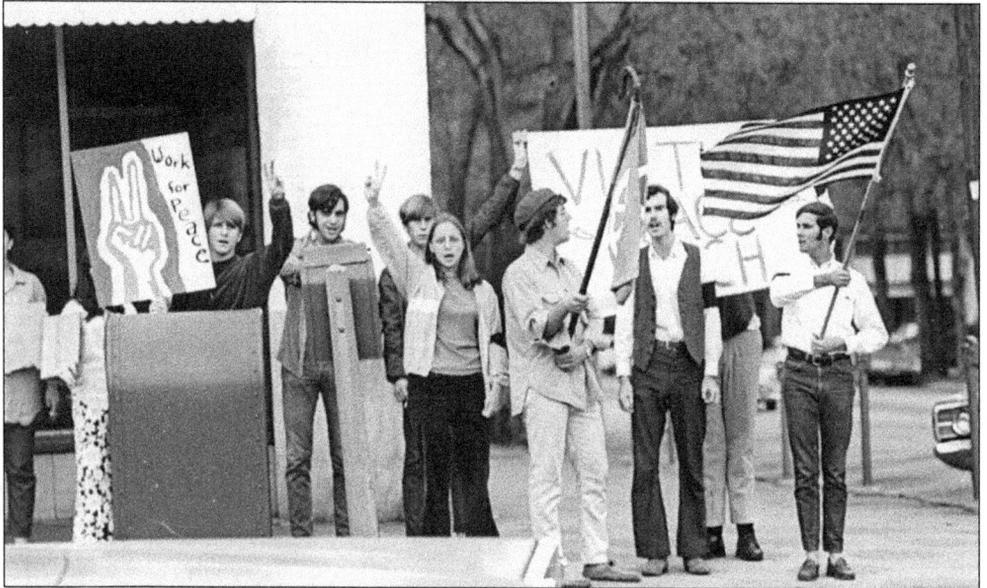

In the late 1960s and early 1970s, students from LaGrange College joined the national trend and took to the streets to voice their opposition to the Vietnam War. Protests of this nature have been rare in Troup County—usually a rally here is to promote something rather than oppose it. Students gathered on the west side of the Court Square near Broad Street to let the public know about their cause.

102

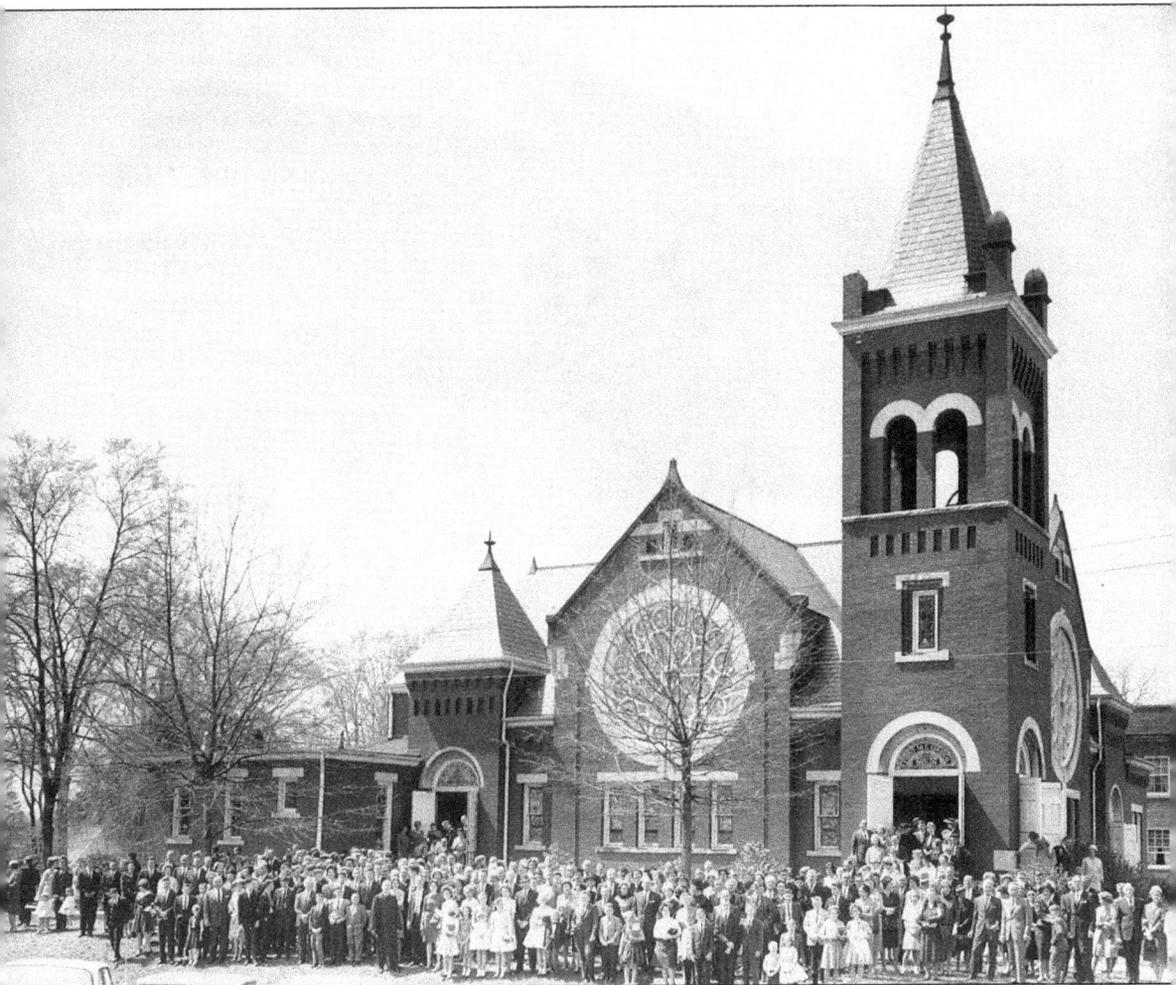

The congregation of First Methodist Church of LaGrange gathered on March 24, 1963. They had just participated in the final service held in this 1898 building. Prior to razing the structure, architectural details, including the rose and other stained-glass windows, were salvaged. The college chapel, designed by Ed Neal, features many of the windows. A new sanctuary opened in 1964 on this Broad Street site, where the church has been since 1827. (Photograph by J. Hugh Campbell.)

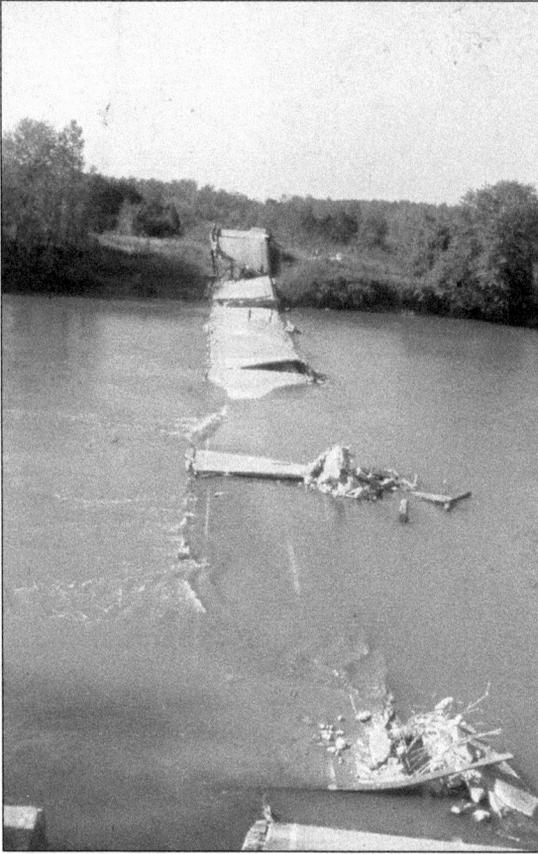

West Point Lake brought many changes to Troup County: altered landscapes and traffic patterns and relocated people, churches, stores, and cemeteries. The 1948 concrete Glass Bridge was one victim. Losing this bridge in 1973 eliminated a major east-west transportation artery. To reach the far side of the river seen in this Katherine Hyde Greene photograph, one must go south to West Point or north to Roanoke Road and circle back.

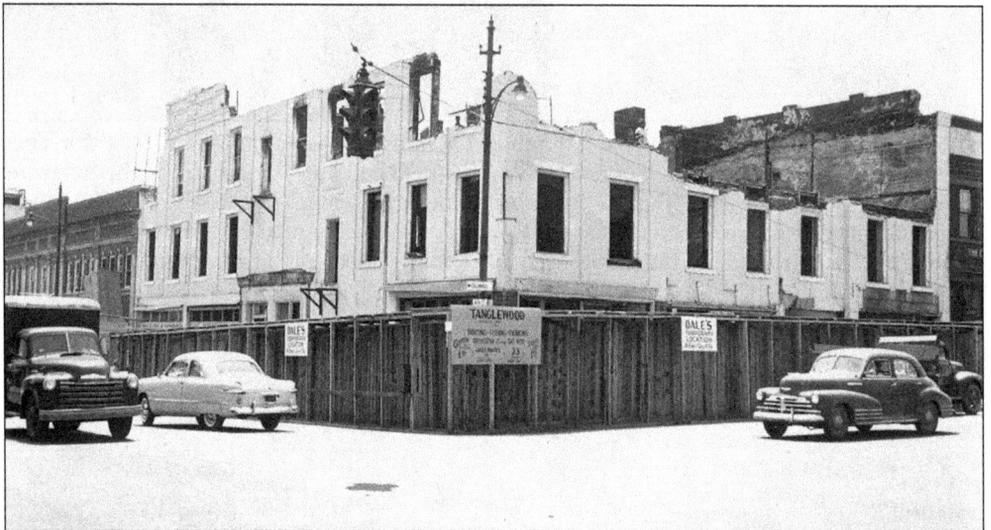

Park Hotel stood on the corner of Main Street and South Court Square from at least the 1850s until April 21, 1953, when fire gutted it beyond repair. The hotel hosted many prominent LaGrange visitors, including actor Edwin Booth, whose brother, John Wilkes Booth, assassinated Pres. Abraham Lincoln. The Mallory-Hutchinson Building, with office, retail, and restaurant space, has occupied the site since 1954.

Katherine Hyde Greene photographed the Ben Hill House at Tenth Street and Fifth Avenue in West Point in 1963, shortly before it was demolished. West Point Manufacturing Company later built a parking lot on the site. Benjamin Harvey Hill, nephew and namesake of the famed Troup County and Georgia statesman, built this grand home. The front replicated Bellevue, the elder Hill's home in LaGrange.

Towns such as Abbottsford began to suffer population loss as early as the 1920s. Abbottsford held on for several decades as a small commercial center just west of the Chattahoochee River, partly because of being located on the main road between LaGrange and Roanoke. Soon after this 1964 photograph was made, the town further declined when the main road was rerouted because of West Point Lake. (Photograph by Katherine Hyde Greene.)

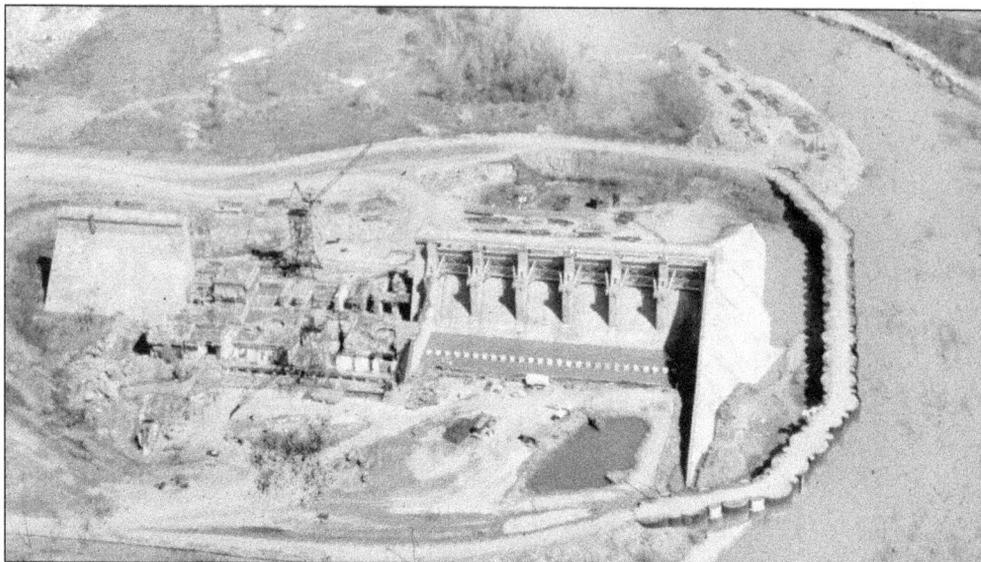

This aerial photograph shows construction of West Point Dam. The first concrete was placed during a ceremony in 1968, while the dam and powerhouse were dedicated on June 7, 1975. Secretary of the Army and LaGrange native Howard H. "Bo" Callaway gave the dedicatory address. The Corps of Engineers project cost $116 million. West Point Lake has several purposes: flood control, power generation, recreation, fish and wildlife enhancement, and stream flow regulation. (Photograph by Katherine Hyde Greene.)

Long Cane Masonic Lodge 132 (now 424) originally organized in the 1840s. They built this meeting hall with their rooms on the second floor. The first floor housed a store and stagecoach stop prior to the coming of railroads. Though they were generally very secretive about their organization, the Masons' most visible activity involves laying cornerstones for public buildings. This building was demolished in the mid-1970s, and a new lodge was constructed nearby. (Photograph courtesy of Marion Carson.)

Myrtice Carpenter, a local educator, ice-skated in the fountain on the Square in January 1970, thus proving that at times this area has very cold weather. The coldest day of the 20th century did not arrive until January 21, 1985, when the thermometer reached four degrees below zero. The coldest day ever recorded occurred on February 13, 1899, when it reached 10 degrees below zero. Textile mills could not operate that day because of the cold, snow, and frozen pipes.

In February 1975, Count Rene de Chambrun, descendant of the Marquis de Lafayette, and Celestin Quincieu, mayor of Le Puy-en-Valey, France, joined local citizens in unveiling and dedicating this statue. LaGrange City Council then renamed Court Square as Lafayette Square. The statue is an exact replica of one that stands in Le Puy-en-Valey, Lafayette's hometown. It was obtained through the efforts of Waights G. Henry, president of LaGrange College, and is on loan to the city.

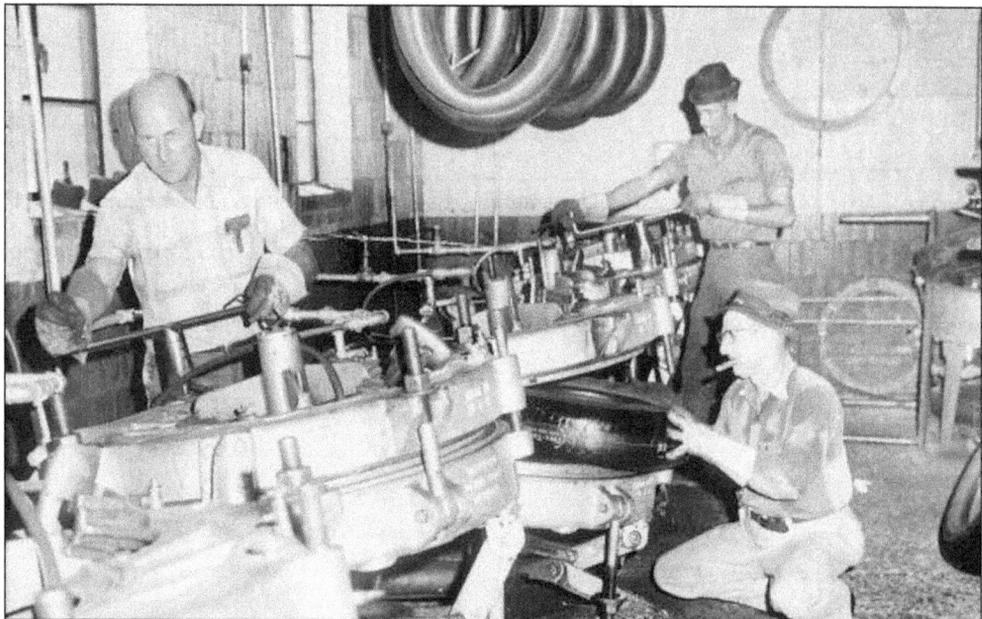

Workers at Thornton Tire Company on Greenville Street in LaGrange are using steam molds to recap automobile tires in the 1970s. An early form of recycling, recapping extended the life of tires. This was a widespread practice from the war years until the 1970s, when radial tires began to dominate the market. O. E. Thornton operated the tire store from the 1940s until the 1980s. (Georgia Archives, Vanishing Georgia Collection, TRP-91.)

West Point photographer Katherine Hyde Greene poses in front of the post office at Gabbettville in southwestern Troup County. Longtime historian William Davidson took the picture. In 1964, they collaborated on *Pine Log and Greek Revival,* a classic history of this area. He wrote the text while she made the photographs. Though the community no longer has a post office, it is the center of much activity with the coming of Kia Automotive.

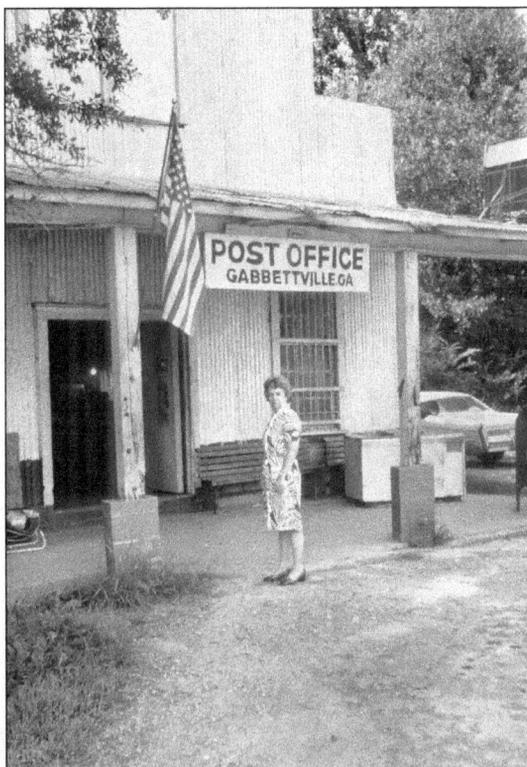

Local attorney Alfred Zachry photographed Louise Hardy Hogg Thompson of the Pleasant Grove community as she left the Letter Shop on Church Street in 1972. Julius Schaub constructed the building in 1884 for his photography studio. Prior to its 1993 demolition, the building housed many businesses, including a beauty parlor and this stationery store. The old hexagonal pavers once common in downtown LaGrange are clearly visible.

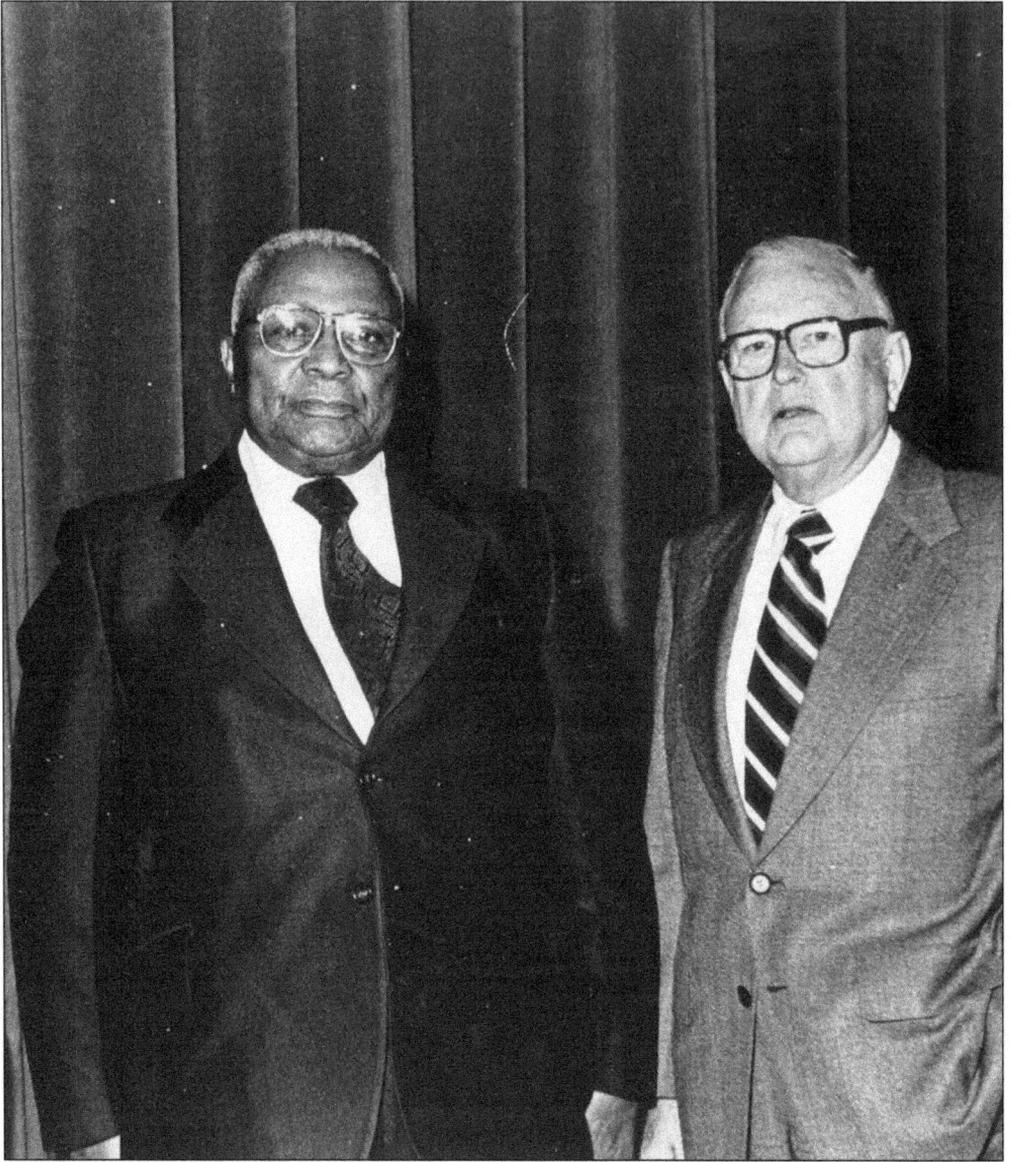

Throughout the years, LaGrange College has brought many famous people to the county. Dr. Martin Luther King Sr., affectionately known as "Daddy King," and Dr. Waights G. Henry Jr. conversed on one such occasion in March 1978. When Dr. Henry retired after 30 years as college president, the board of trustees created the special office of chancellor to honor him. The college brings in speakers for forums, graduations, baccalaureates, concerts, convocations, and other special occasions.

Seven

More Recent Times
1980–Present

Charlie Brewer was a heroine at age 23. As a nurse, she assisted her employer, Dr. Henry Terrell, and worked day and night following the cyclone that struck Troup County in March 1920. She continued making contributions the rest of her life as a community and church leader. Many people in town knew and loved "Miss Charlie," as she was affectionately known. Alabama artist Sherre Sorrell, while showing her work in the Affair on the Square, sponsored by the Chattahoochee Valley Art Museum, saw her coming out of a store in LaGrange and immediately knew she had to paint her portrait. Miss Charlie exuded all the charm of the typical "Southern Lady," and that was the title the artist gave the painting. Sorrell took some liberties with the background, as the storefront in the picture is in Alabama. The painting won Best in Show in Eufaula, Alabama, where the mayor was so taken with it that he bought it on the spot. Miss Charlie died in 1993. (Painting by Sherre Waller Sorrell, used with her permission.)

Marianne Murphy (left) and Monica Kaufman (now Pearson) confer in the chapel at LaGrange College. Pearson, a popular news anchor at WSB-TV in Atlanta, spoke in LaGrange several times, including at college events. Murphy is married to Walter Murphy, who served as president of the college from 1980 until 1996. During his tenure, Callaway Foundation gave Callaway Educational Association buildings and lands to the college, greatly increasing the size of their campus. (Photograph by David Griffin, LaGrange College Collection, Troup County Archives.)

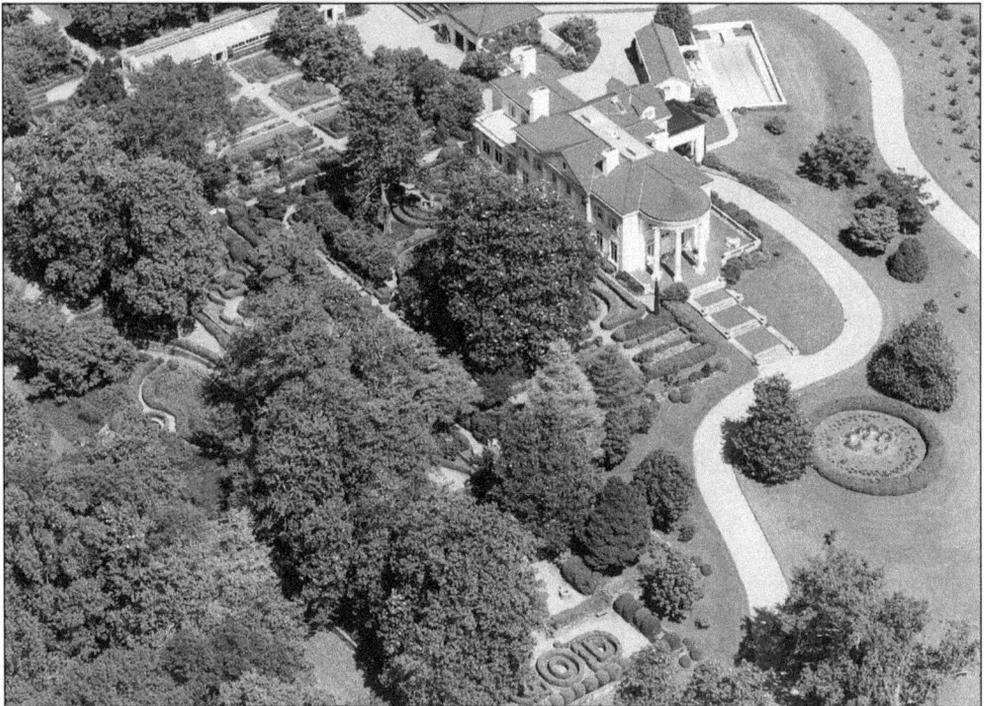

This aerial photograph of Hills and Dales and Ferrell Gardens dates from 1990, when it was the home of Mr. and Mrs. Fuller Callaway Jr. In the foreground, "God" is spelled in boxwoods planted by Sarah Coleman Ferrell. She wanted this at the entrance of her garden because the Bible states, "In the beginning was God." The centerpiece of the estate is the Neel Reid–designed house completed in 1916. Other prominent features include the herb garden, greenhouse, sunburst garden with gazebo, and swimming pool. Following the deaths of the Callaways, the estate was opened to the public. A new visitors' center complementing the architecture of the house opened on October 4, 2004.

This unidentified man stands in front of Harmony United Methodist Church in 1977. Established in 1843, Harmony is located near Abbottsford in western Troup County. The church building dates from the early 1900s. Members were probably preparing for dinner on the grounds. They hold a public barbecue every October as a fund-raiser. (Georgia Archives, Vanishing Georgia Collection, TRP-243.)

West Point mayor John Costley Barrow and his two grandsons admire the plaque at the dedication of the Barrow Bridge in 1977. The new bridge on U.S. Highway 29 spans the Chattahoochee River connecting the east and west portions of West Point. This bridge replaced the old steel one built in 1920. (Photograph by Katherine Hyde Greene.)

The Affair on the Square has been a popular springtime event since its inception in 1963. The Chattahoochee Valley Art Museum sponsors the annual festivities that showcase both local and regional artists. The Hydrangea Festival, held each year since 2001 in May or June, is another time that the city draws both locals and tourists into downtown. Garden clubs are involved, and planting hydrangeas throughout the city is encouraged.

Located on Alford and Broome Streets, LaGrange Memorial Library sits on the site of the former Harwell Avenue School, which burned in 1964. This construction occurred in 1995. The library is part of the Troup-Harris Regional Library. One special program sponsored by the library, LaGrange College, Troup County Board of Education, and others is the Azalea Storytelling Festival held each year in March. The festival brings nationally known storytellers to LaGrange. (Photograph by Howard Abbott.)

114

The Sweet Land of Liberty Parade started in 1985 under the inspiration and guidance of Annette Mills Boyd. She visited every school in the county and enthusiastically promoted interest in the July Fourth parade. She made patriotism more visible to the public and more meaningful to children. She brought the same energy to many projects, including Special Olympics. City leaders renamed the old city park Boyd Park to honor Annette and her husband, Jim, for their contributions to the community. Although made up of youth 19 and under, the parade also honors adults who are community leaders. In the 1989 photograph below, Julia Hope Johnson, longtime and much-beloved dance instructor, is surrounded by parade participants, including youth selected to represent Miss Liberty and Uncle Sam. The community was saddened when Johnson died in November 1989 and Boyd in 2004. (Below, used with permission of *LaGrange Daily News.*)

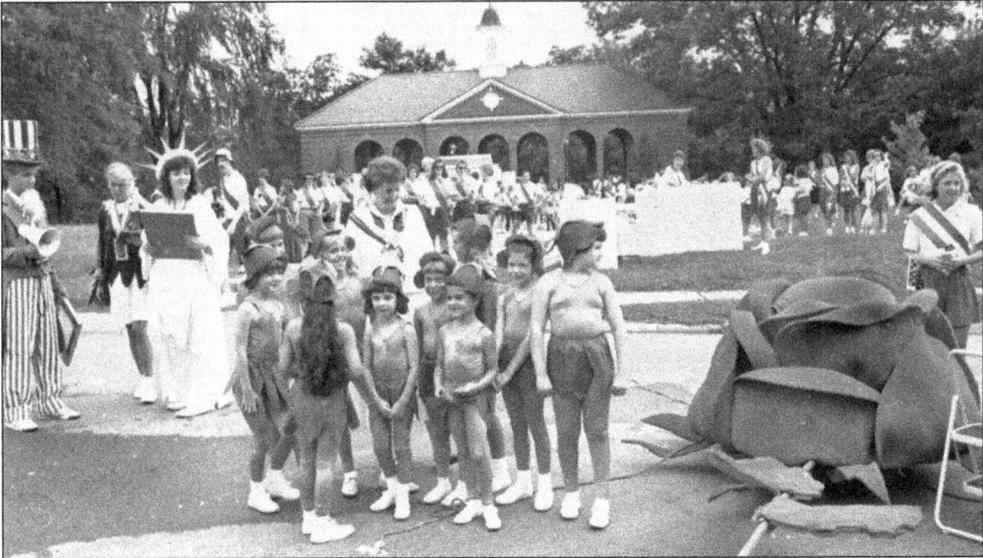

For generations, the people of LaGrange have supported the arts. Young Singers of LaGrange, led by Debbie Ogle from founding in 1996 until 2002, are shown at First Presbyterian Church. They have performed in New York City, England, and on the West Coast. Stacy McCord Hardigree has directed the group since Ogle joined the LaGrange College faculty. The singers are part of the LaFayette Society for the Performing Arts (LSPA).

LaGrange and Troup County have often hosted foreign guests, including students at LaGrange College. Groups such as LaGrange International Friendship Exchange (LIFE), Georgia Rotary Student Program, and others bring people from around the world. LIFE has encouraged the Sister City program. Elske Wortman from Holland attended the college from 1995 to 1996 as part of the Rotary program. The LaGrange club has sponsored students since 1950.

The building on the left, Hoofers Restaurant, began its existence as the Troup County Cattle Barn. Where beef was auctioned live "on the hoof," it is now served by the steak. The Gospel Barn shares the same complex and draws large crowds to hear well-known gospel and bluegrass musicians. An RV park helps accommodate the crowds. Local contractor Rick Torrance and his family have developed and operate this attraction.

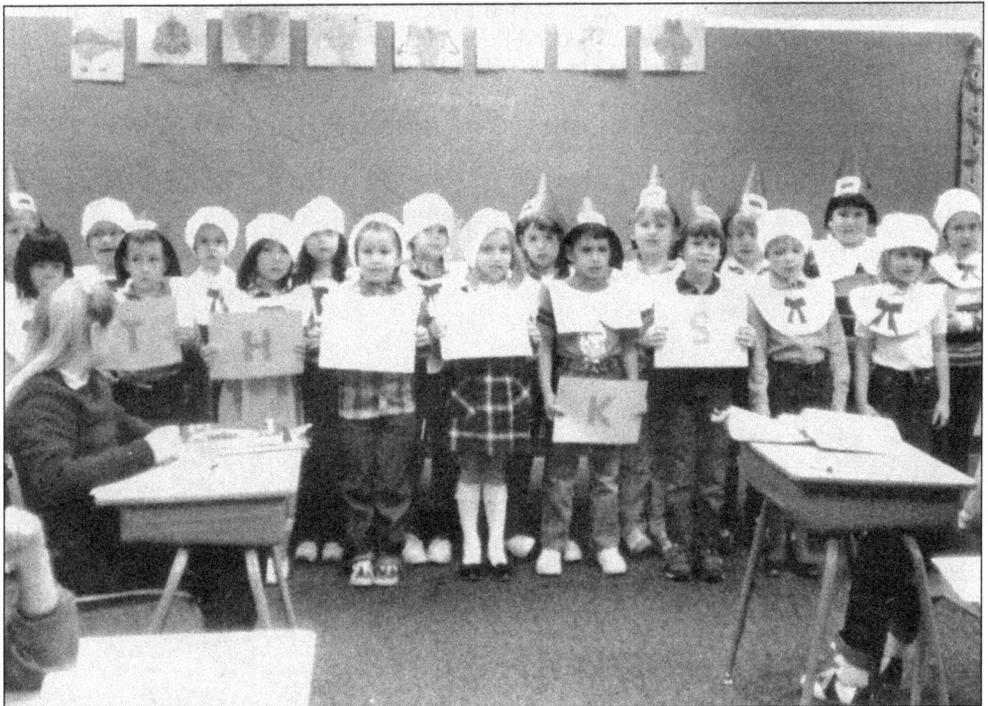

LaGrange Academy first organized in 1970 as a private college preparatory school. With their campus on Vernon Road, the academy serves students from kindergarten through high school. These first graders are presenting a Thanksgiving program in 1983. In addition to academics, the academy offers a range of athletic programs, some of which have won state championships. (Photograph from *Lagalog* 1983, used with permission.)

Union Lodge No. 28 of the Free and Accepted Masons first organized in LaGrange in 1842. Through time, they occupied various second-floor meeting halls in downtown until they built this new temple on Hogansville Road in 1963. The Masons meet twice monthly and share this facility with the Order of the Eastern Star. A related group, the Shriners, does much community good and maintains a meetinghouse in the Hillcrest community north of LaGrange.

Built by Roy Freeman in the early 20th century, this Dutch-style barn with a gambrel roof in Gabbettville serves as a landmark on U.S. 29 between LaGrange and West Point. Freeman came to Troup County from Tennessee as a mule trader and later became a farmer. Looking at this tranquil scene, one would never suspect that just beyond the barn, work is underway at one of the largest automobile manufacturing plants in the South.

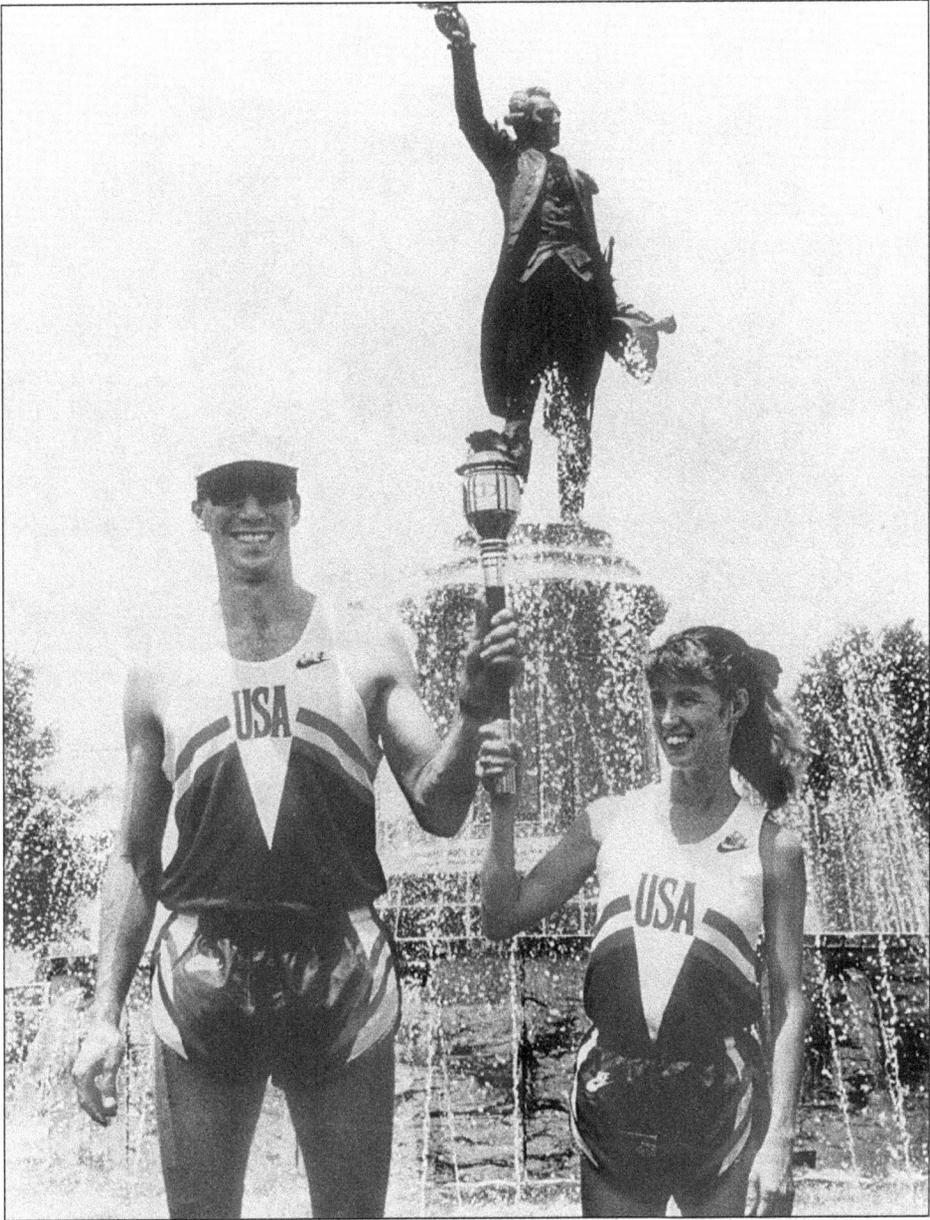

Soon after the announcement was made that Atlanta would host the Olympics in the summer of 1996, LaGrange became a training site for athletes. The "I Train in LaGrange" program brought over 400 Olympic hopefuls from more than 40 countries throughout the world to this area. Beginning in 1993, the athletes, based mostly at LaGrange College, became part of the community and benefited from warm Southern hospitality. They were frequent visitors to local schools. Training here helped the athletes adjust to the Georgia climate, and several won medals at the games. Racewalkers Michelle Rohl and Allen James hold the Olympic torch in front of the statue of Lafayette. On July 17, 1996, James and 29 community leaders selected by United Way of West Georgia as torchbearers carried the flame across Troup and Heard Counties. The Olympic racewalking time trials were held in LaGrange, and the winners then participated in the Olympics.

LaGrange hosted the Georgia State Special Olympics fall games from 1999 to 2001. Jim and Annette Boyd spearheaded the organization and fund-raising for the games. Parades and special ceremonies celebrated the opening each October. Here athletes are receiving their awards following one of the events. (Photograph by Nat Gurley, used with permission of *LaGrange Daily News*.)

Local photographer Lee Cathy made this aerial picture capturing how downtown LaGrange looked in the year 2000. He was looking west across Lafayette Square toward LaGrange College. Significant changes have occurred since the picture was made. (Photograph by Lee Cathey, Multi-Image Studios, used with permission.)

120

Many activities marked the changing of the calendar to the year 2000. The ladies above proudly display a millennium quilt made at the Troup County Senior Center. They donated the quilt, featuring local historical scenes, to the Troup County Archives. The major event, called Celebrate 2000, occurred downtown on December 31, 1999. Fireworks at midnight marked the arrival of January 1, 2000. Over 10,000 people gathered downtown for special musical acts, large-screen viewing of historical films about the county, food vendors, and dancing in the street. (Lower photograph by Sherri Brown, used with permission of *LaGrange Daily News*.)

On February 23, 2001, citizens gathered to rededicate the statue of the Marquis de Lafayette on the Square in downtown LaGrange. They were joined by 26 French guests of the local Rotary Club. The visitors were from Le Puy-en-Valey, France, Lafayette's home, where the original statue stands. Miss Georgia, Pam Kennedy from Troup County, sings the national anthem. Behind her from left to right are LaGrange mayor Jeff Lukken, Charles Hudson Jr., French Consul General Jean-Paul Monchau, and Dr. George Henry.

The LaGrange Symphony Orchestra, under the direction of Maestro Patricio Cobos, performs in their new home, Callaway Auditorium at LaGrange College. The building was extensively renovated and changed from a multipurpose center with basketball goals to a world-class performing arts venue. Callaway Foundation, Inc., provided the funds. (Photograph courtesy of LaGrange College.)

In March 2006, executives of Hyundai Corporation in South Korea announced they would build a new Kia automotive plant near West Point. This photograph from August shows that grading quickly got underway on the 1,000-acre site located next to Interstate 85. Diethard Lindner, Drew Ferguson, Jane Fryer, and others spearheaded the local efforts to secure Troup County as the site for the plant. The State of Georgia helped as well. (Photograph by Matt Jones, *LaGrange Daily News*, used with permission.)

On September 9, 2006, LaGrange College celebrated a milestone in its 176-year history when it held its first home football game. LaGrange hosted Rhodes College from Memphis, Tennessee. Pres. Stuart Gulley marks the occasion with special words prior to the game as the team looks on. The football program was instituted to enhance enrollment, improve athletic facilities, and increase community participation. (Photograph by Matt Jones, *LaGrange Daily News*, used with permission.)

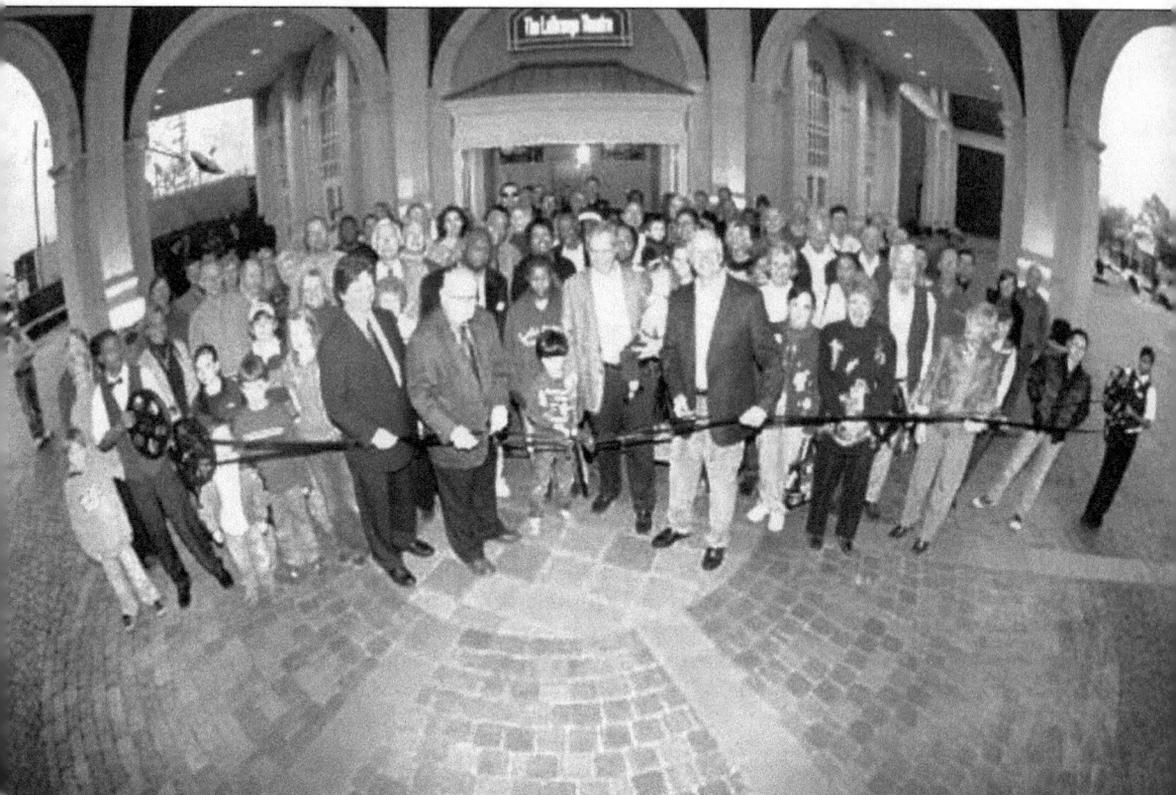

Local people and government officials gathered under the dome of the new LaGrange Cinemas 10 on December 23, 2006, for a ribbon-cutting. For this special occasion, the "ribbon" was an old reel of movie film, though the new theaters are completely digital. The facility houses 10 theaters, a concession stand, and a precinct of the LaGrange Police Department. A new parking deck completes the project. Located on the corner of Main and Broome Streets, the building replaced a 1913 post office, a 1929 theater, and several stores and old cotton warehouses. Downtown LaGrange has been the center of extensive revitalization efforts in recent years. Over $42.7 million in public and private monies have been spent in downtown between 2004 and 2006. New structures have been built, other buildings have been rehabilitated, sidewalks have been improved, and two parking decks have been added. (Photograph by Matt Jones, *LaGrange Daily News*, used with permission.)

SELECTED BIBLIOGRAPHY

Chattahoochee Valley Historical Society. *West Point on the Chattahoochee*. West Point, GA: self-published, 1957.

Davidson, William H. *Pine Log and Greek Revival*. Alexander City, AL: Outlook Publishing Company, 1964.

———. *Brooks of Honey and Butter*. Alexander City, AL: Outlook Publishing Company, 1971.

———. *150 Years of West Point Methodism 1830–1980*. West Point, GA: Hester Printing, 1980.

Greene, Oliver N. *From the Brush Arbor to the Temple Beautiful*. Columbus, GA: Quill Publications, 1995.

Johnson, Forrest C. III. *History of LaGrange, Georgia 1828–1900*. LaGrange, GA: Family Tree, 1987.

———. *Genealogical and Historical Register of Troup County, Georgia*. LaGrange, GA: Family Tree, 1987.

———. *Memories in Marble: Hill View and Hill View Annex Cemeteries*. LaGrange, GA: Sutherland–St. Dunston Press, 1992.

———. *People of Antebellum Troup County, Georgia*. LaGrange, GA: Sutherland–St. Dunston Press, 1991.

———. *Where Your Treasure Is: History of LaGrange First Methodist Church*. LaGrange, GA: Sutherland–St. Dunston Press, 1996.

Jones, John. *Americanism: World War History of Troup County, Georgia*. Atlanta, GA: Webb and Vary Company, 1919.

LaGrange Daily News.

LaGrange Graphic.

LaGrange Reporter.

Lawrence, John, et al. *Travels through Troup County: A Guide to its Architecture and History*. LaGrange, GA: Troup County Historical Society, 1966.

Major, Glenda R. *Paid in Kind: History of Medicine in Troup County, Georgia 1830–1930*. LaGrange, GA: Troup County Historical Society, 1989.

Major, Glenda R. and Clark Johnson. *Treasures of Troup County: A Pictorial History*. LaGrange, GA: Troup County Historical Society, 1994.

McClendon, Dorothy H., Lillie Lambert, and Danny Knight. *Family, Church, and Community Cemeteries of Troup County, Georgia*. LaGrange, GA: Family Tree, 1990.

The Shuttle.

Smith, Clifford L. *History of Troup County*. Atlanta, GA: Foote and Davies, 1935.

Strain, Jane M. *History of the Town of Hogansville 1860–1970*. Hogansville, GA: self-published, 1986.

Troup County Archives. Manuscript and Photographic Collections.

Troup County Historical Society. *Troup County in Vintage Postcards*. Charleston, SC: Arcadia Publishing, 2002.

U.S. Army Corps of Engineers. *The Meal Tastes Sweeter: Documentation of Young's Mill*. Atlanta, GA: Brockington and Associates, 1989.

INDEX

Visit us at
arcadiapublishing.com

www.ingramcontent.com/pod-product-compliance
Lightning Source LLC
Chambersburg PA
CBHW050704150426
42813CB00055B/2447